灵动的彩绘
Ethereal Colors

魏新萍舞台摄影艺术

Wei Xinping Stage Photography Art

Ethereal Colors

灵动的彩绘

海风出版社

HAIFENG PUBLISHING HOUSE

Ethereal
Colors

魏新萍舞台摄影艺术

Wei Xinping's Resume

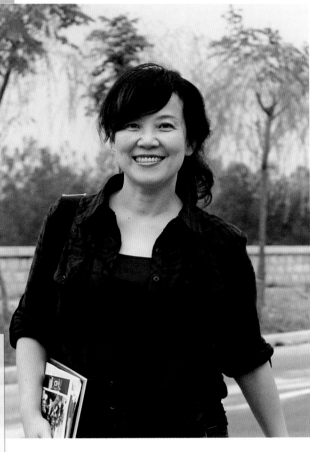

福建省泉州市人，大专学历，现为中国摄影家协会会员、福建省艺术馆艺术研究部副研究馆员。长期从事舞台艺术摄影、摄影辅导培训教学等工作。发表相关摄影理论文章十余篇，近百幅作品在各级影展比赛中入选和获奖。其中《旋律》荣获福建省第十七届摄影艺术作品展金奖、第五届中国摄影精品展荣誉奖；《隐翅待翔》荣获第十四届"群星奖"全国摄影比赛铜奖；《星汉梦归女》荣获"龙土岁月行"全国摄影比赛二等奖；《恍若仙女下凡来》荣获首届"金鹤杯"全国摄影比赛银奖。

Wei Xinping is from Quanzhou, Fujian. She is a junior college graduate, a member of the Chinese Photographic Society, and an research associate at the Fujian Provincial Art Institute. She has worked for a long time as a stage photographer and teacher of photography for training programs, and has published more than a dozen research papers in her field. About one hundred of her works have been chosen for exhibits or have received awards. Among them, *"Rhythm"* won the gold medal in the 17th Fujian Provincial Art Photography Competition, and received an honorable mention in the 5th National Photography Exhibit. *"Ready to Fly"* won the bronze medal in the 14th Qunxing Photography. *"The Woman Dreaming of Coming Home in the Starlight"* took second place in the National Photography Competition of Longtu-Suiyuexing. *"Goddesses Descending from Heaven"* won the silver medal in the first Jinhe National Photography Competition.

灵动的彩绘
Wei Xinping Stage Photography Art

序 Preface

据我所知，在作家和美术家的群体中，年轻漂亮的女性常在称谓前被冠以"美女"二字以示强调，因此就有"美女作家"、"美女画家"等时髦称号。照此类推，我们摄影界当然也有"美女摄影家"，不但有"美女摄影家"，还有"美女摄影家群"。这个由年轻的女性摄影家组成的创作群体，活跃在福建摄影界，常常在一起组织开展摄影活动，为我省摄影事业的繁荣和发展，做出了贡献。魏新萍同志就是这个群体中的一员。

我已记不清是什么时候认识魏新萍的，但有一个场景我却记忆犹新：那是在福建省第十七届摄影艺术作品展评选揭晓的时候，魏新萍的作品《旋律》获得了金奖，有人在观展的时候大声问："谁是魏新萍呀？""就是那位长得漂亮又会变魔术的女孩呀！"有人回答道。其实，那时小魏已经是一个孩子的母亲，同时也是一位颇具艺术素质的摄影家了。

魏新萍是一位从表演队伍中走出来的摄影家，从小就与舞台结缘。因此她刚涉足摄影就自然地选择舞台摄影作为其主攻的方向。这些年来小魏很努力和用心，俗话说，勤奋出天才，正是这种勤奋，使得小魏摄影技艺进步神速，她拍摄的作品视角独特，富有节奏感和韵律感。

魏新萍拍摄的舞台摄影作品的确是有灵气的。人们常说舞台是无形的音乐、有形的诗，但要拍好，着实不易。然而，小魏拍的舞台作品却是那样地耐人寻味，无论在舞台语言的捕捉、音乐感的表达、形式美的追求、舞台灯光的取舍还是在内容情感的展示上，她的作品都把握得恰到好处：既全面展示了自己摄影专业水平，又彰显了自己的艺术才华。

舞台摄影是有难度的。相对于户外摄影创作，舞台摄影受到更多条件的限制，在技术层面对摄影者技能要求更全面更高深。然而，从小魏作品中散发出来的不仅是摄影技巧的纯熟，更是灵感飞舞地随心所欲。没有深厚的艺术功底和知识经验的积累，以及自身不懈的努力，是不可能有如此成就的。

魏新萍喜爱摄影，更热爱舞台摄影，对舞蹈摄影情有独钟。因此，她打算结集的第一部作品就是舞台摄影集，这是很值得祝贺的事情。我们也希望她在摄影领域里进一步开拓视野，取材更加广泛，随着时间的推移，优秀摄影作品能够不断涌现，进而取得更高的艺术成就。

魏新萍同志非常年轻，现在已经是我省为数不多的职业摄影家，同时又是摄影工作的组织者，我们完全有理由相信她会充分发挥自己的优势与才干，团结更多我省的摄影人，为我省新时期的摄影事业做出自己的贡献。

中国摄影家协会 副主席
福建省摄影家协会 主席

Young and pretty female writers and artists are often called "beauty writers" or "beauty artists". Thus, we should also have "beauty photographers" .Fujian has a very active group of young female photographers. Wei Xinping is one of them.

I can't recall when I first met her. But I clearly remember that, when the winner of Fujian's seventeenth photography competition was announced, Wei Xinping's *"Rhythm"* took first place. Someone asked loudly, "Who is Wei Xinping?""She is the pretty girl who performs magic", someone answered. In fact, at that time, Wei was already a mother and a promising professional photographer.

Wei Xinping had been on the stage since childhood. Naturally, she focused on stage photography, especially photographs of dancing. Wei has worked very hard on this during the last several years.
As people say, practice makes perfect, and Wei has made rapid progress. Her works-usually taken from new angles-are rich in rhythm and proportion.

Wei Xinping's photographs of the stage are inspired. People often say that the stage is visible music and tangible poetry, but to capture this in photographs is far from easy. Wei's photographs of the stage, however, are really admirable. Whether they show the language of the stage, the sense of music, the beauty of form, the choice of stage lighting, or the emotions of the acts, she has developed a charm of her own. They also all reveal her expertise and her artistic talent.

Stage photography is difficult. Compared with outdoor photography, stage photography is more restricted. It requires more complete and more advanced skills. Looking at Wei's works, we can see not only how well-versed she is, but we can see the spiritual freedom in her creations. Her works are based on her profound knowledge and her experience in art, as well as her long years of hard work.

Wei Xinping loves photography and particularly stage photography. And so her first book is an album of stage photographs. This is worthy of congratulations. We also hope that she will widen her vision in the field of photography and deal with even more subjects, so that as time passes, she will continue to produce excellent photographs and attain even more artistic achievements.

Wei Xinping is very young, and yet she is already one of only a few professional photographers in our province. She also works for the photographers'society. We believe that she will make the most of her prominence and ability to bring together even more photographers in our province. We believe she will make her own contribution to the new phase of the work of photography in Fujian.

The Vice-chairman of China
Photographers Association & The Chairman of Fujian
Photographers Association

ZhangYu

灵动的彩绘
Wei Xinping Stage Photography Art

Pleasure

人之初，

目之所及，

尽是喜悦。

那些叶绿花红，

那些燕舞莺歌，

均成了最初的梦。

Everything a youth sees is
filled with happiness.
The leaves are green and the
flowers red,
The warblers are singing and
the swallows dancing
in my earliest dreams.

一袭长袖临风飘

Long sleeves flying up

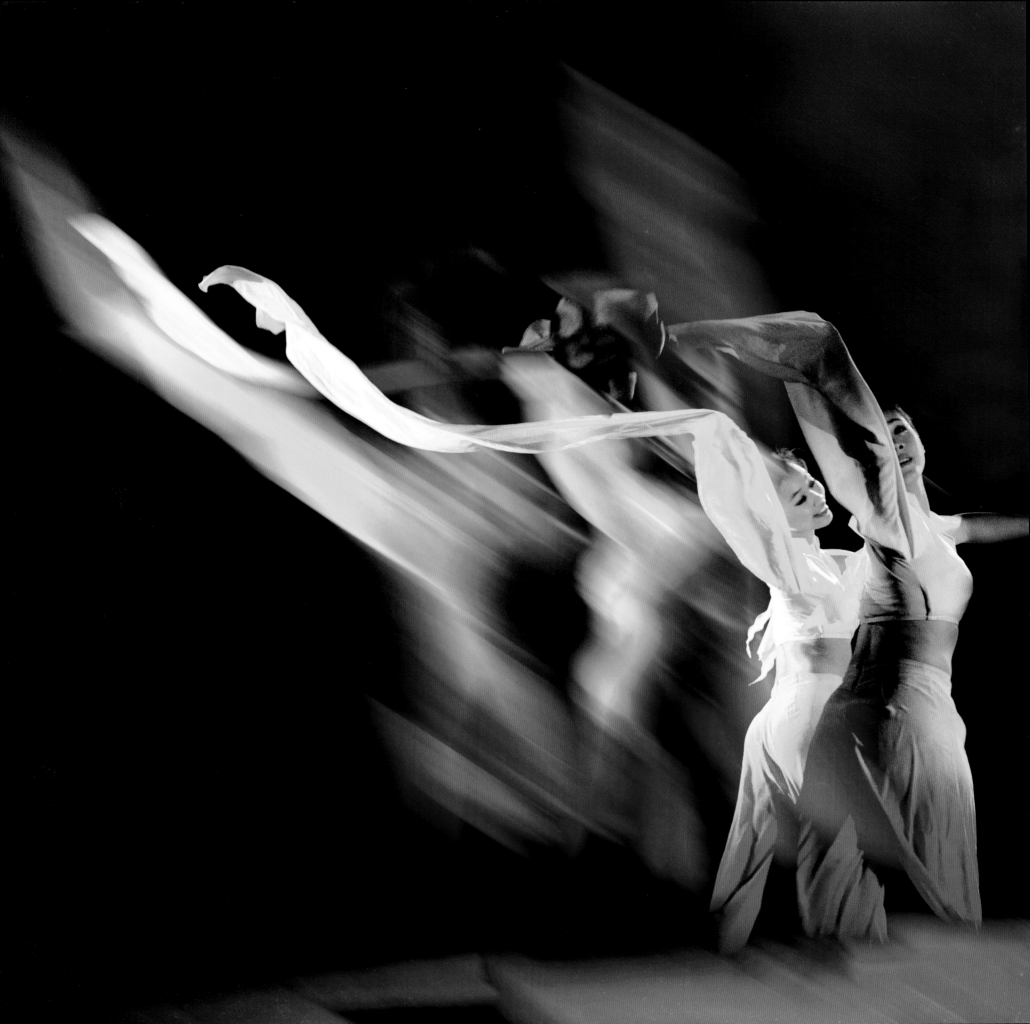

旋　律

Rhythm

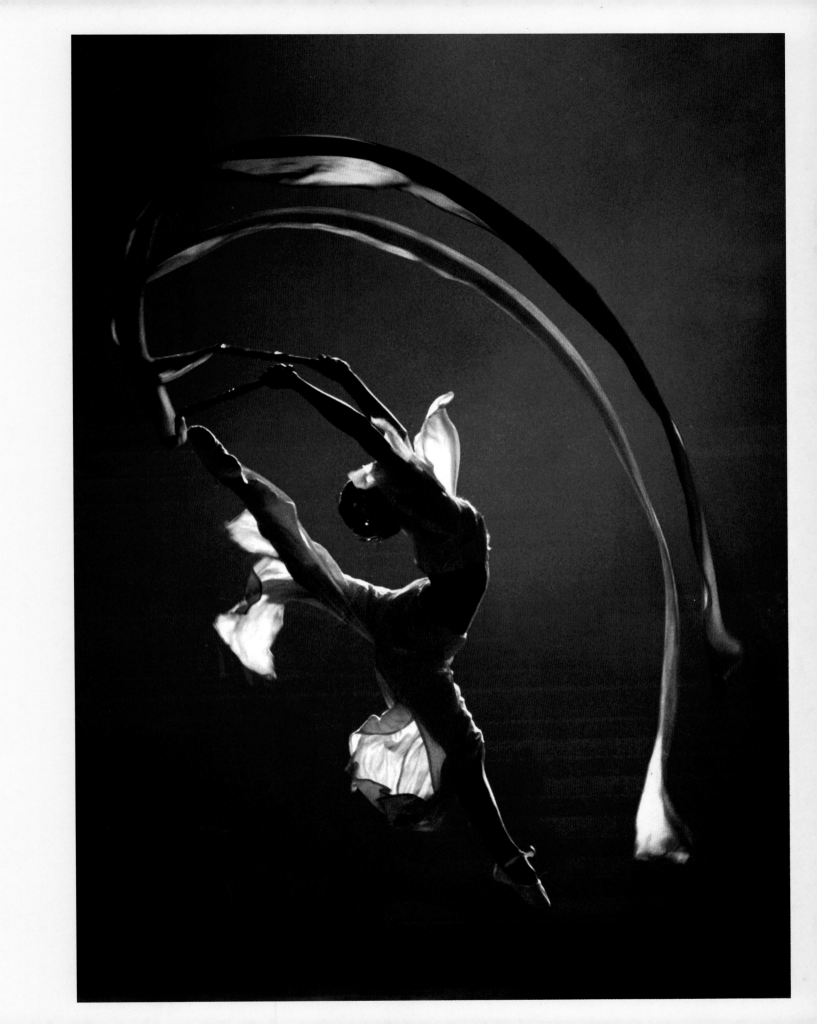

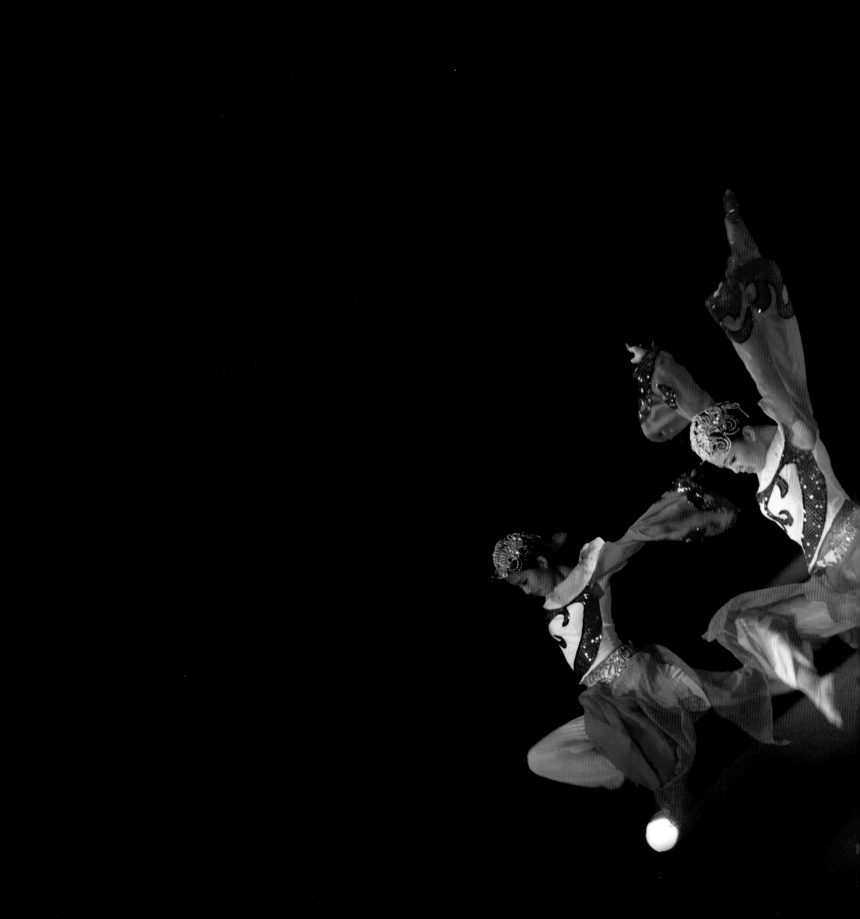

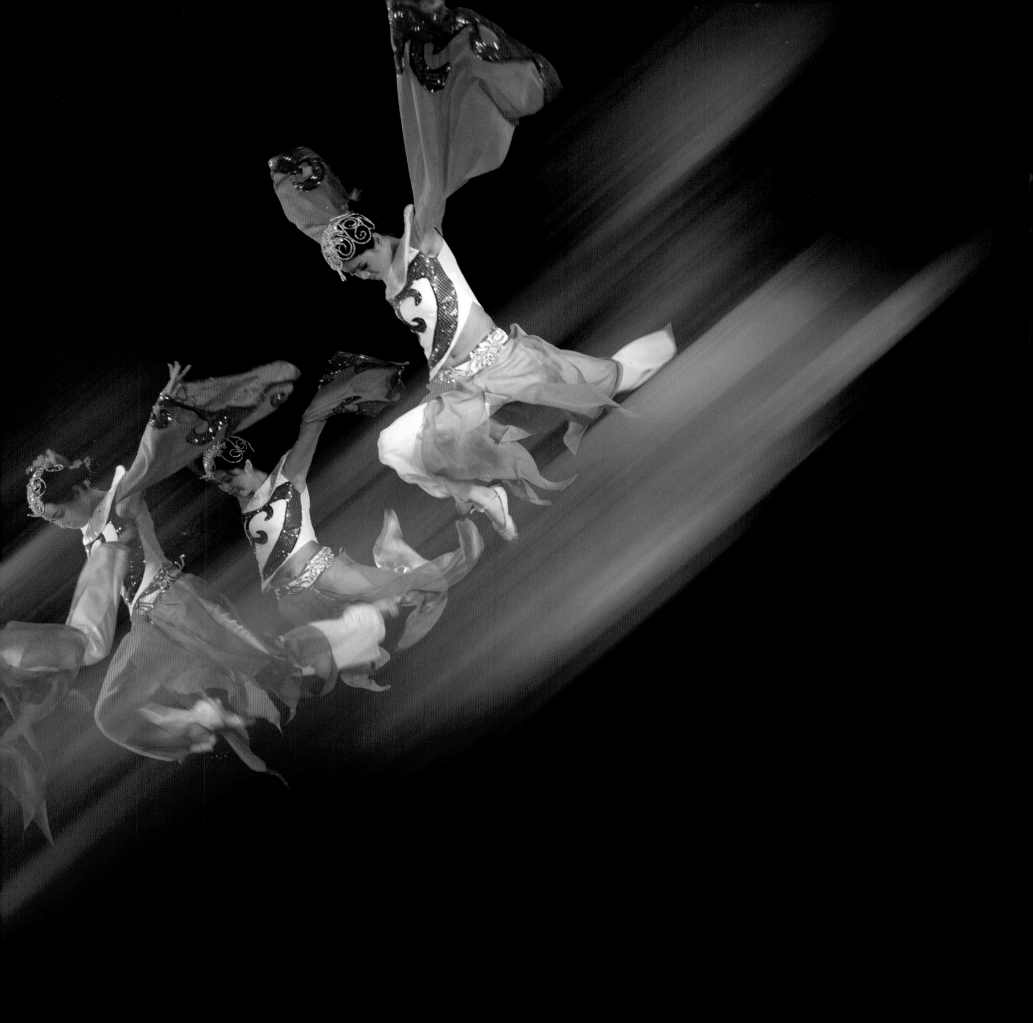

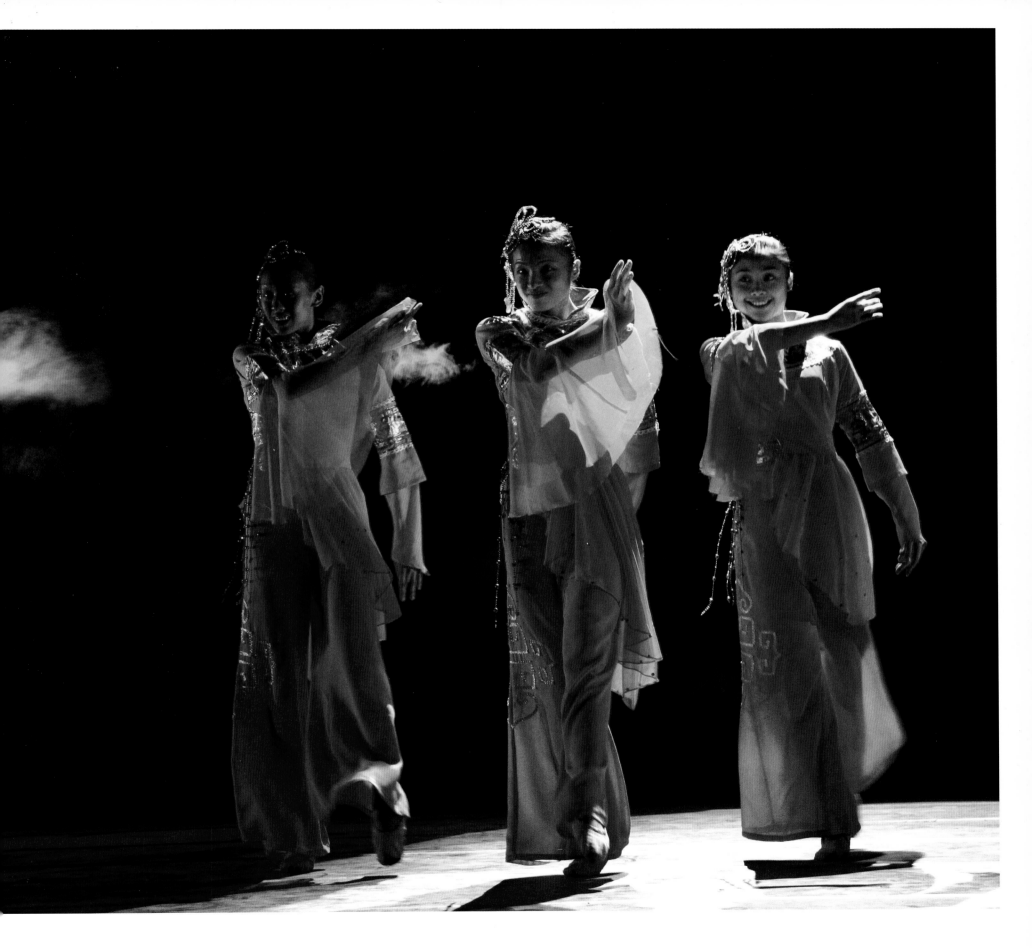

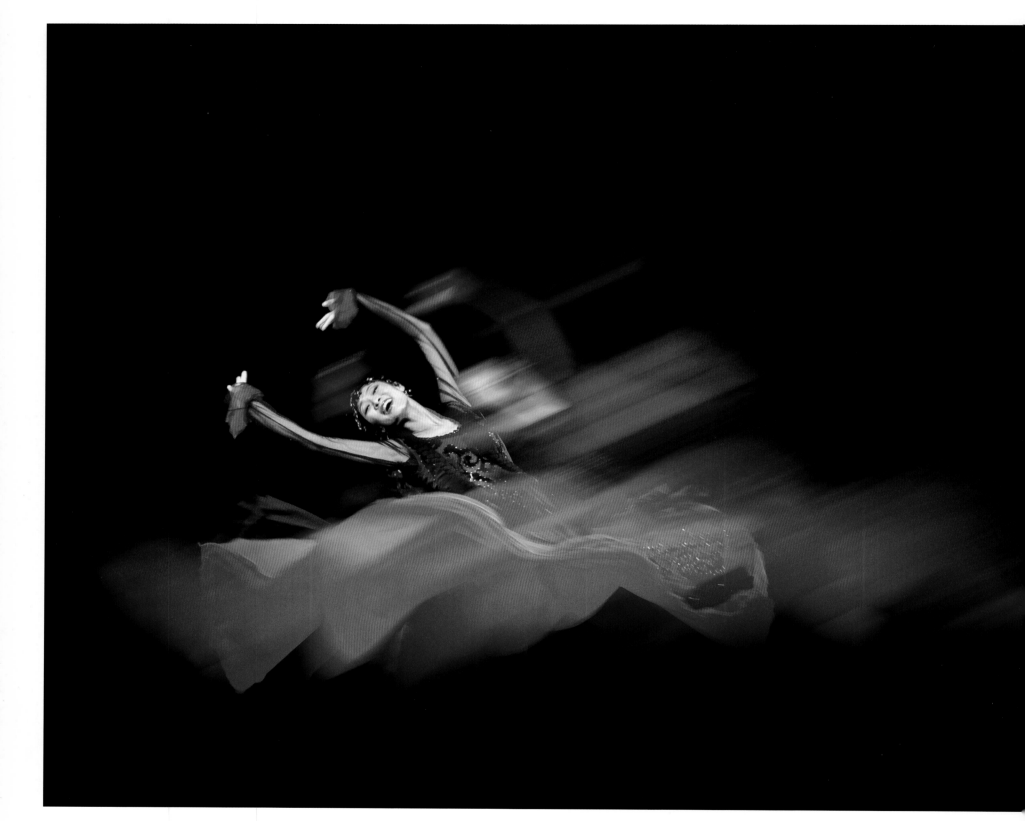

天山舞曲

Dancing of Tianshan Mountain

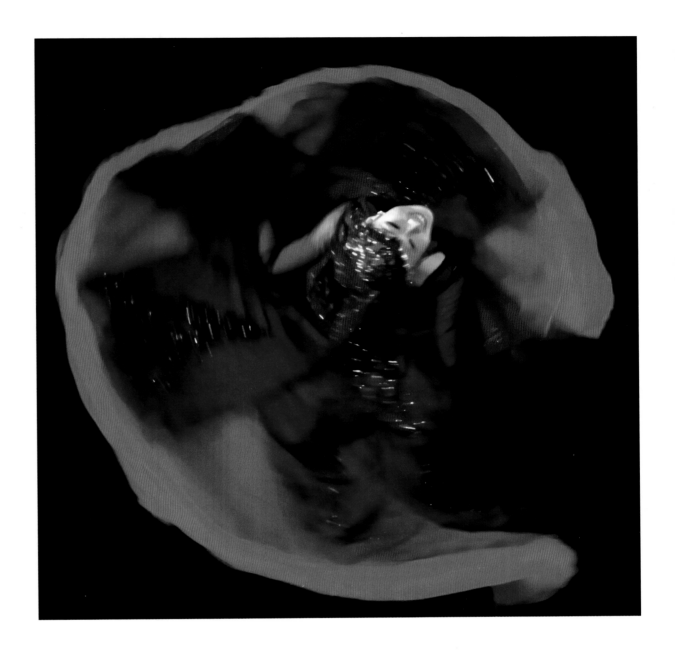

旋转的玫瑰
Revolving red rose

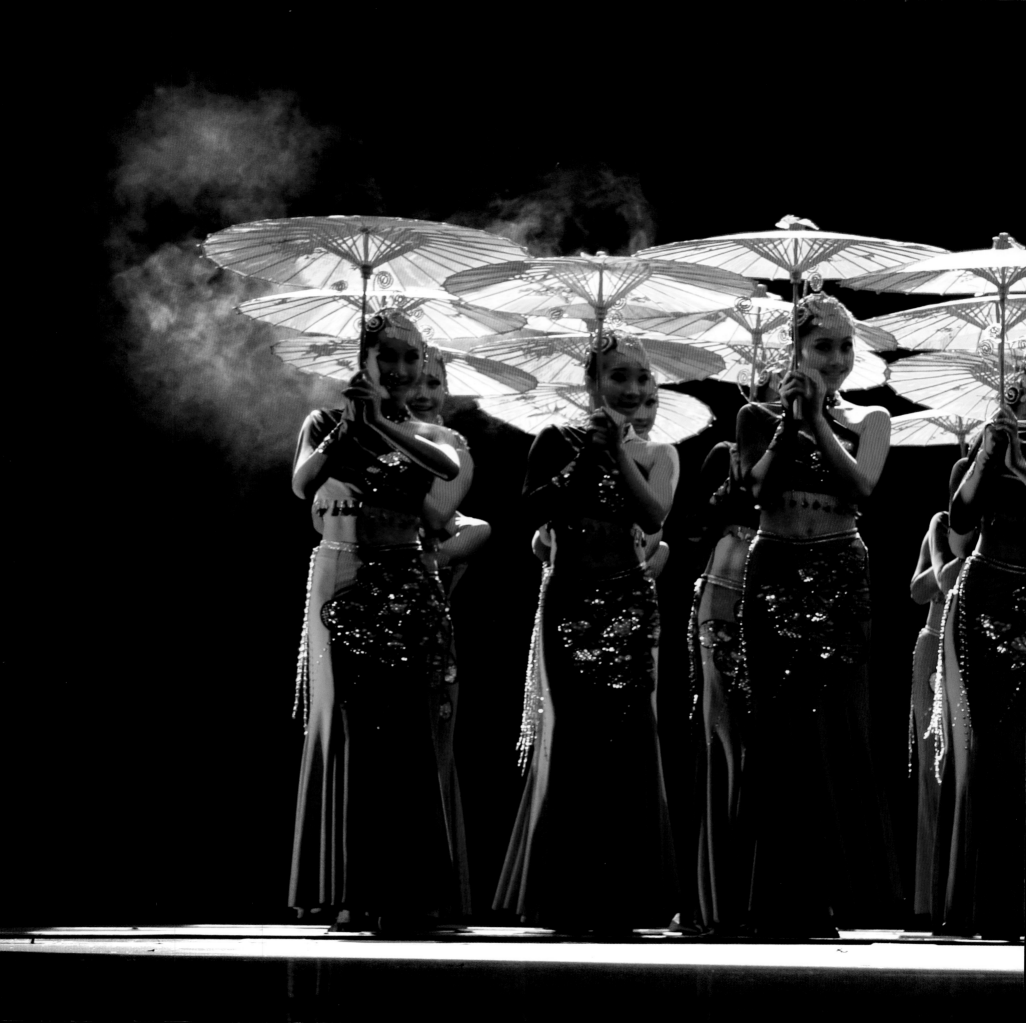

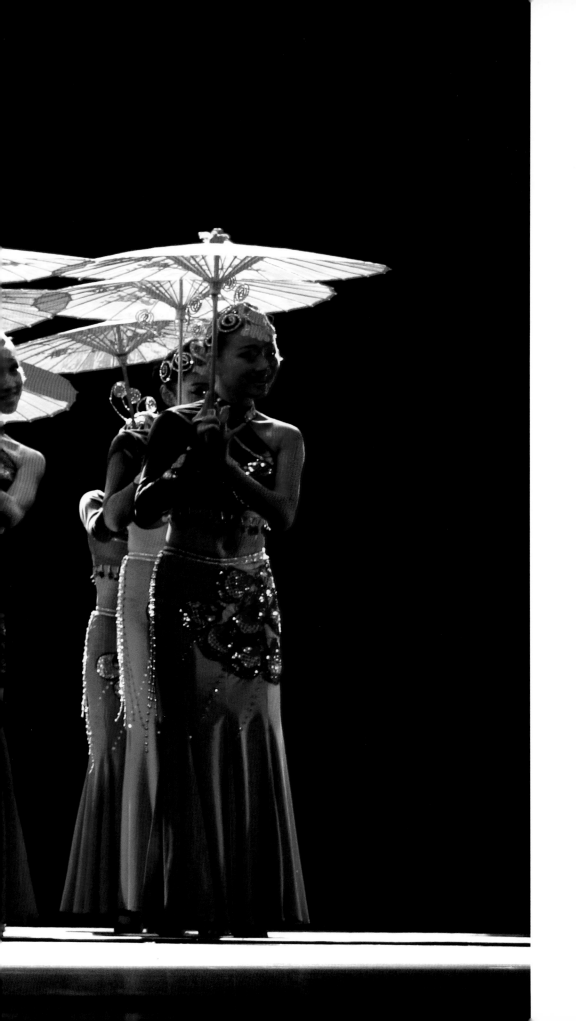

一曲轻柔
Umbrella dance

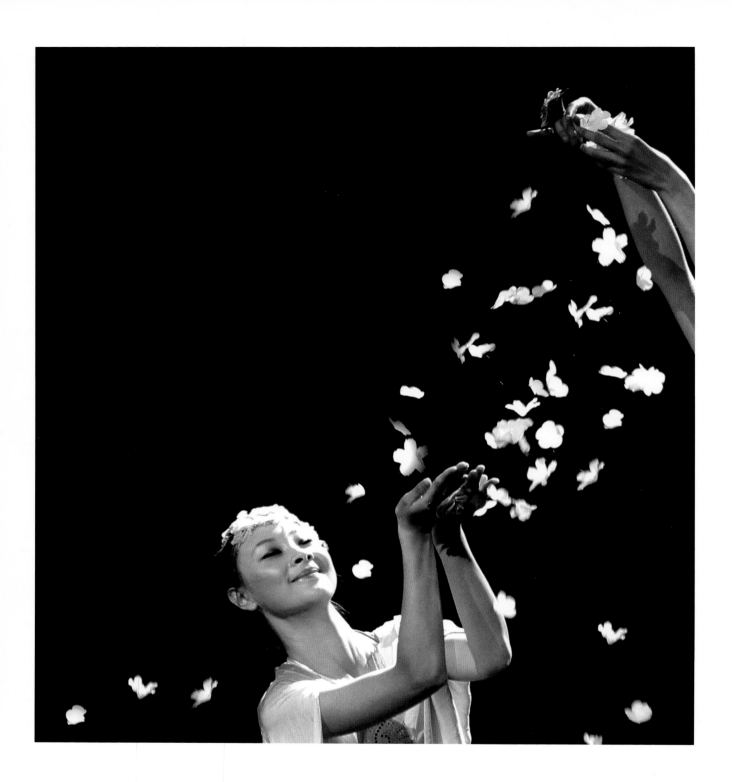

幸福飘香
Fragrant happiness

晶珠不动凝双眸
Lines of yellows

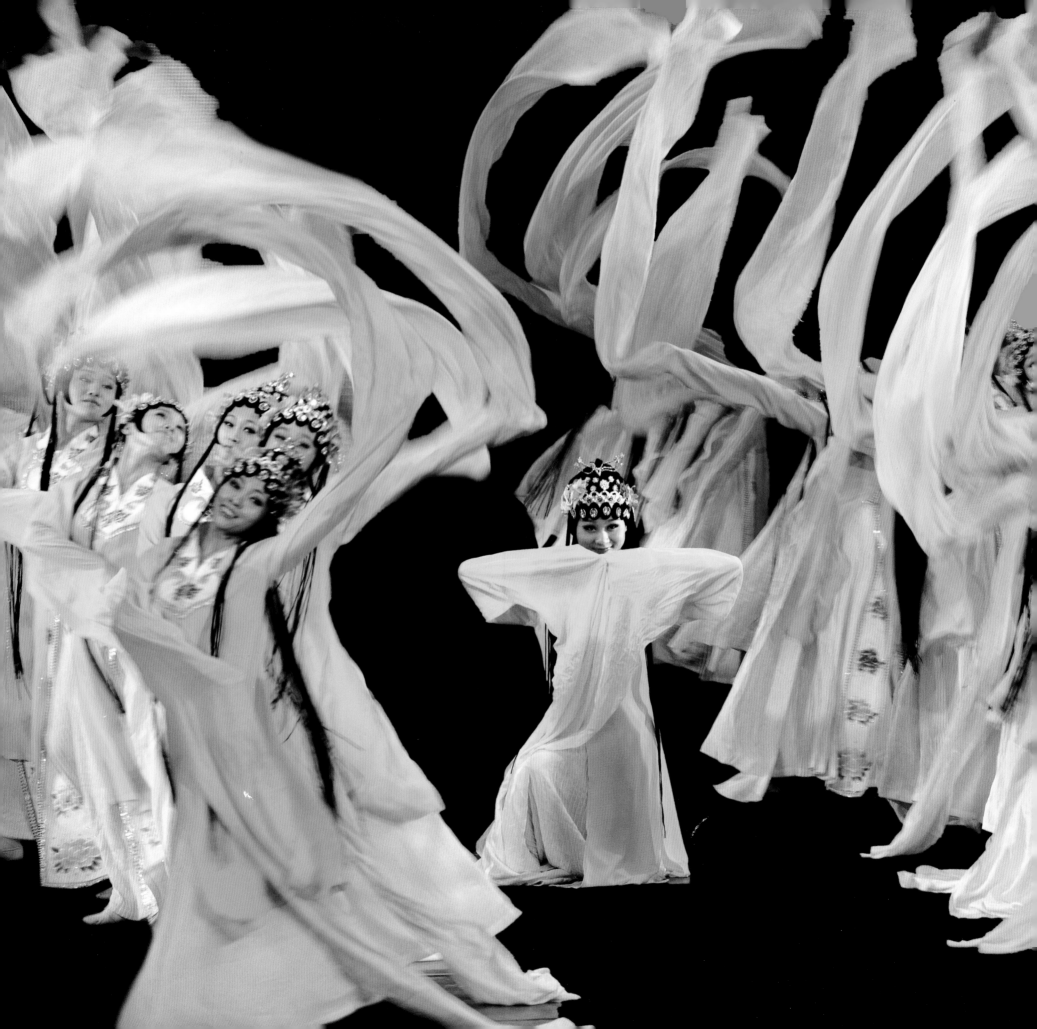

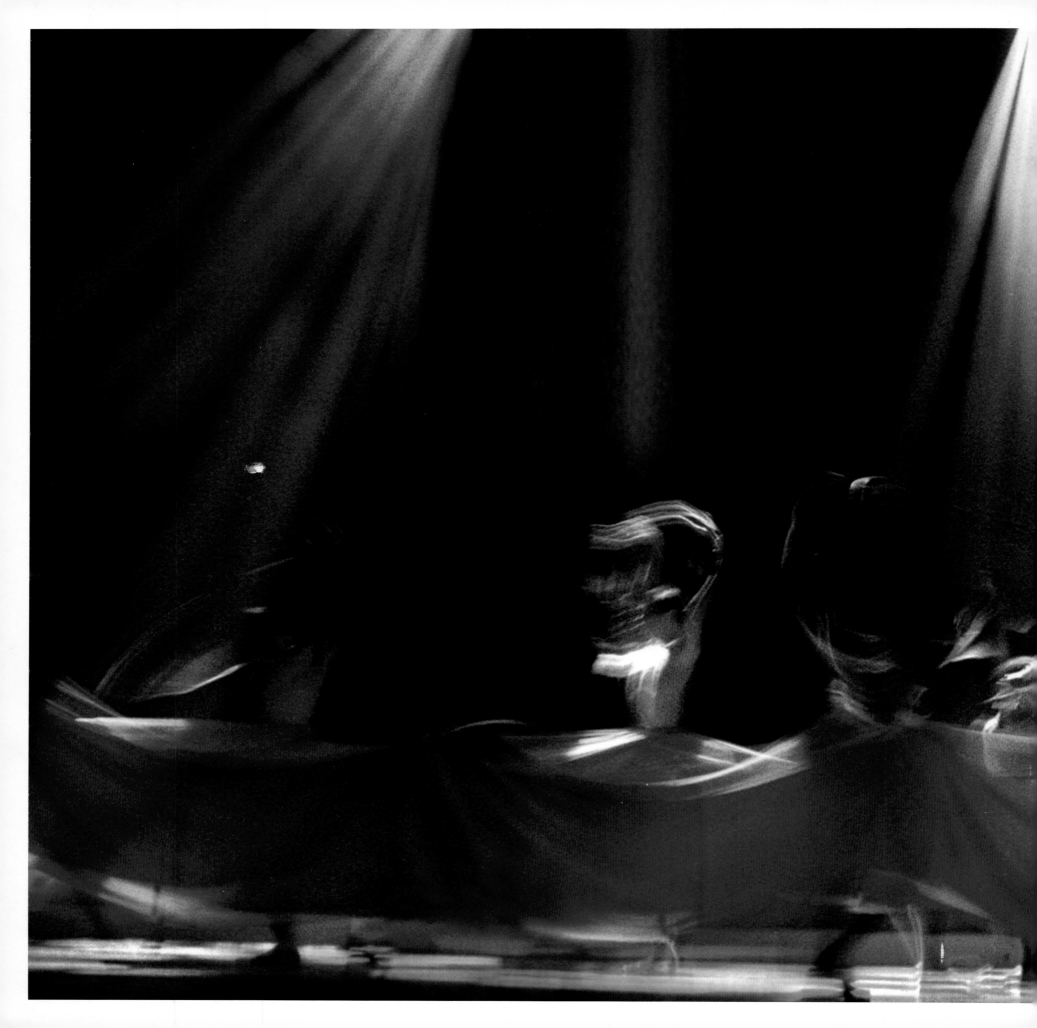

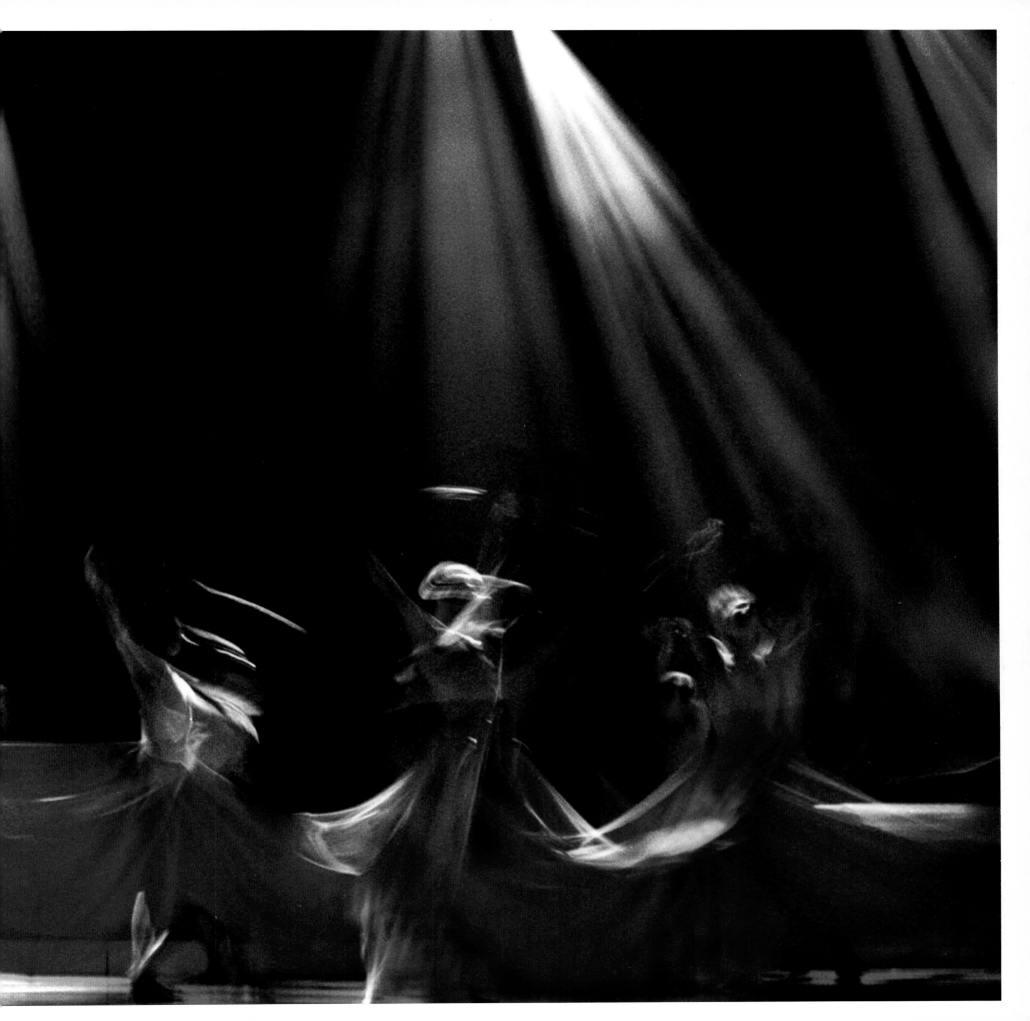

<< 蓝色旋风
Blue twisters

一缕春风吹心田
Spring breeze on one's heart

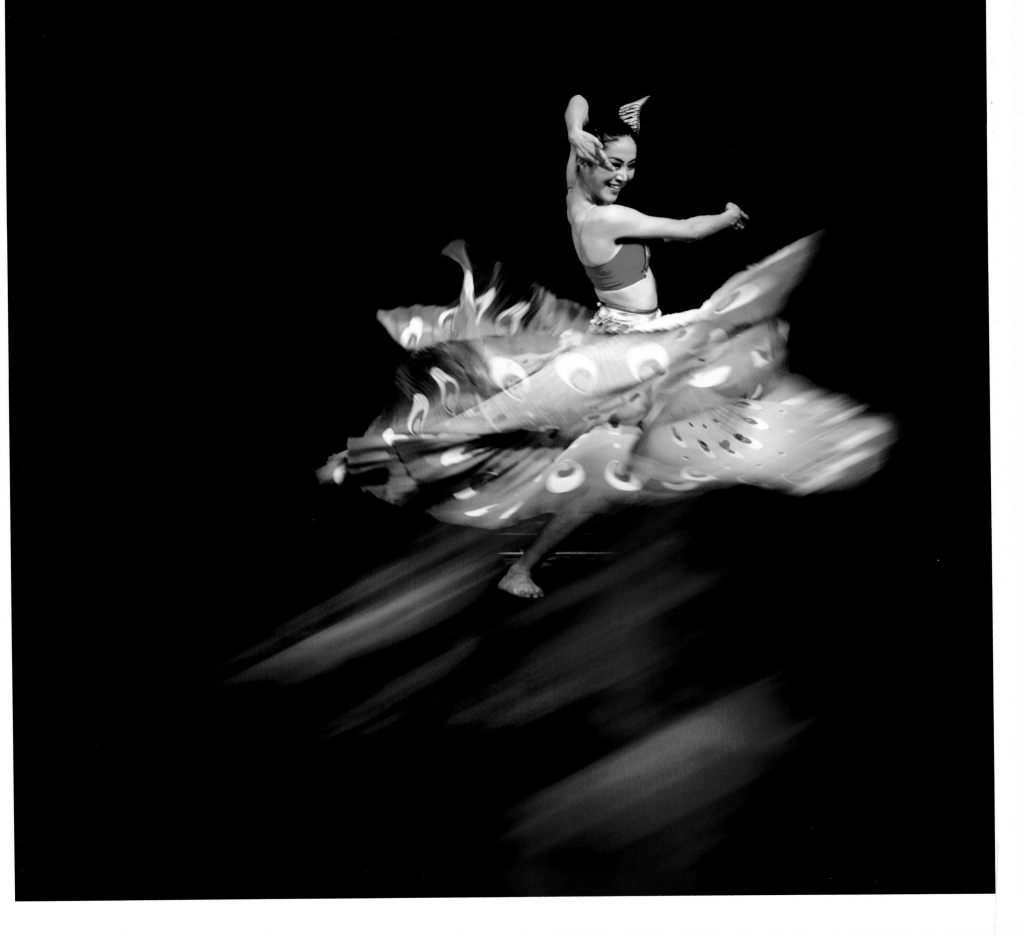

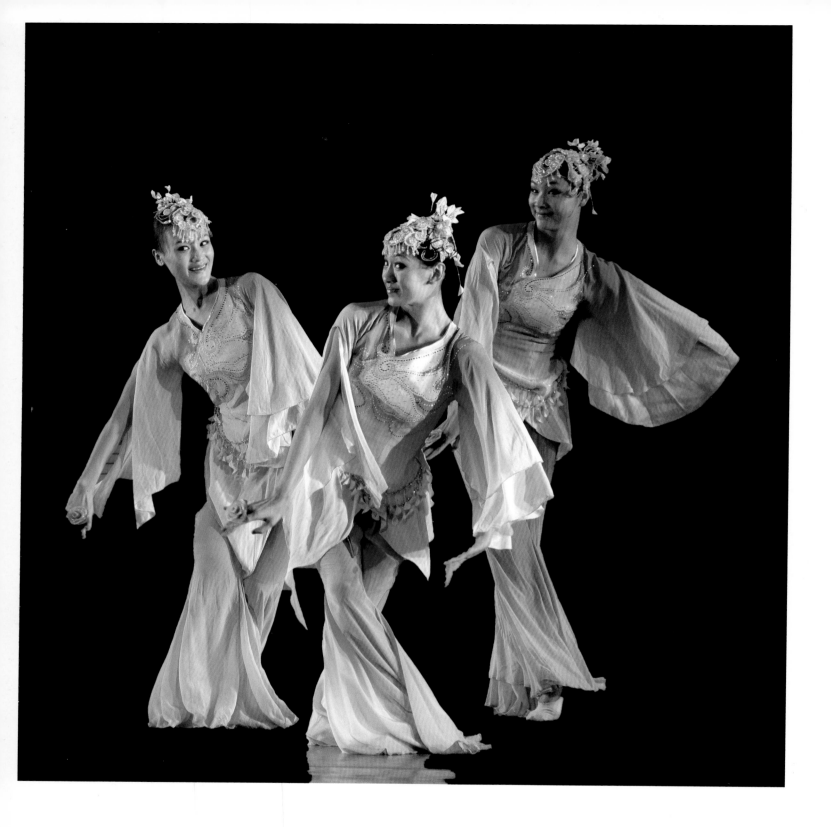

凝眸生百媚
Enchantment

春风拂面
Spring breeze

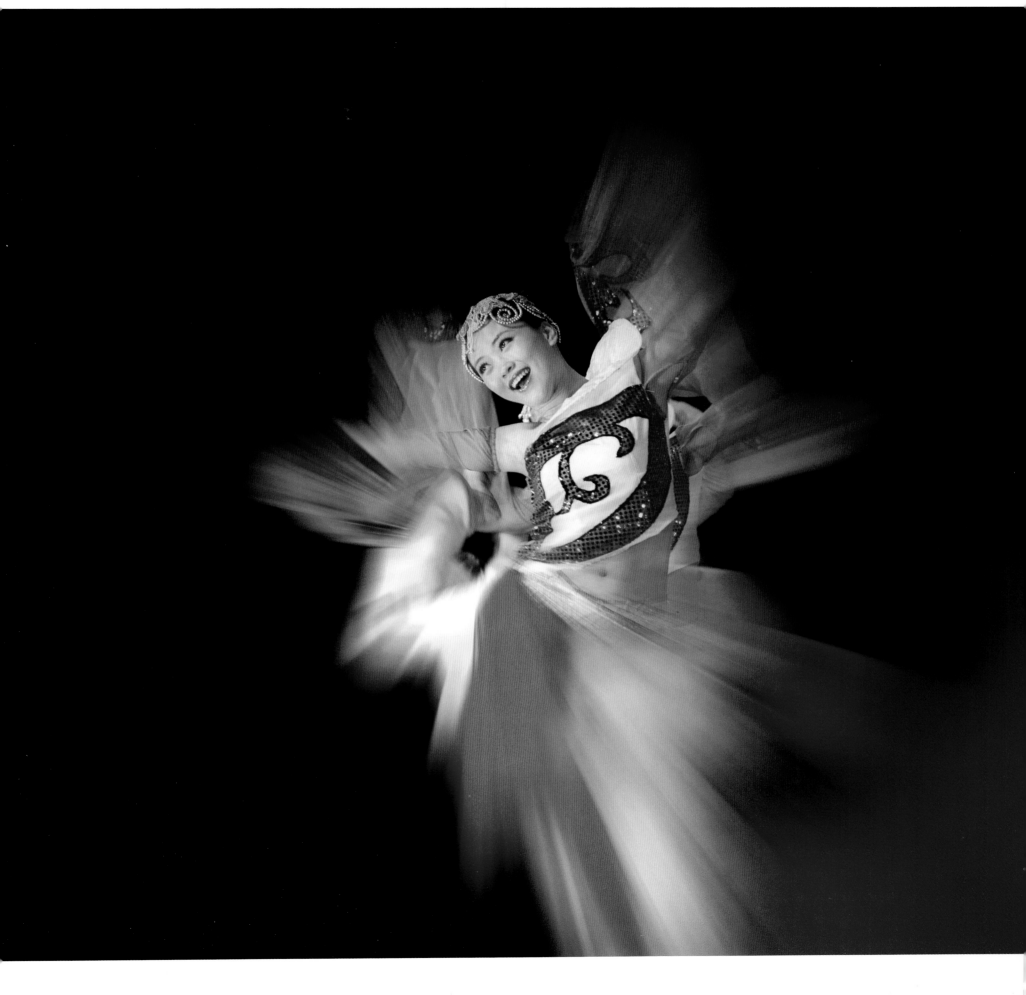

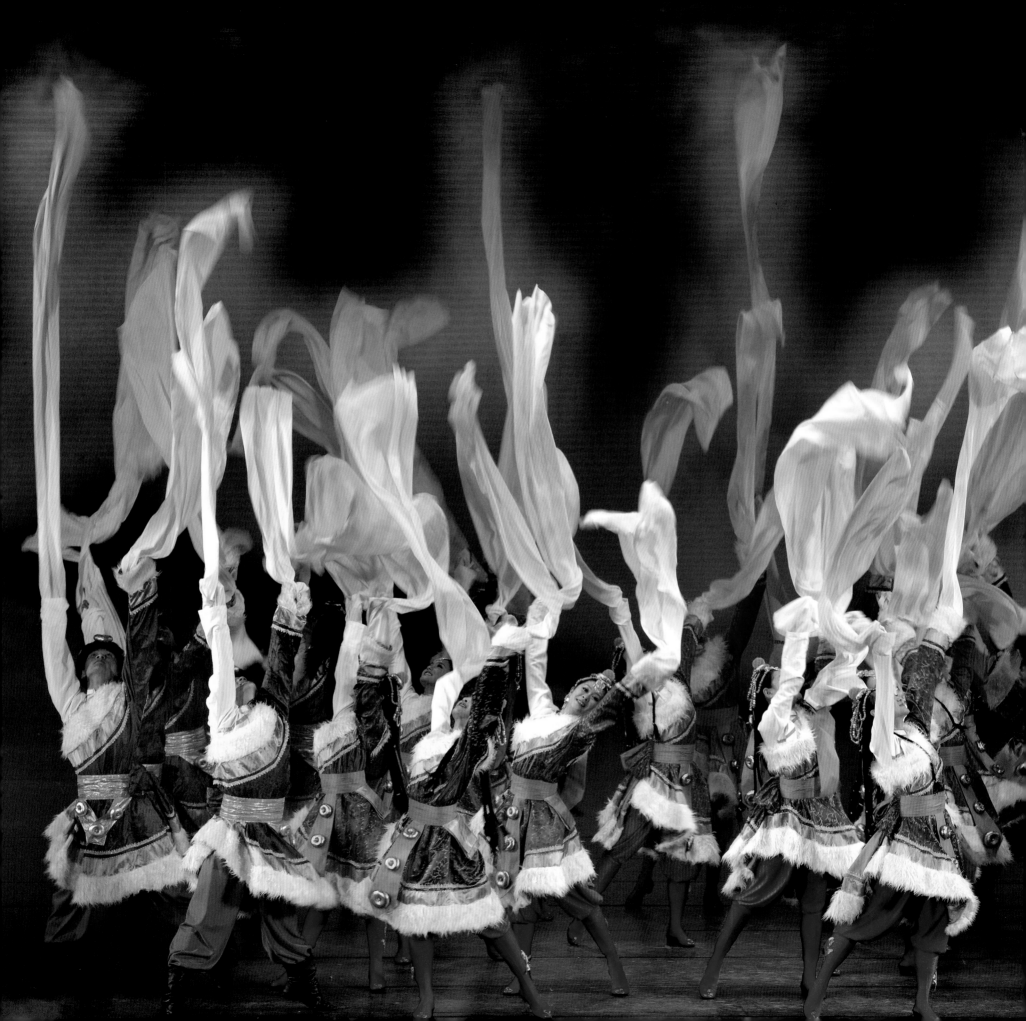

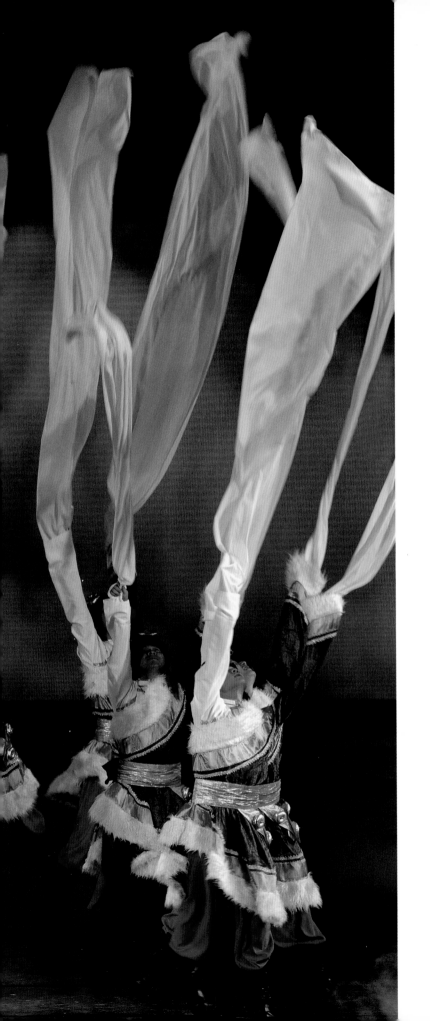

雪山飞舞
Snow mountain-fluttering

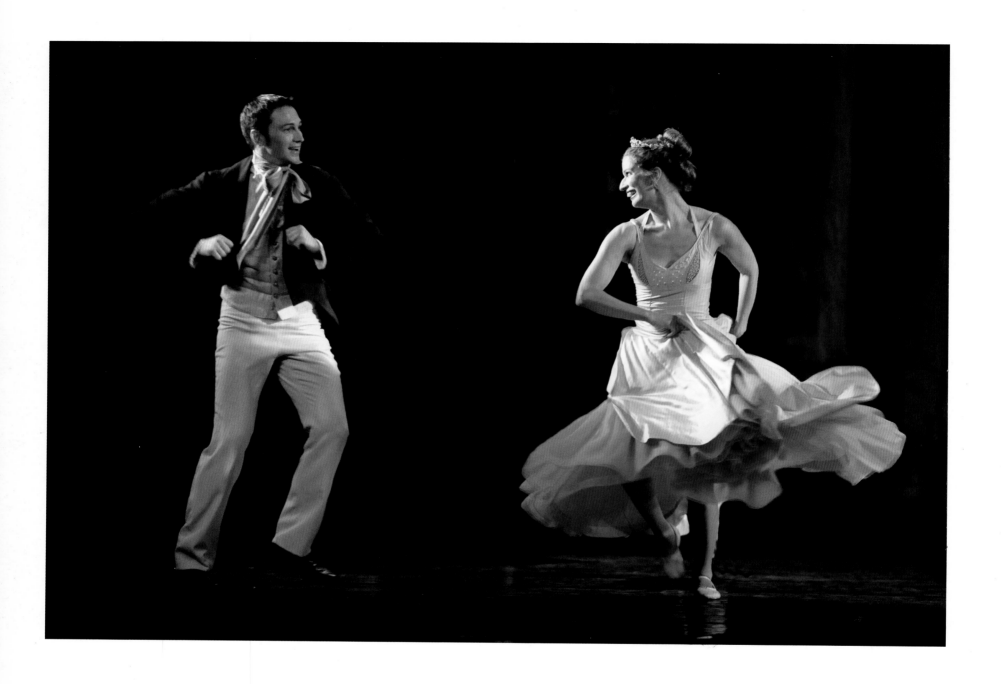

人逢喜事
Joy

珠围翠绕
Jade green

灵动的彩绘 _____ 魏新萍舞台摄影艺术 **034** * 035
Wei XinPing photograph art

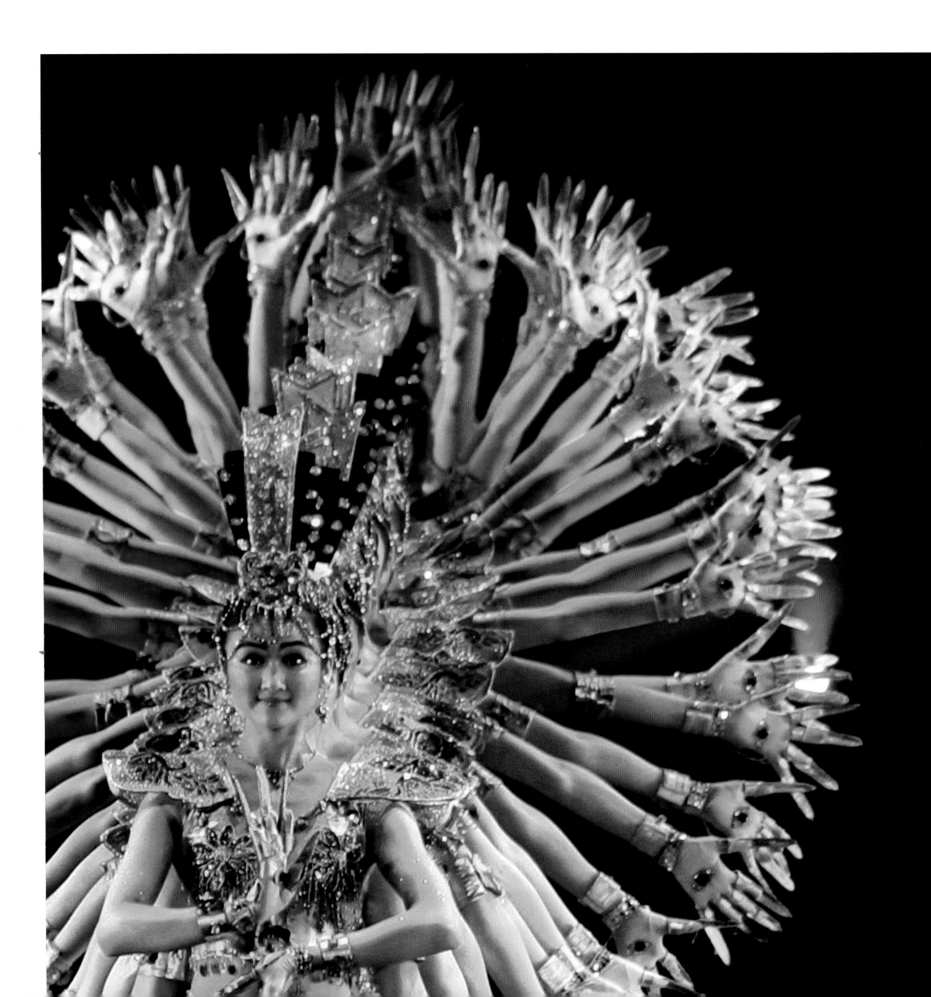

波光幻影漫诗情

Poetry in lights

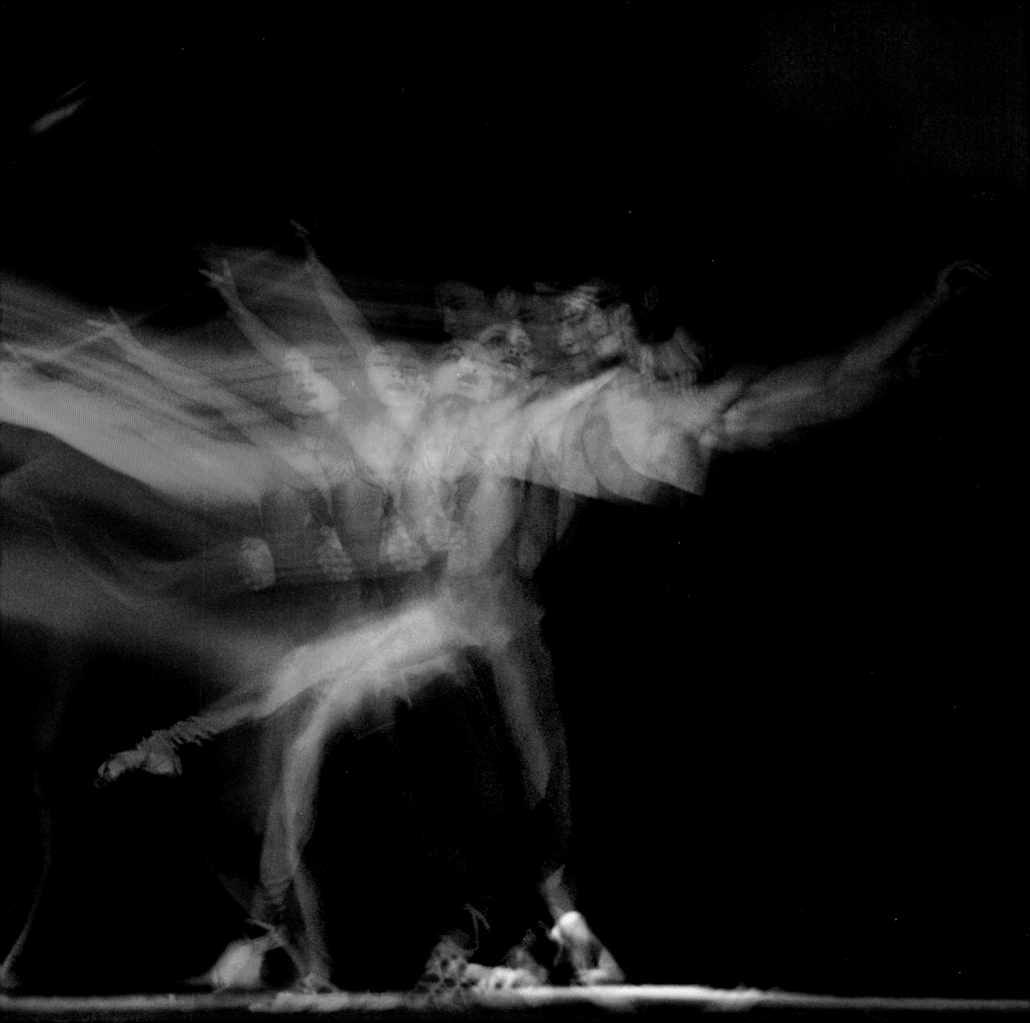

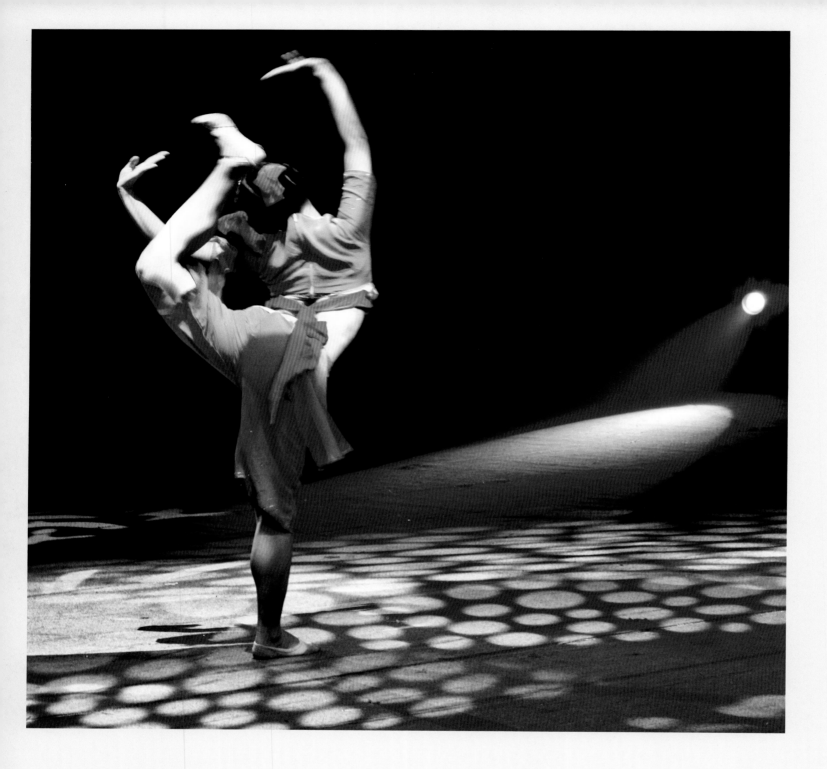

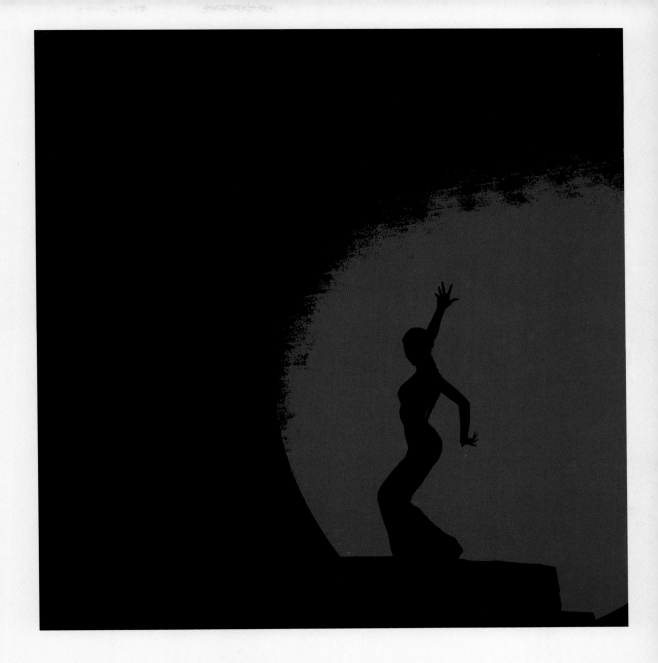

月亮之上
On the Moon

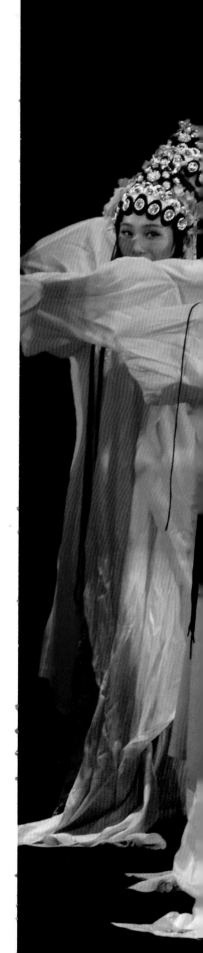

佳丽尽关情
Beautiful girls

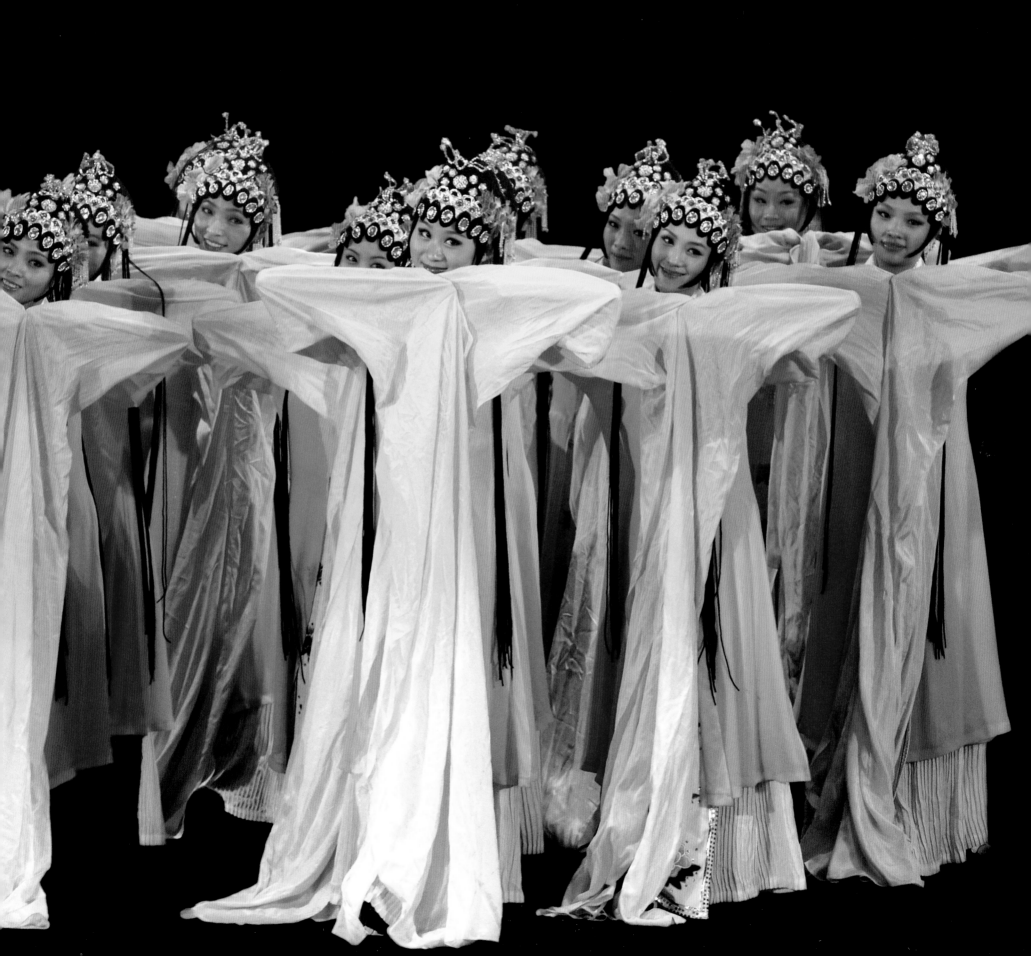

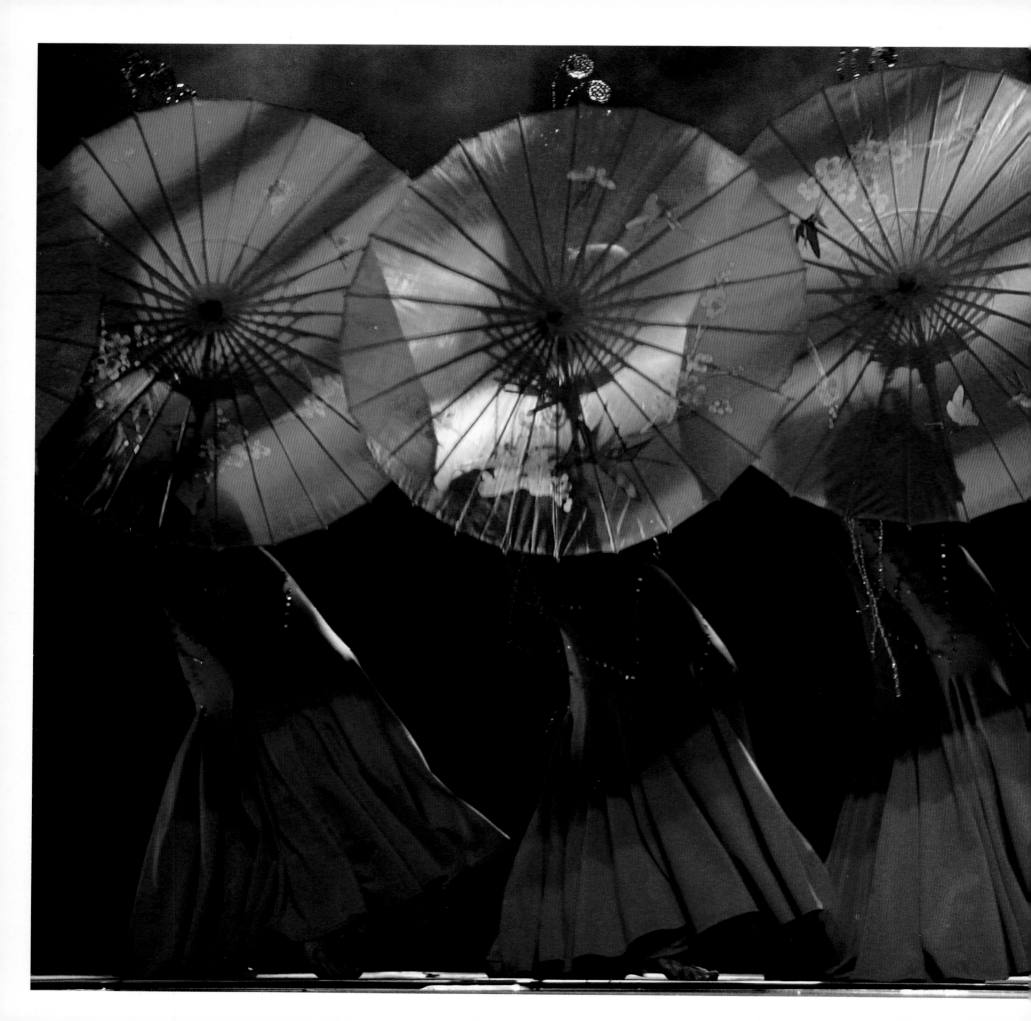

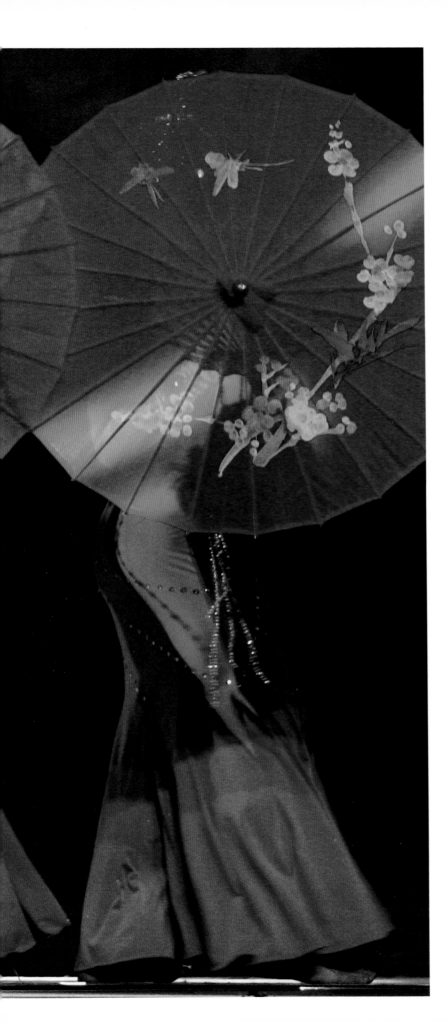

娇躯隐之
Red flowers with green leaves

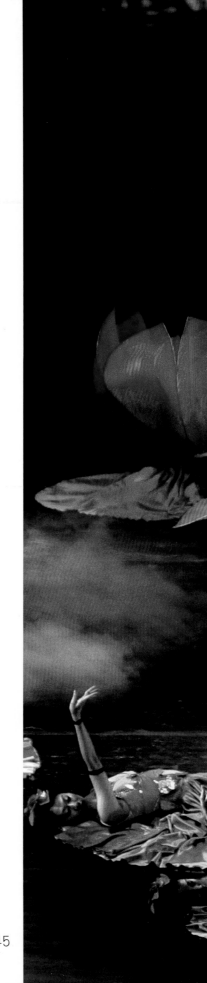

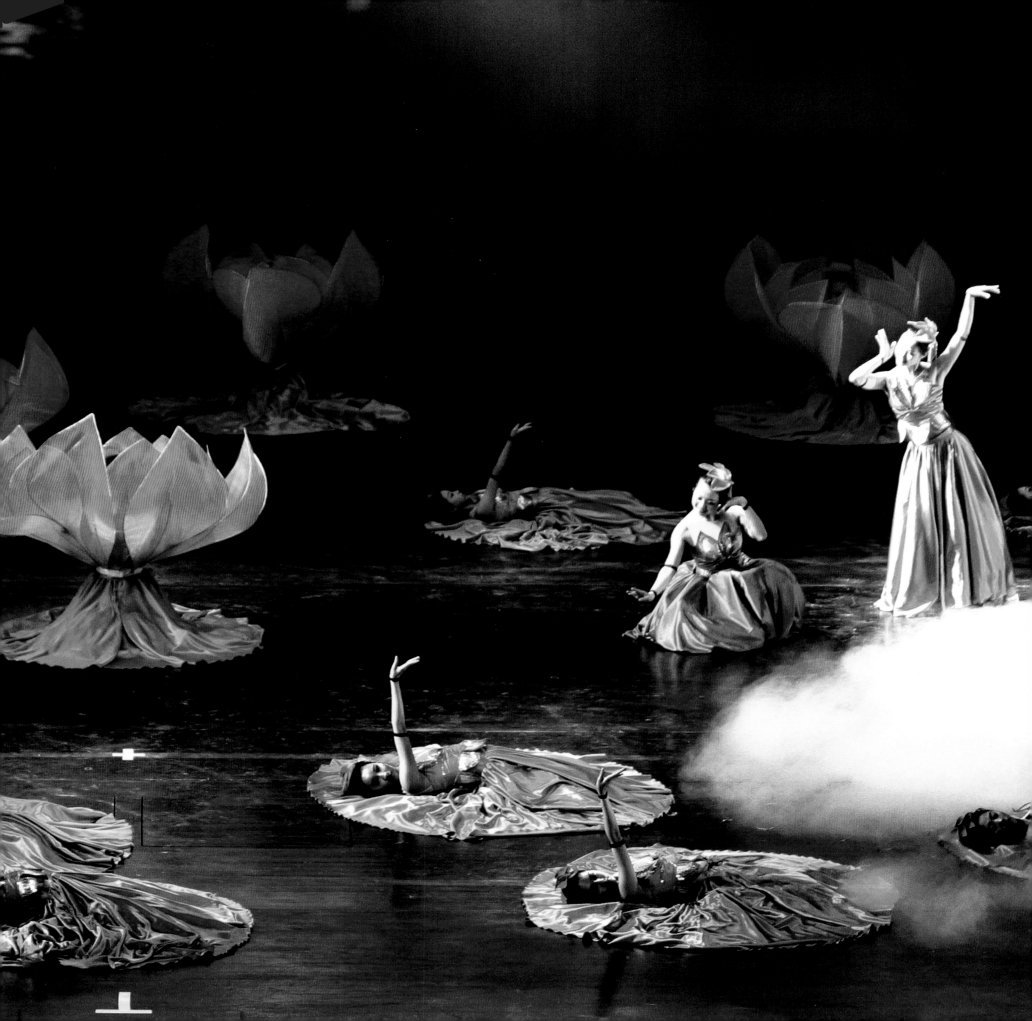

Ethereal
Colors

灵动的彩绘
Wei Xinping Stage Photography Art

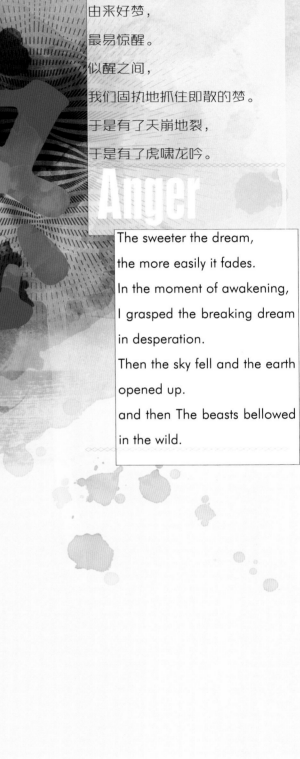

由来好梦，

最易惊醒。

似醒之间，

我们固执地抓住即散的梦。

于是有了天崩地裂，

于是有了虎啸龙吟。

Anger

The sweeter the dream,

the more easily it fades.

In the moment of awakening,

I grasped the breaking dream

in desperation.

Then the sky fell and the earth

opened up.

and then The beasts bellowed

in the wild.

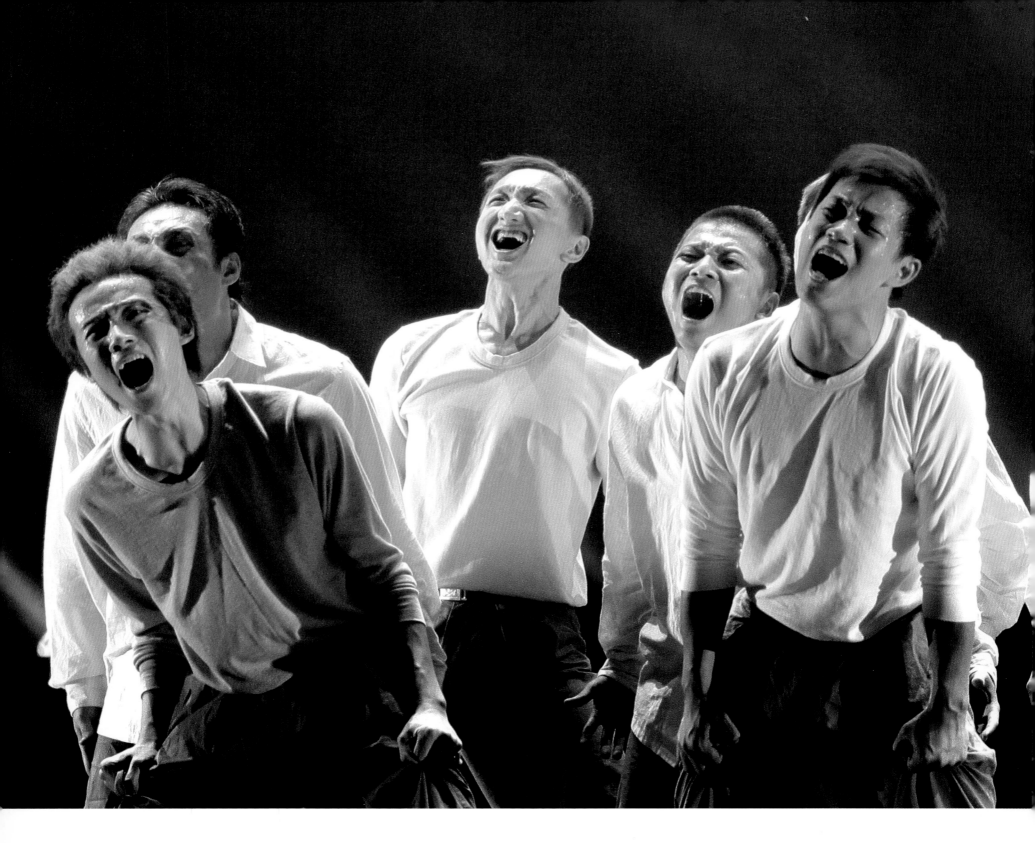

呐 喊

Battle cry

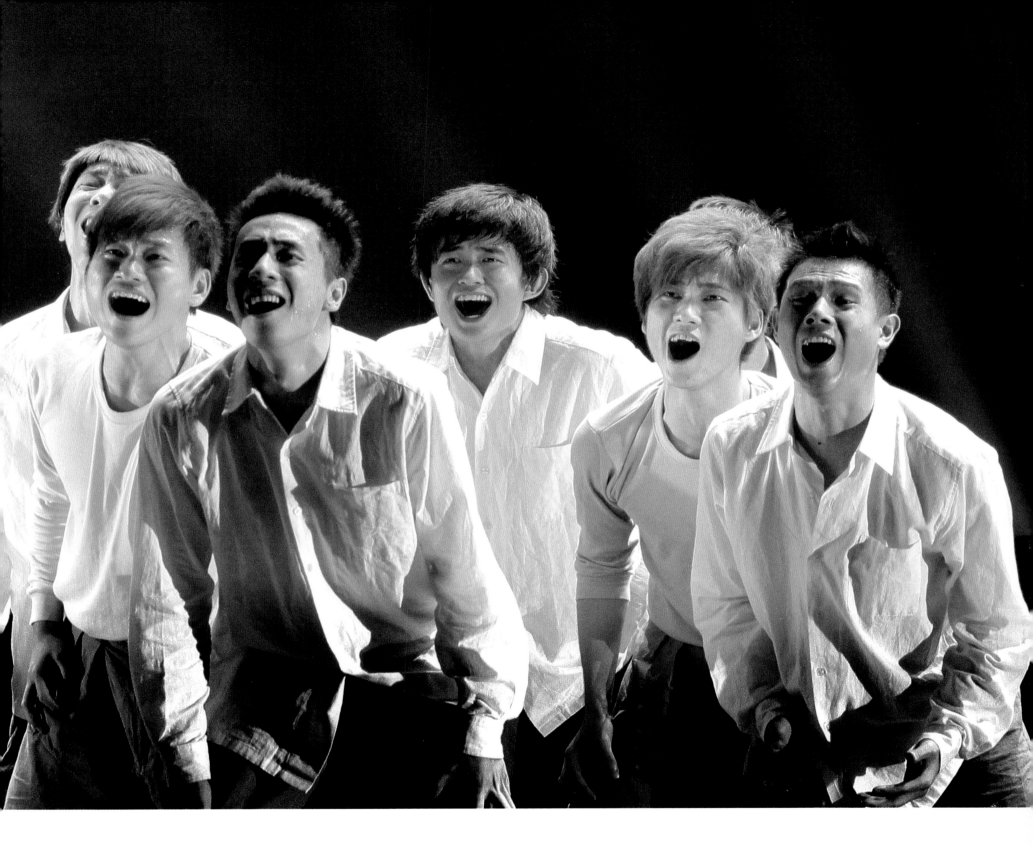

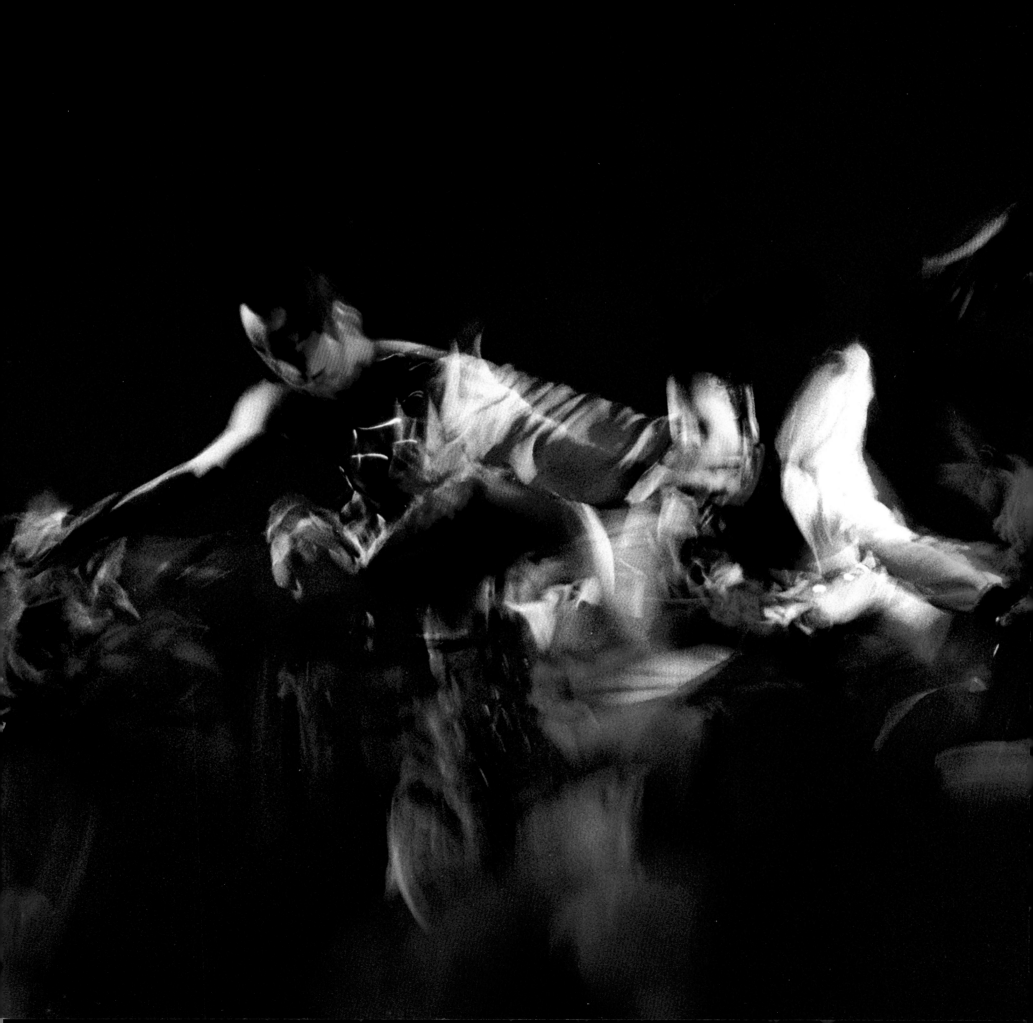

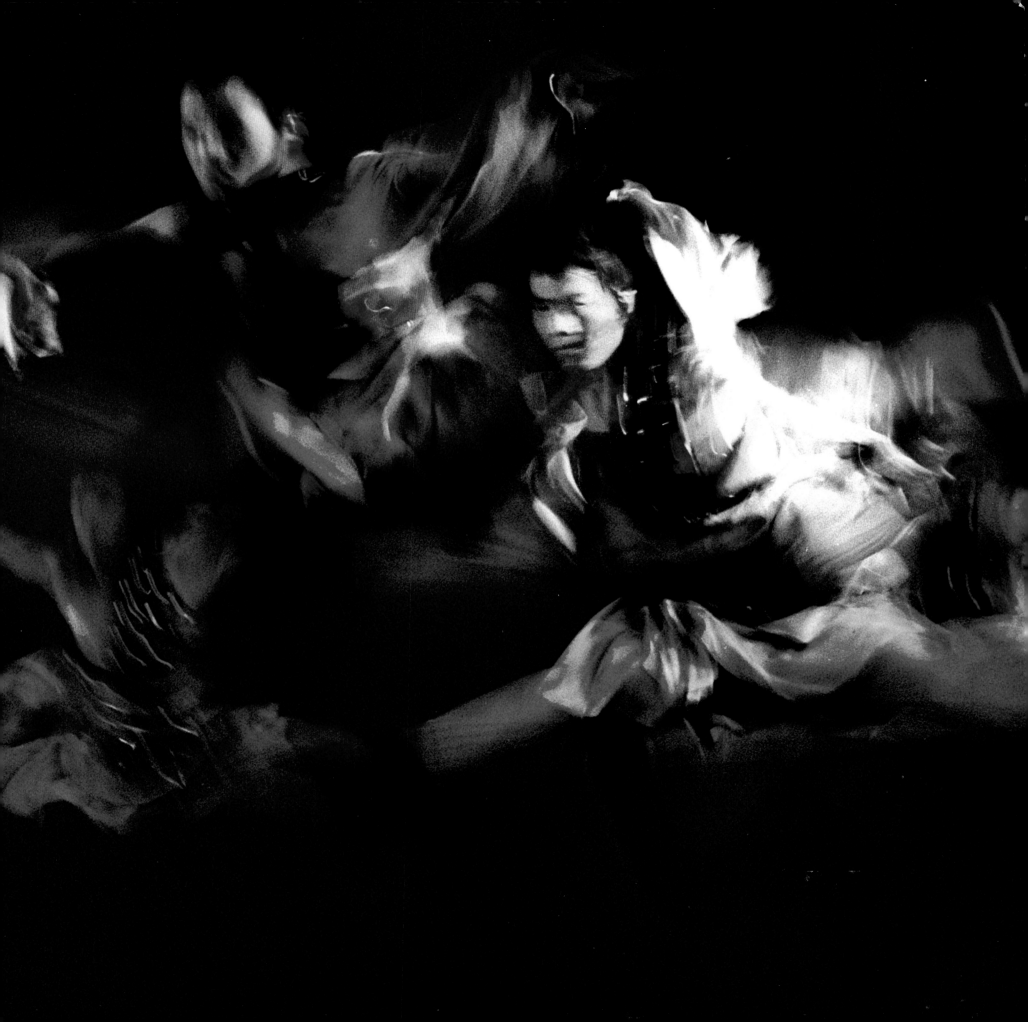

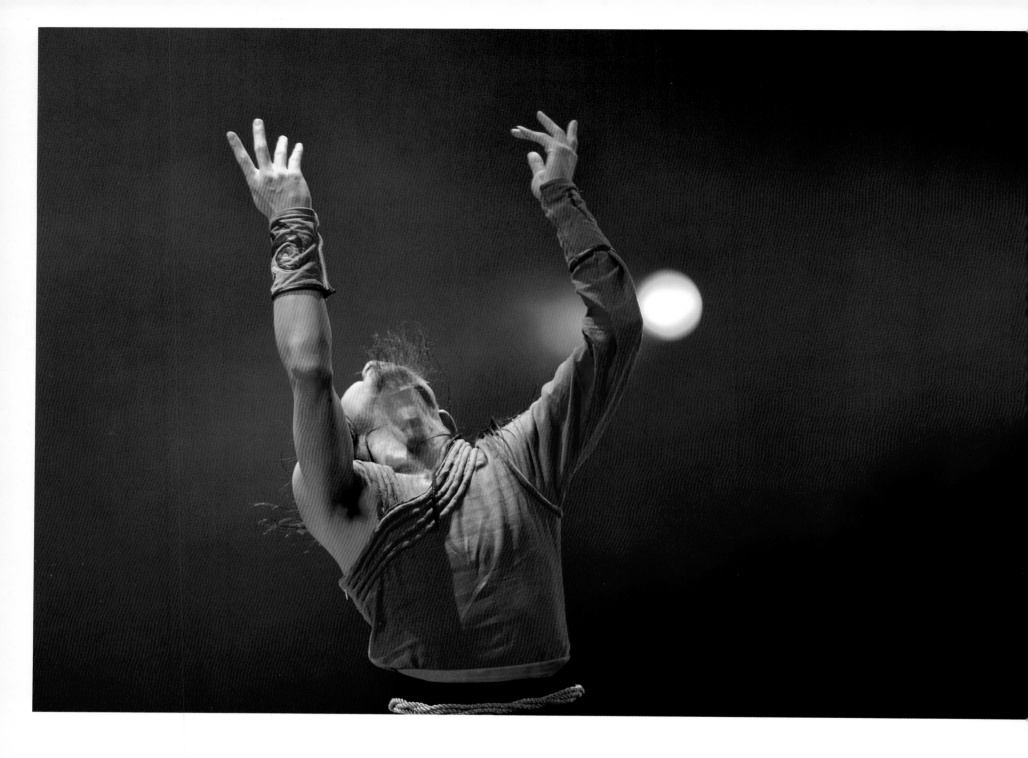

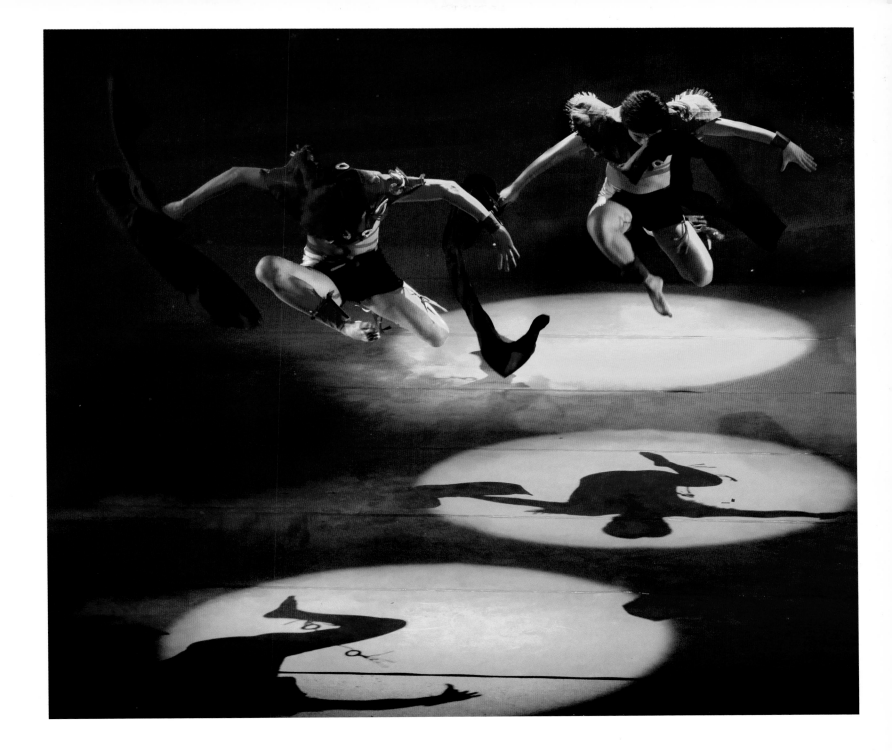

天涯飘客
Leaping escape

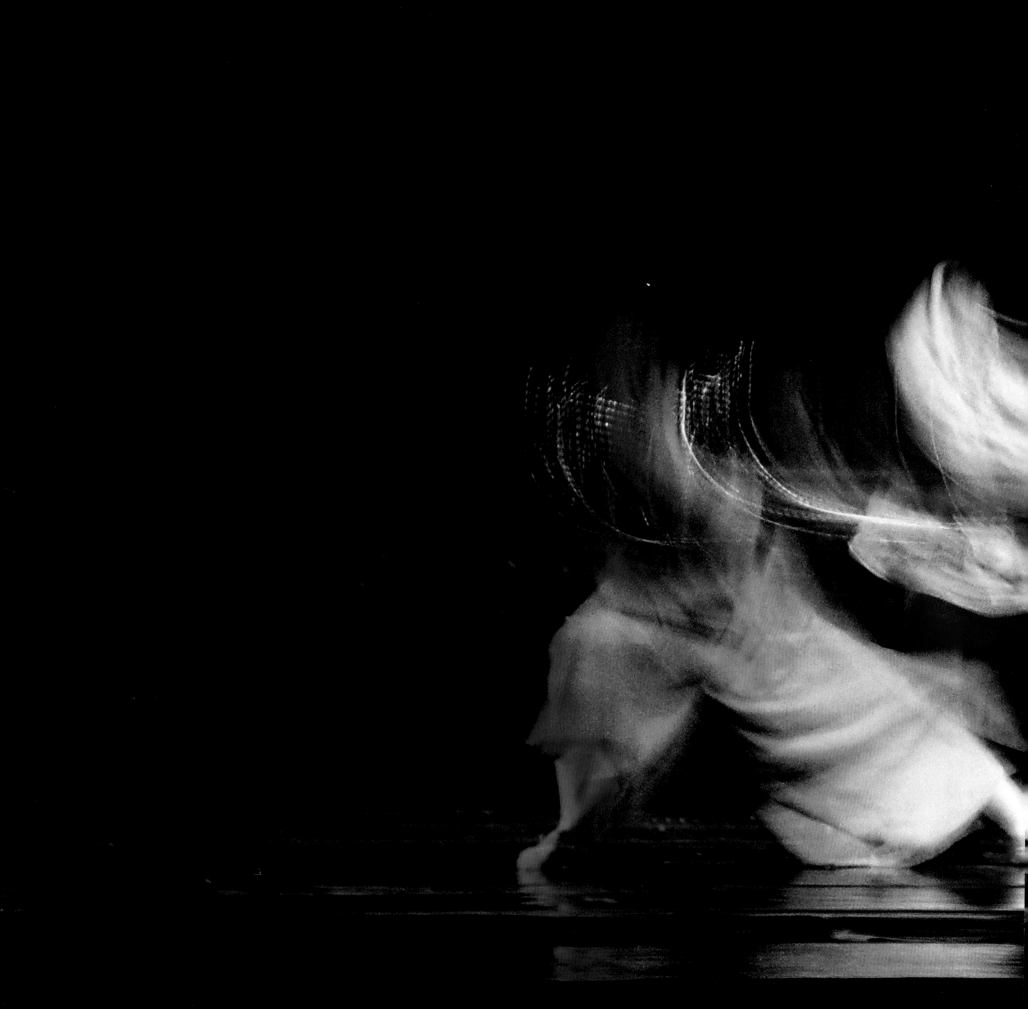

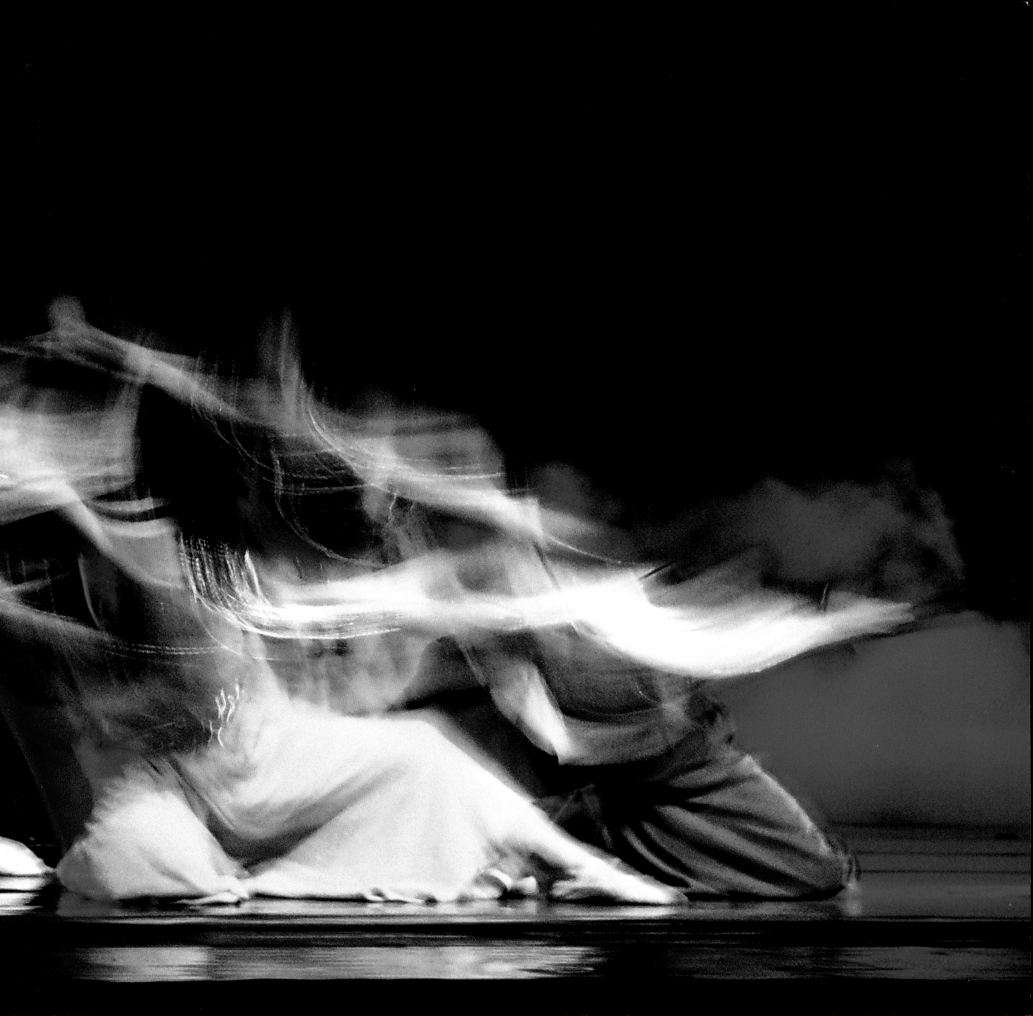

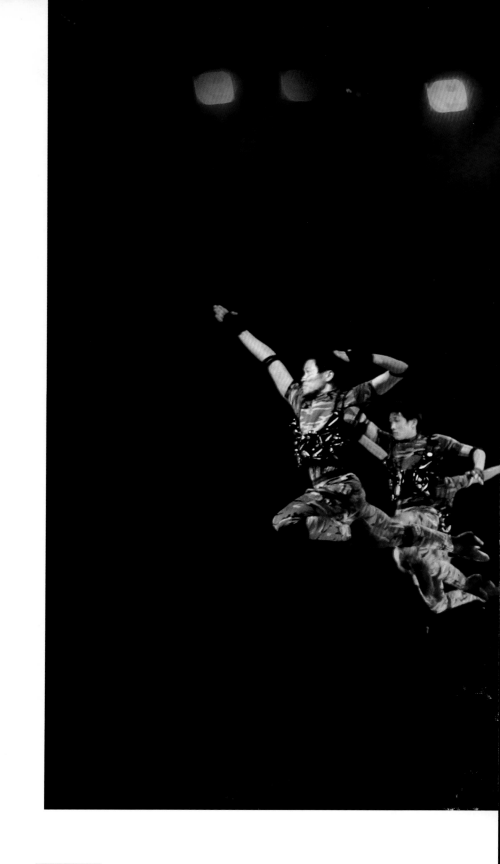

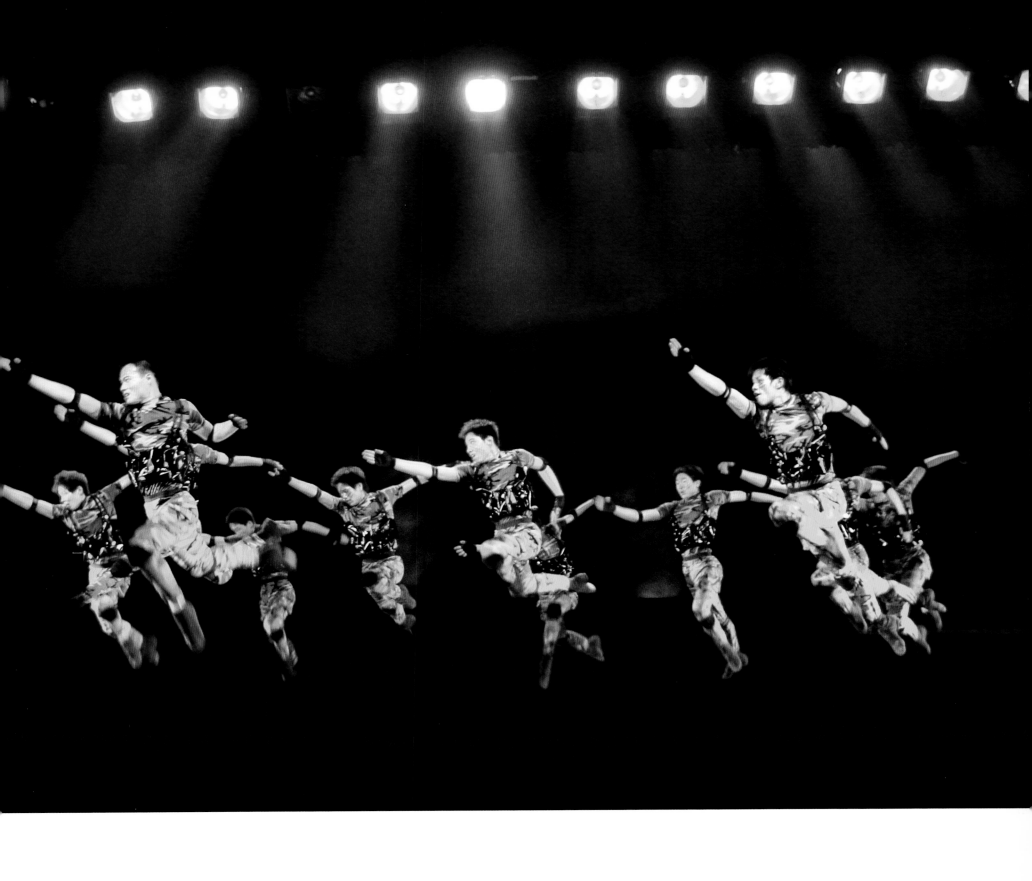

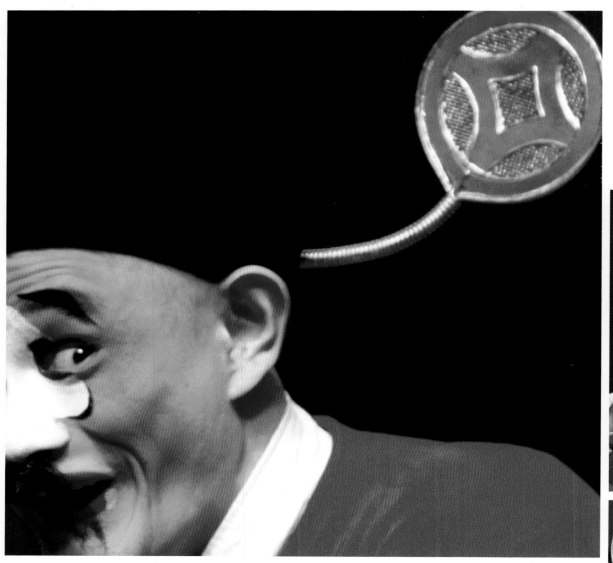
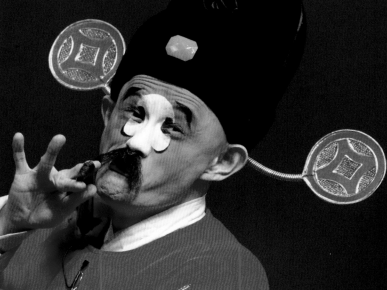
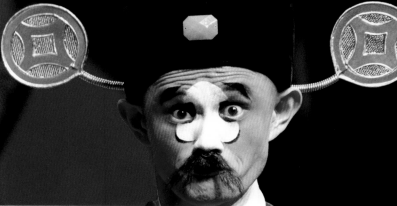

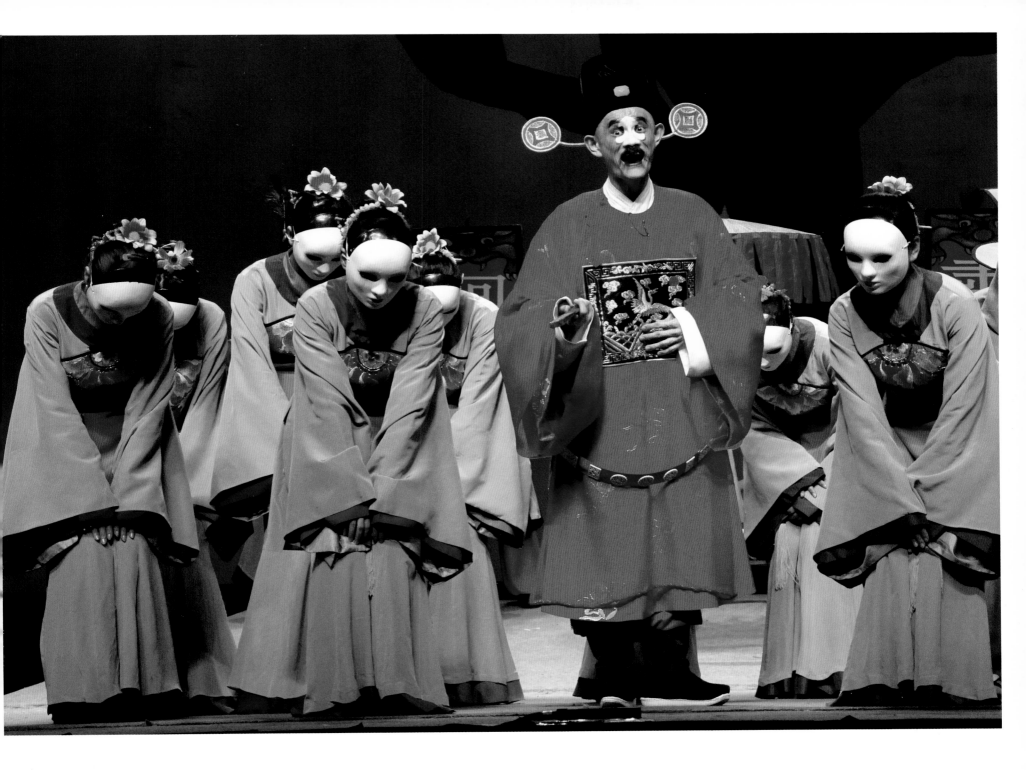

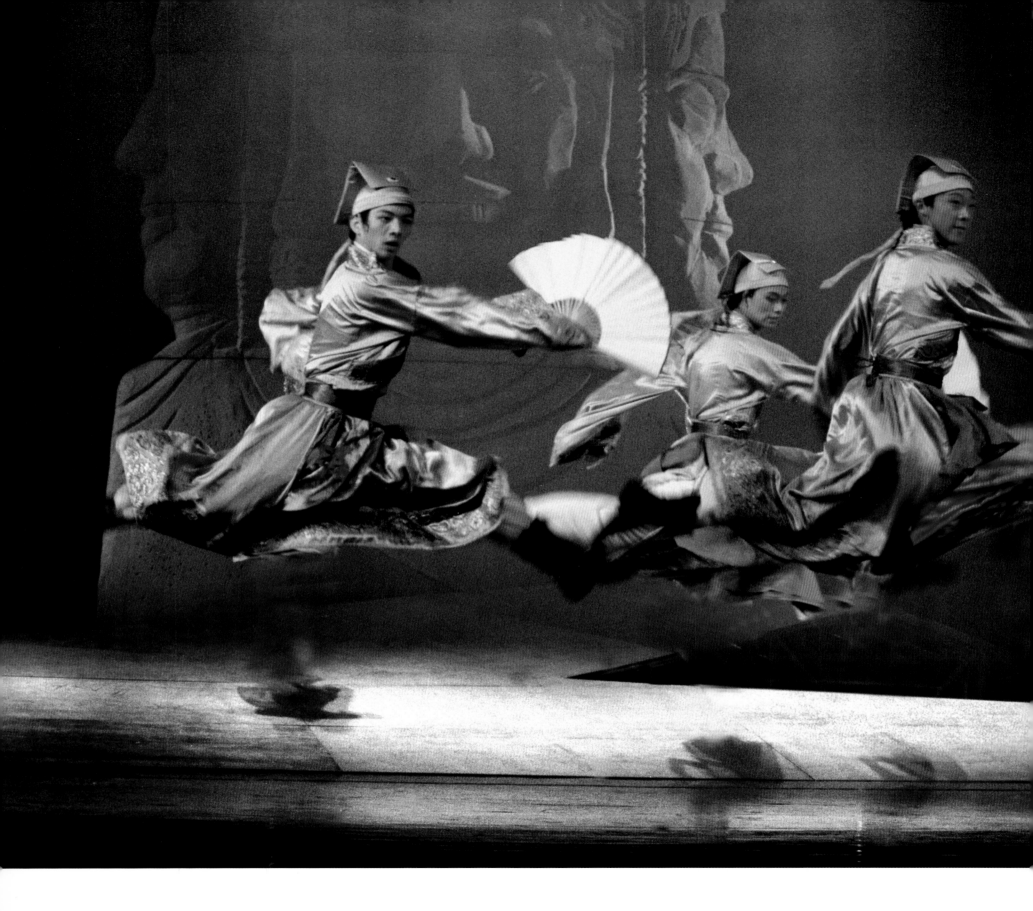

俊逸之恨

Stylish young men

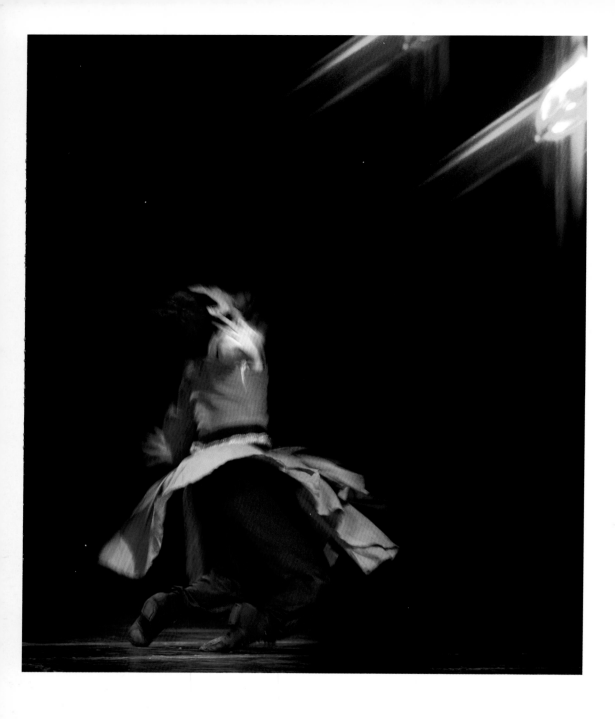

泪的投降
Surrendering in tears

孤星泪
Solitude

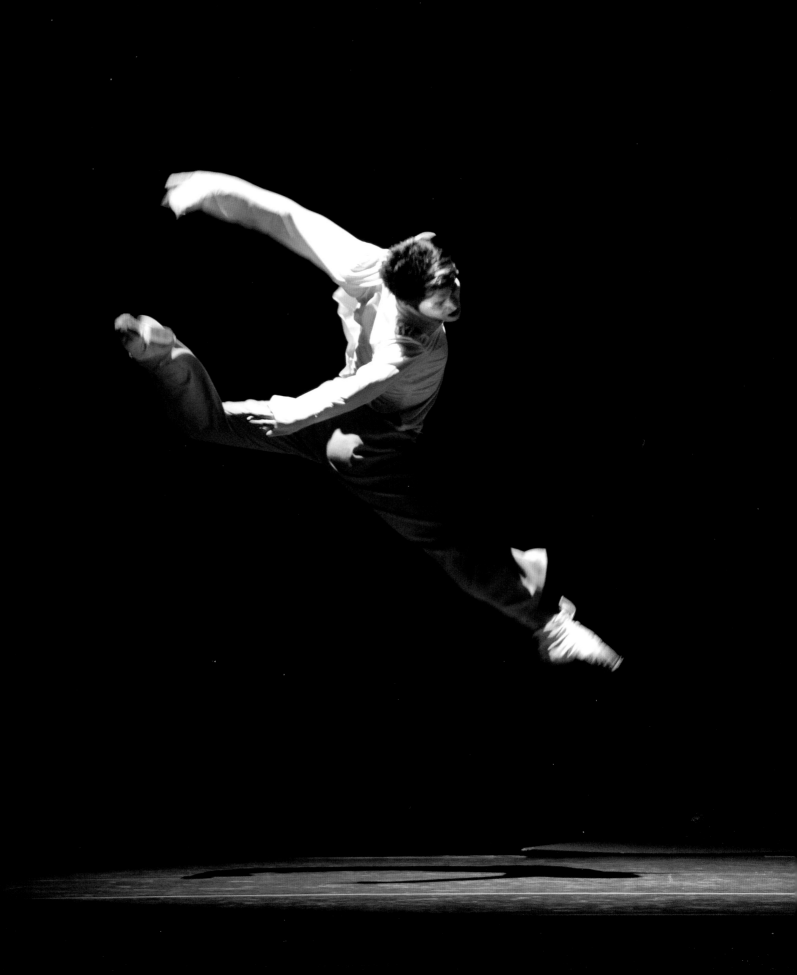

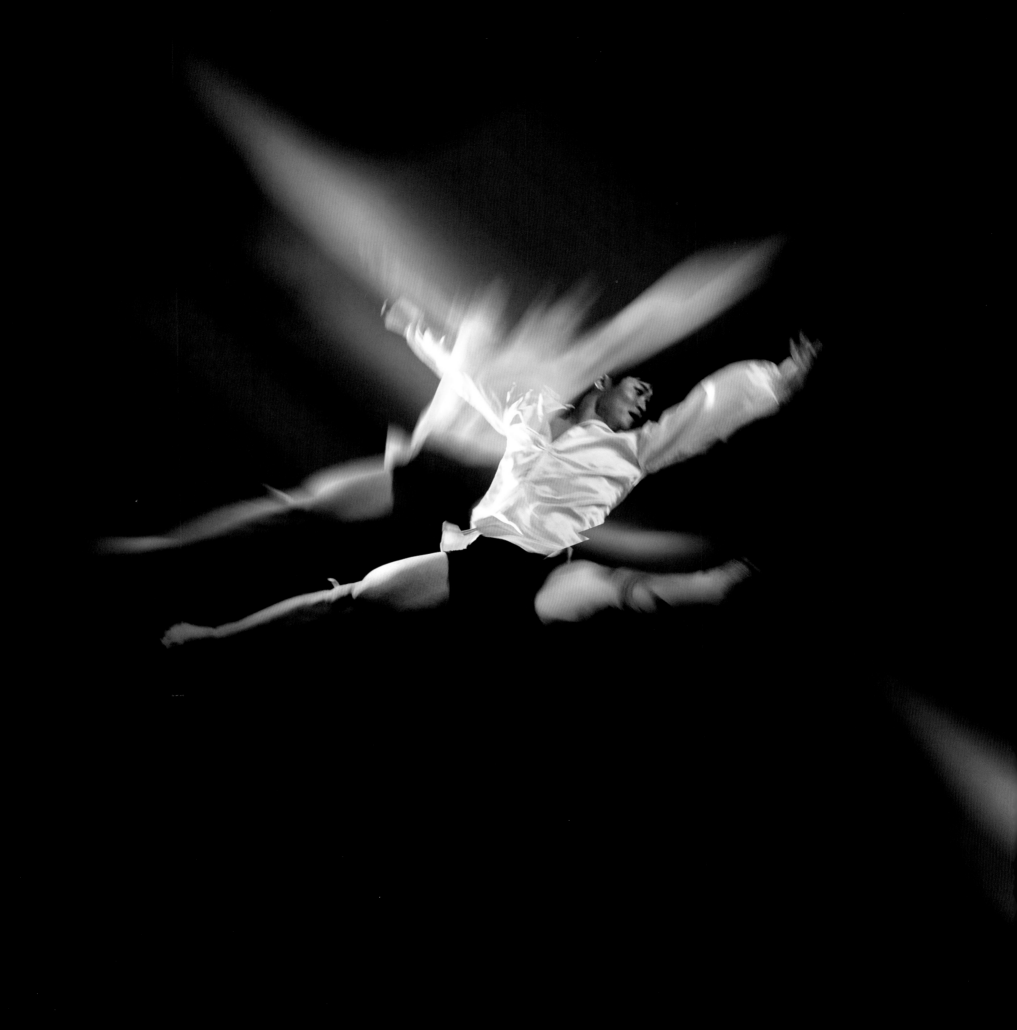

红尘飞扬

Ascending

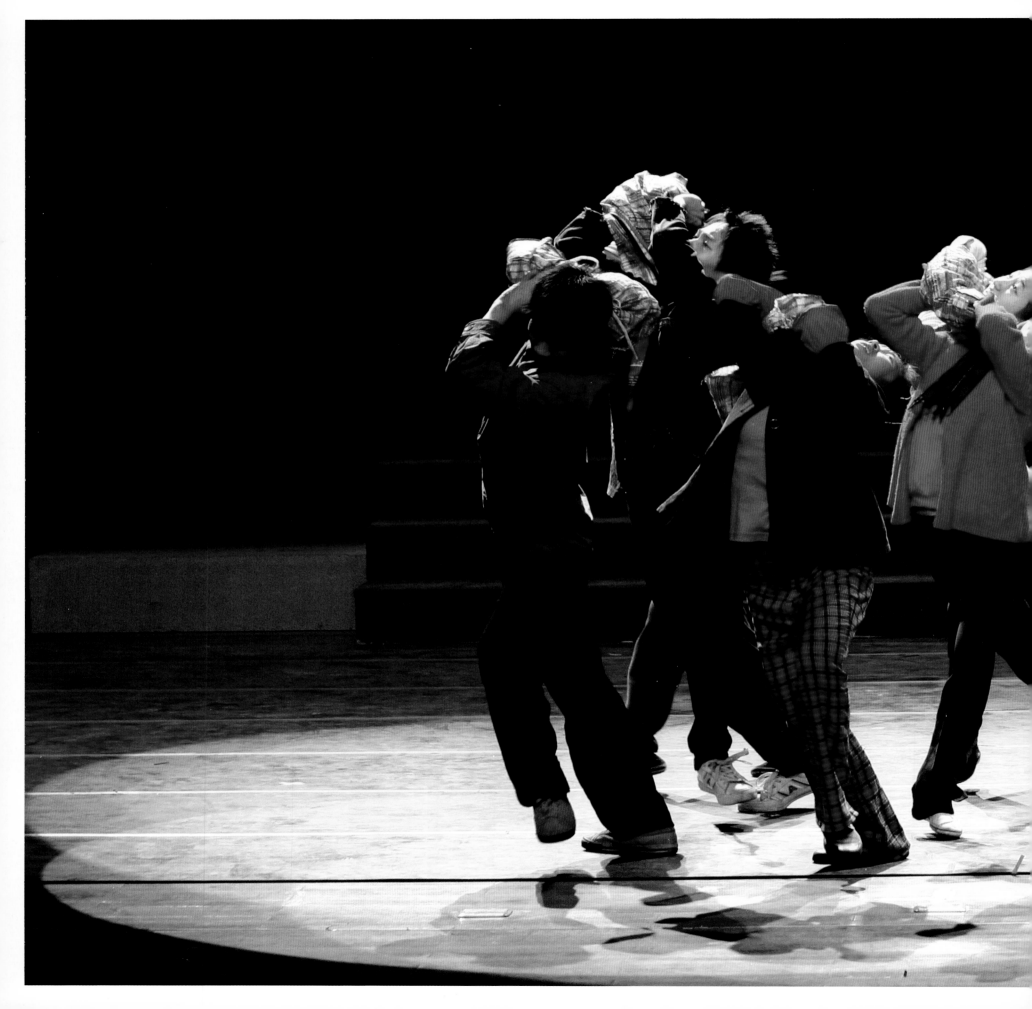

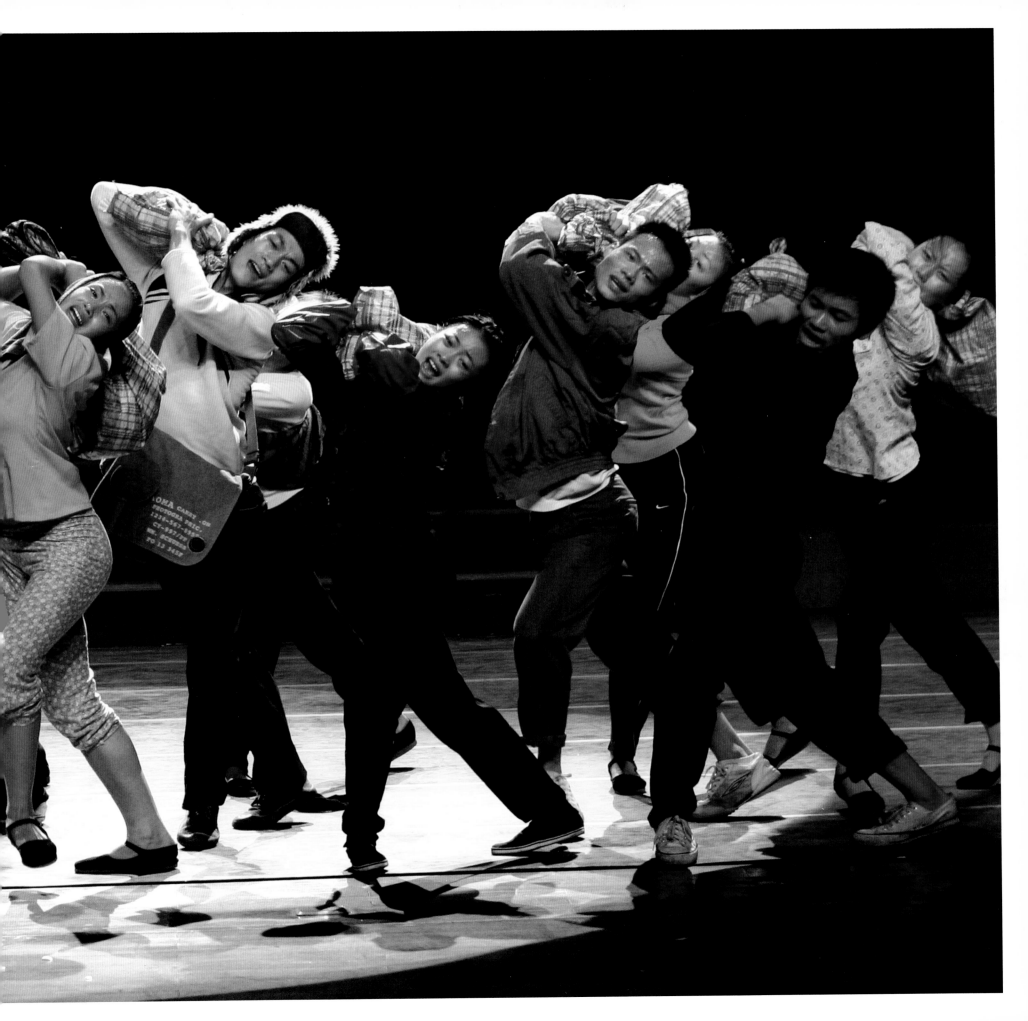

挣 扎
Struggling

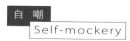
自 嘲
Self-mockery

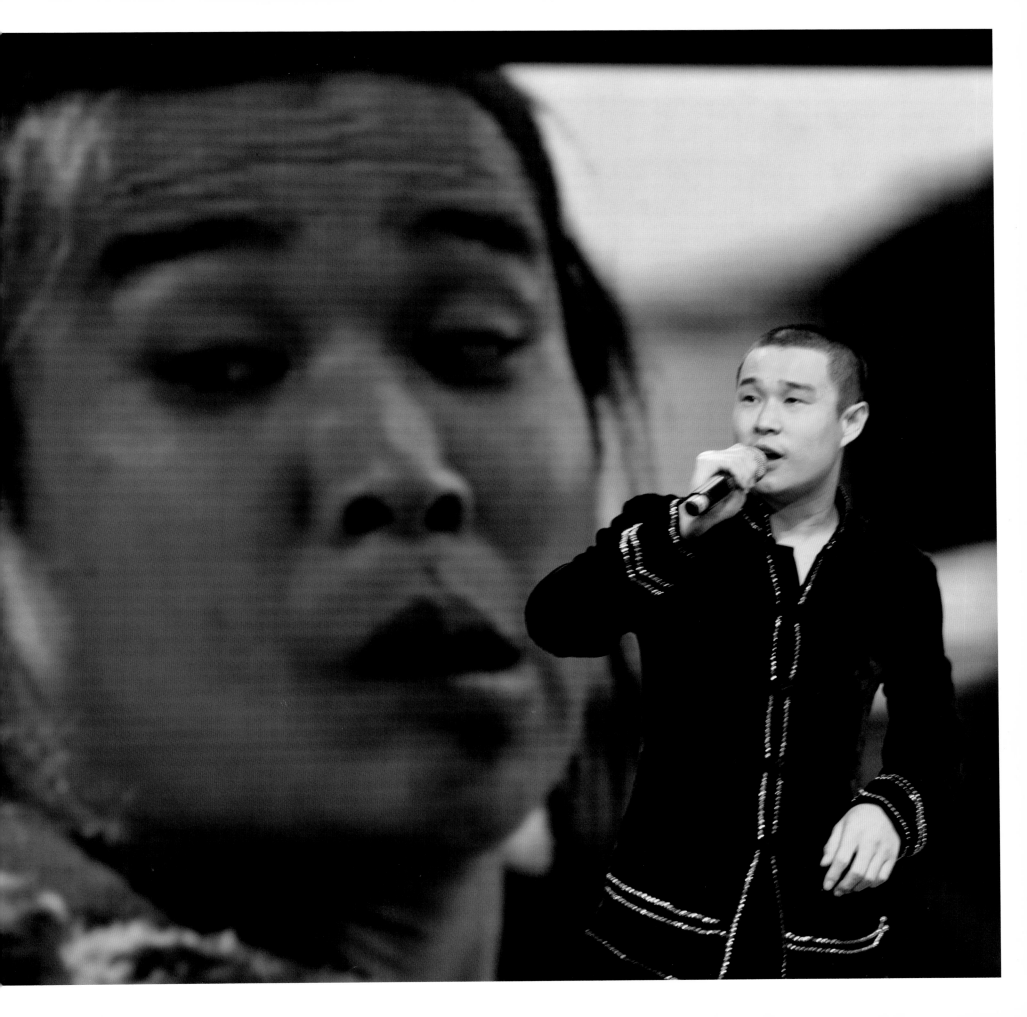

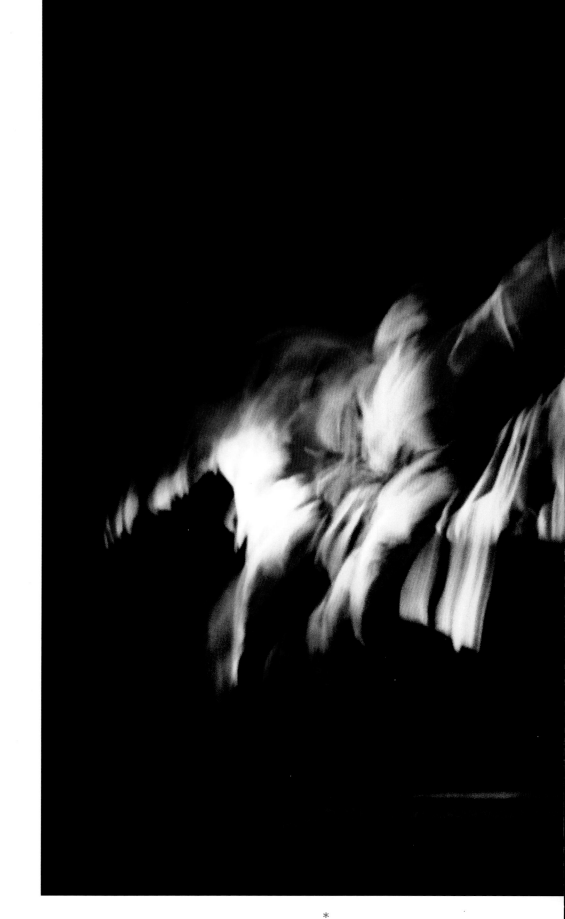

华光坠落如浮云
Falling

我自岿然不动
Indomitable will

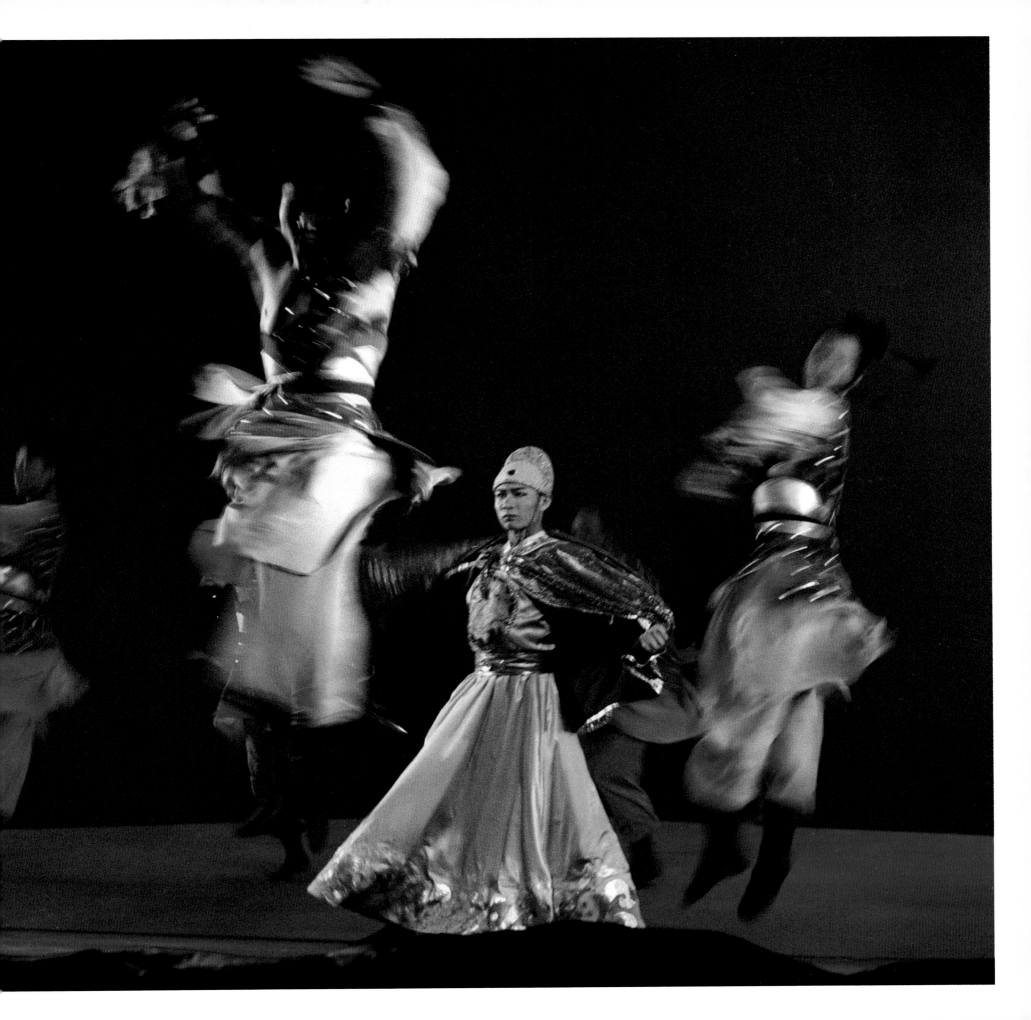

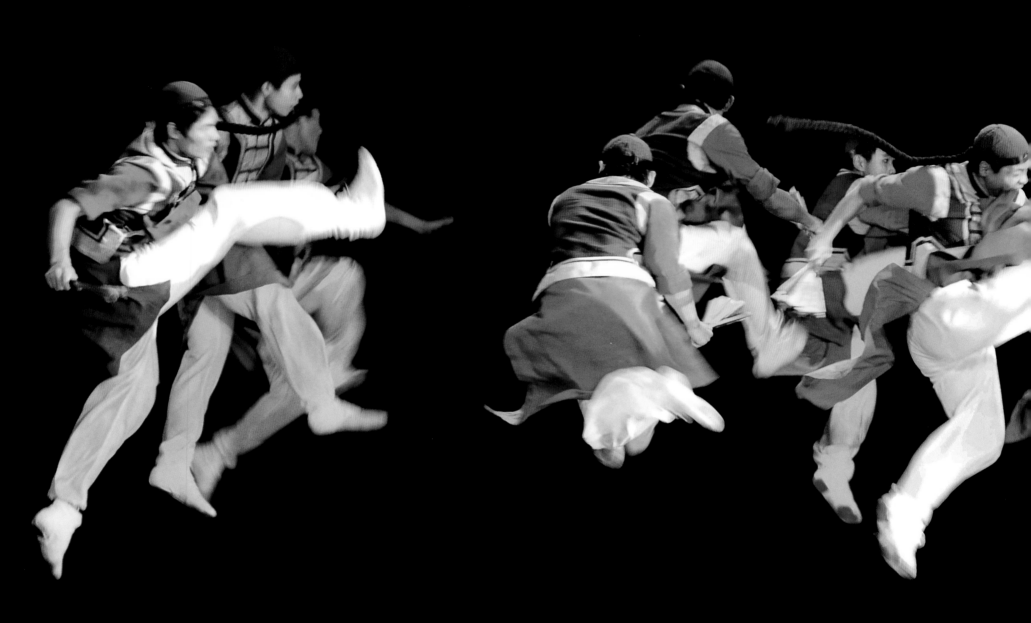

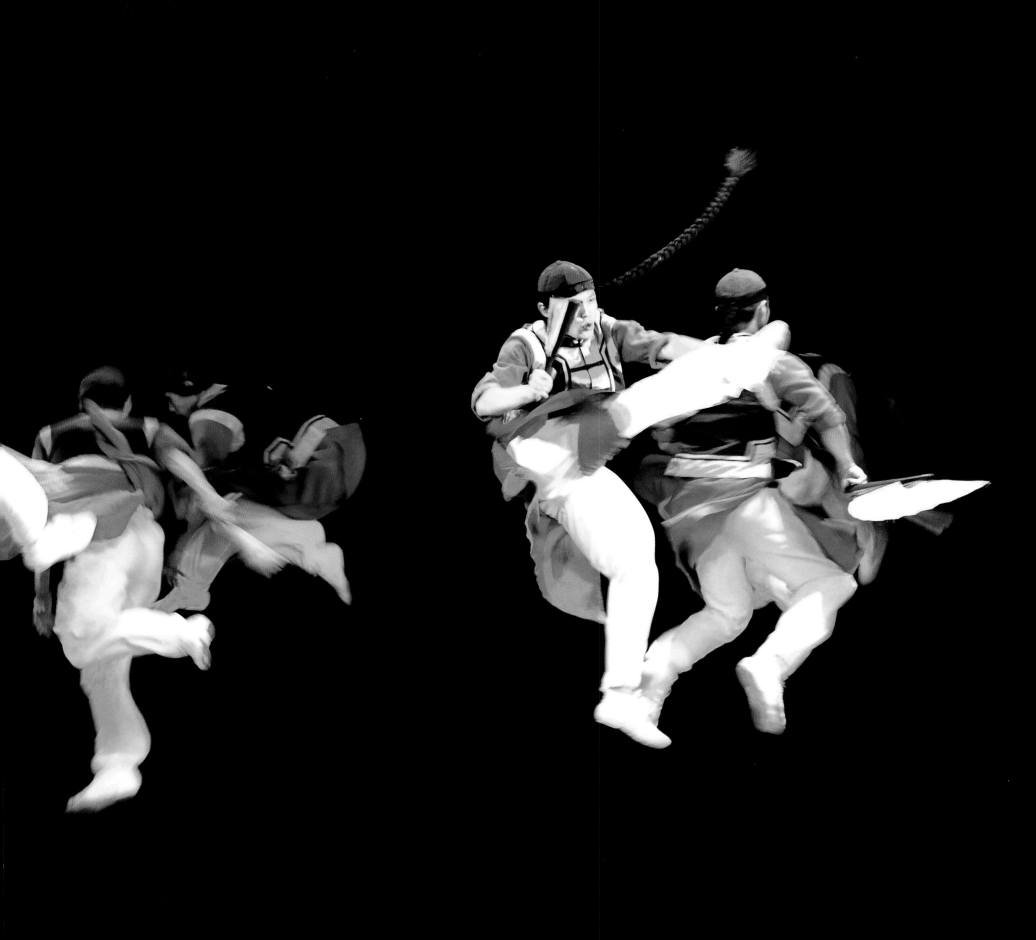

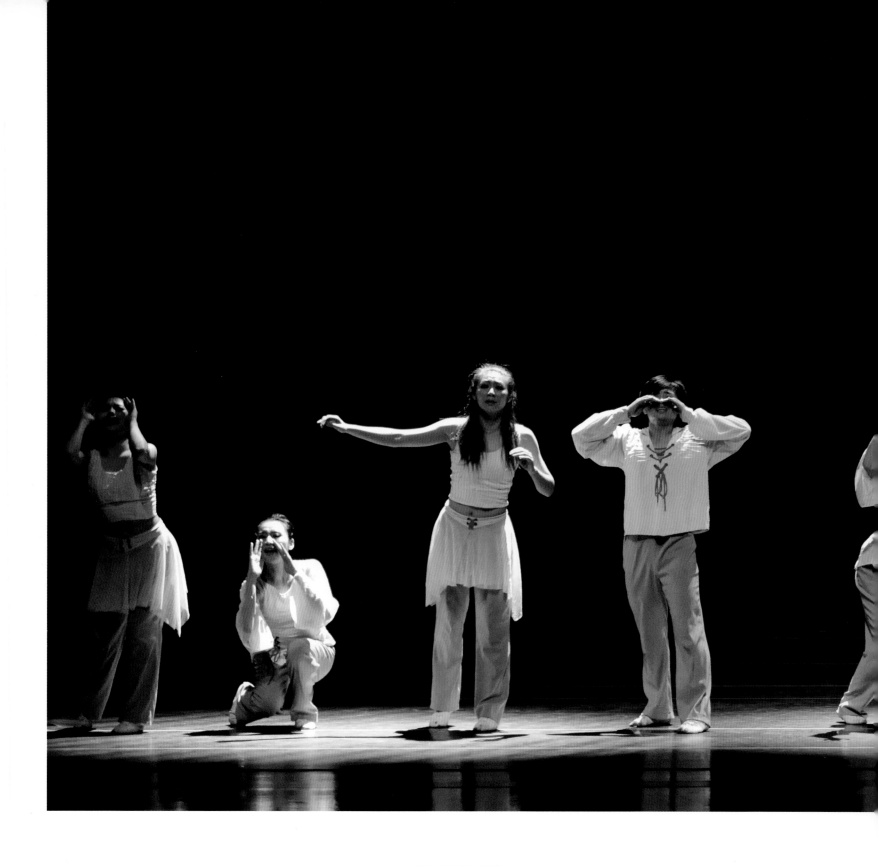

<<

乱舞春秋
Chaos

一群都市人
Urbanites

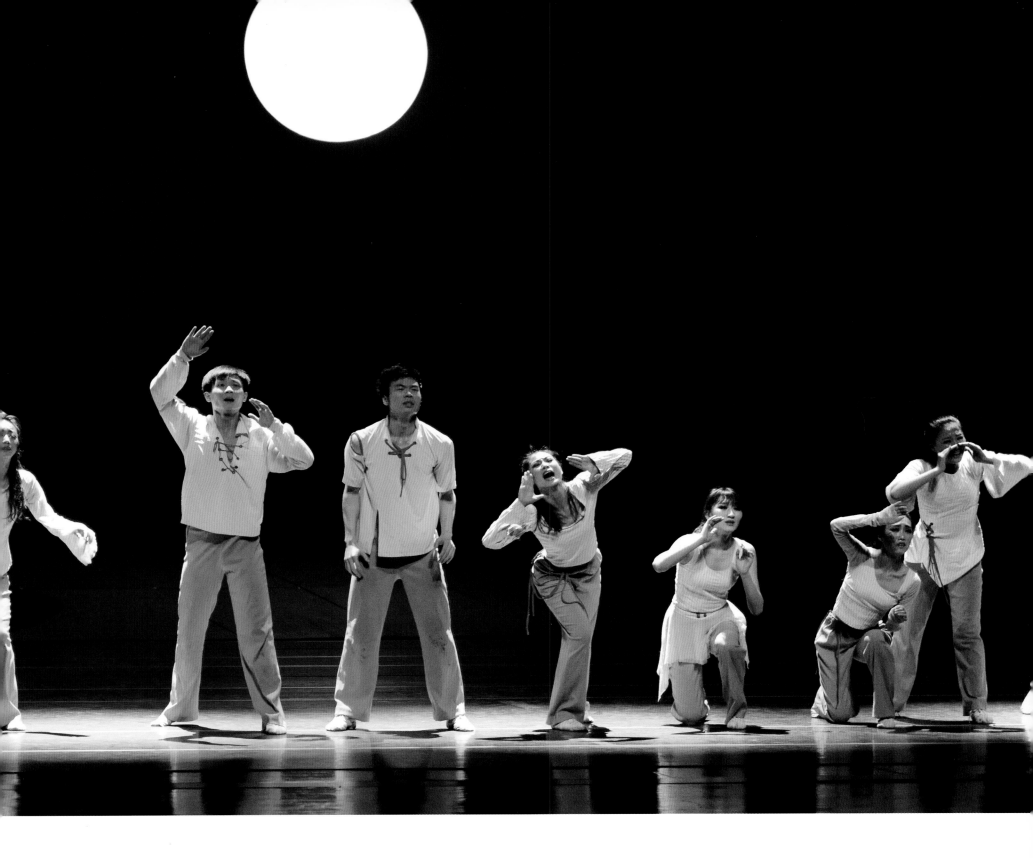

Ethereal Colors

灵动的彩绘
Wei Xinping Stage Photography Art

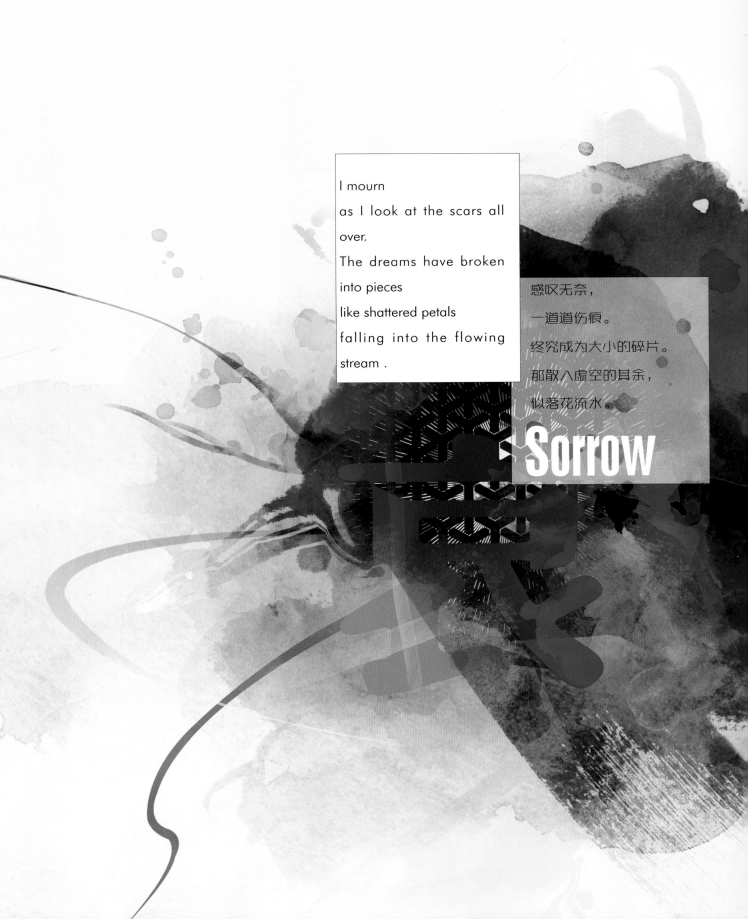

I mourn
as I look at the scars all
over.
The dreams have broken
into pieces
like shattered petals
falling into the flowing
stream .

感叹无奈，

一道道伤痕。

终究成为大小的碎片。

那散入虚空的其余，

似落花流水。

Sorrow

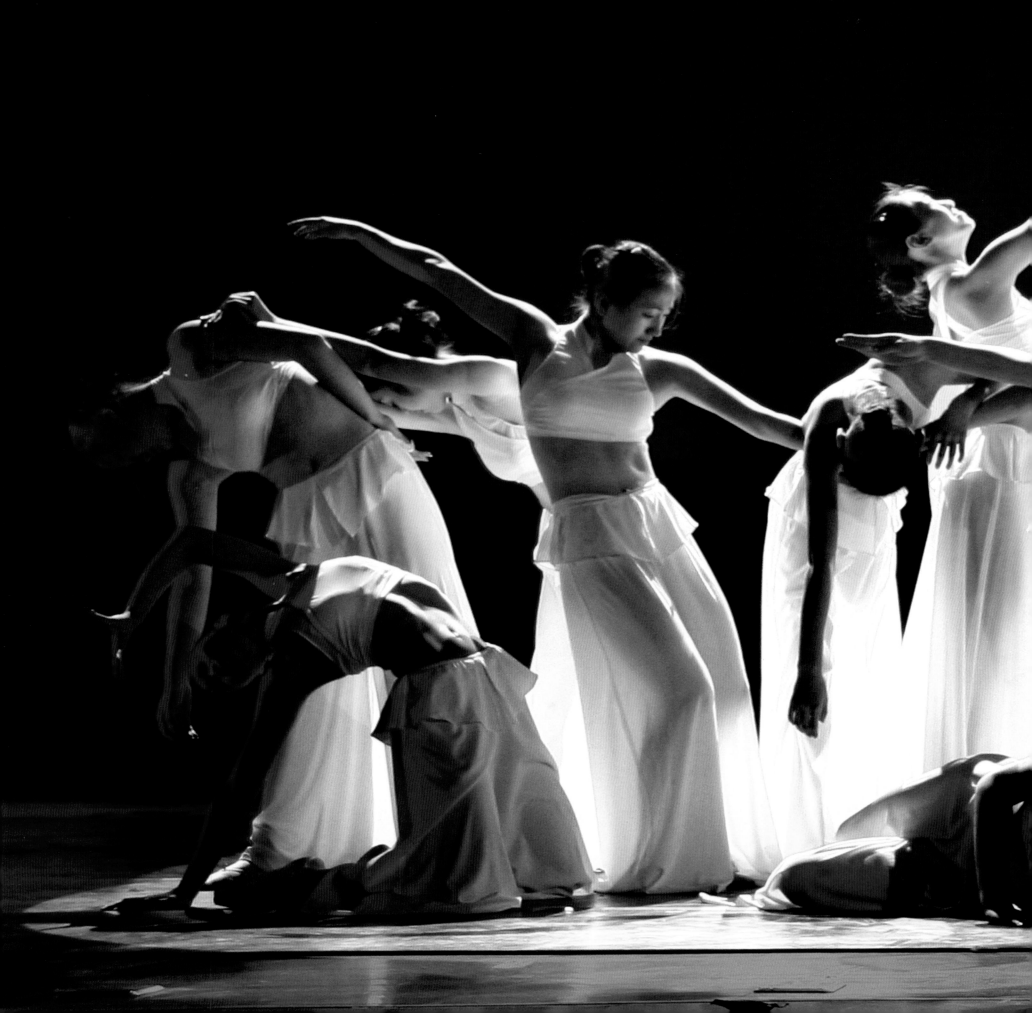

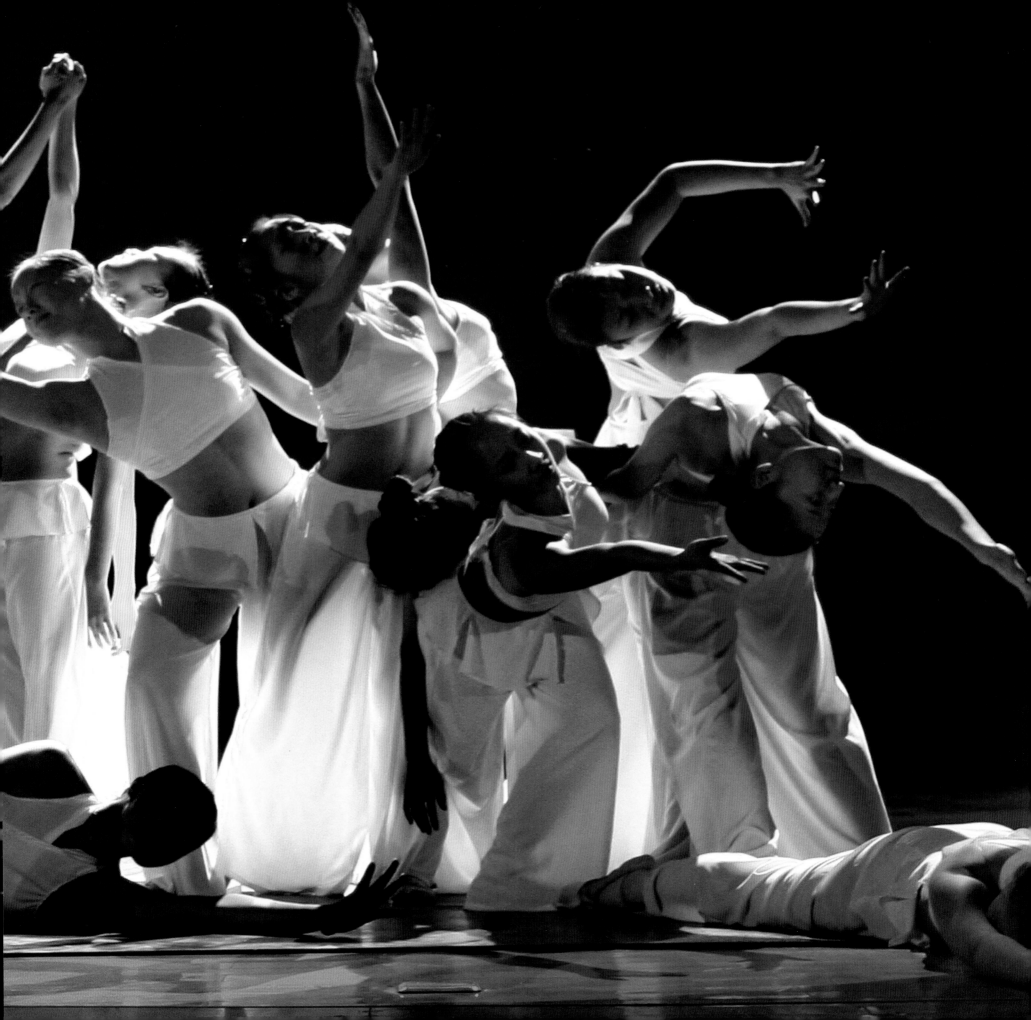

<< 才下眉头
Missing you

第三种人
A fairy

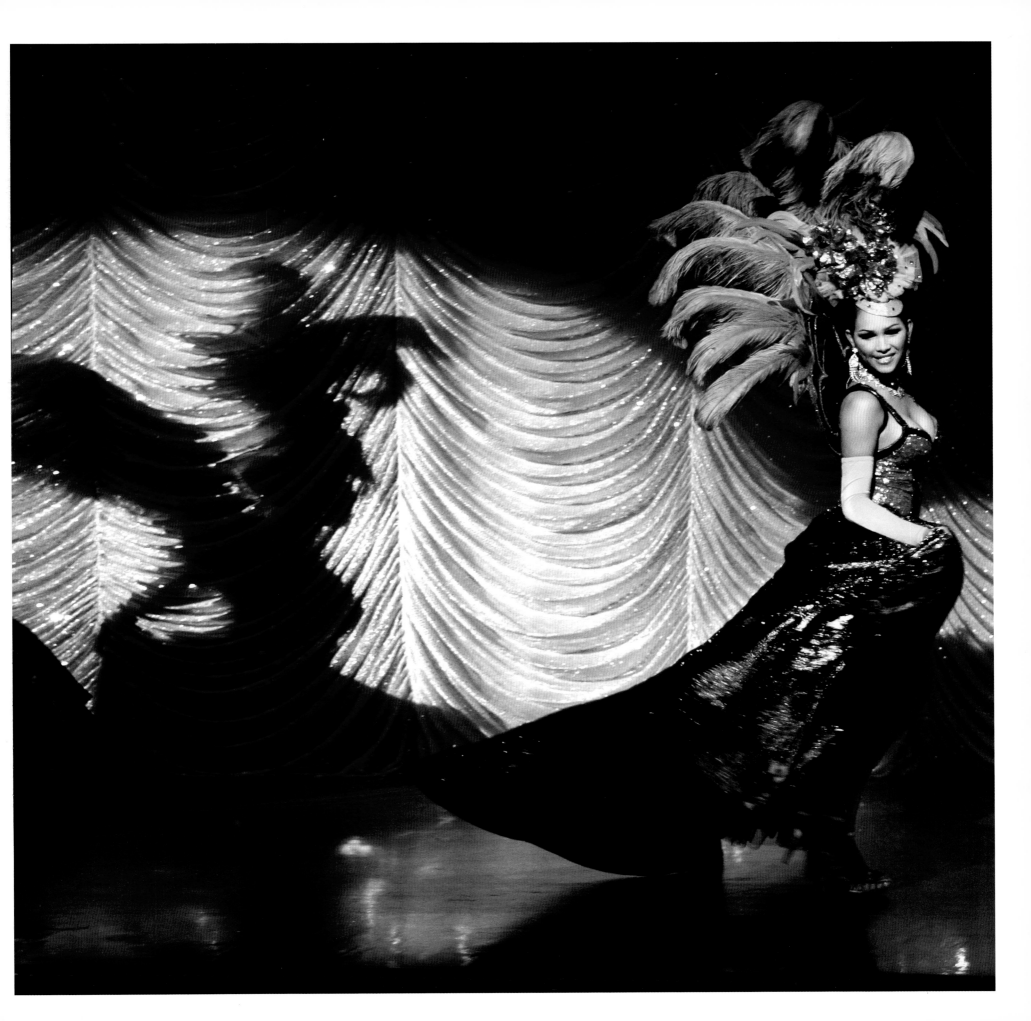

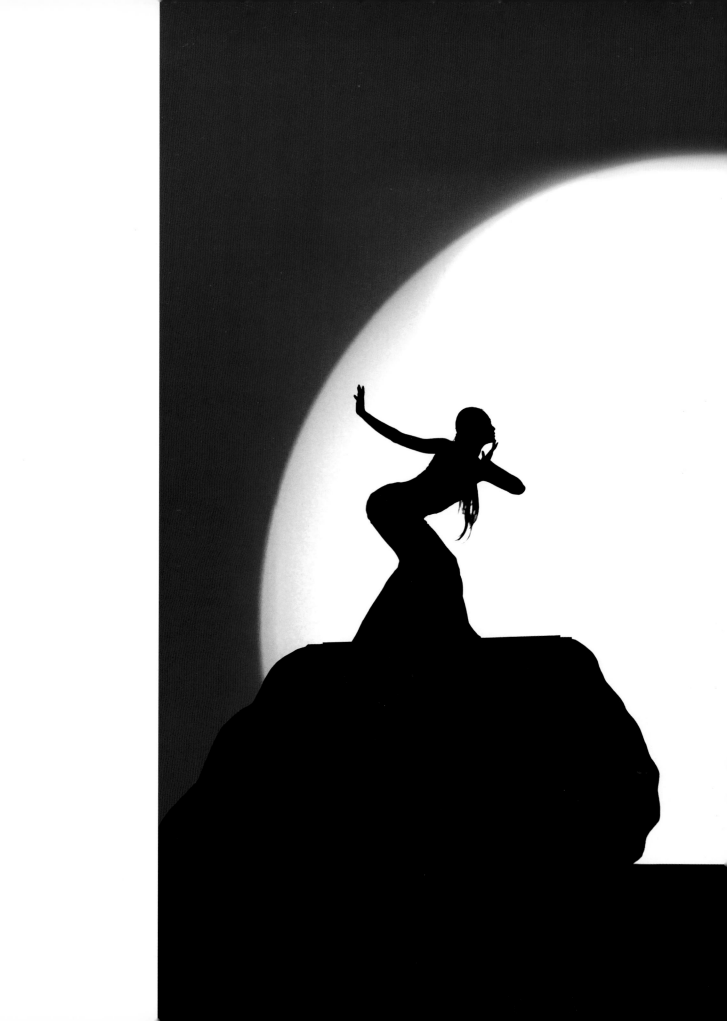

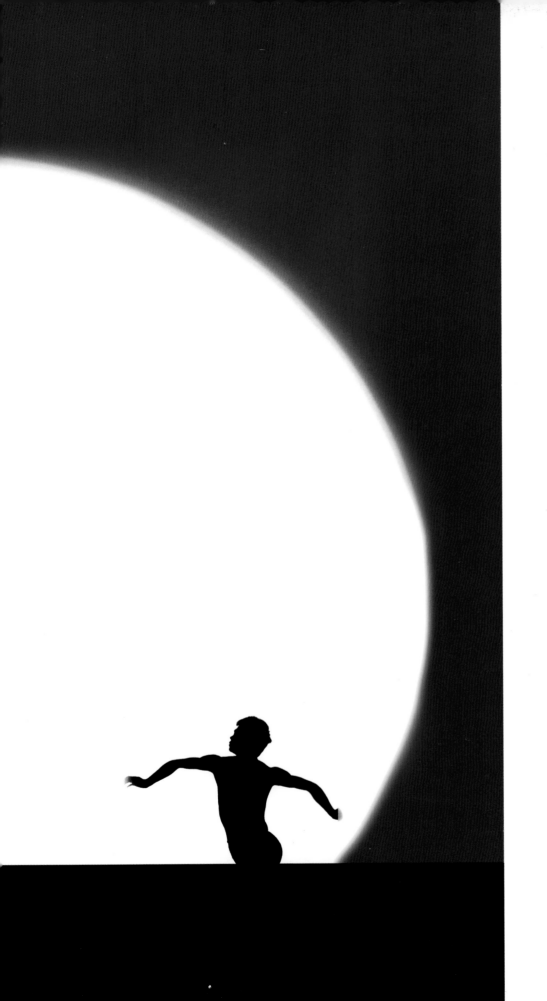

对 话
Dialogue

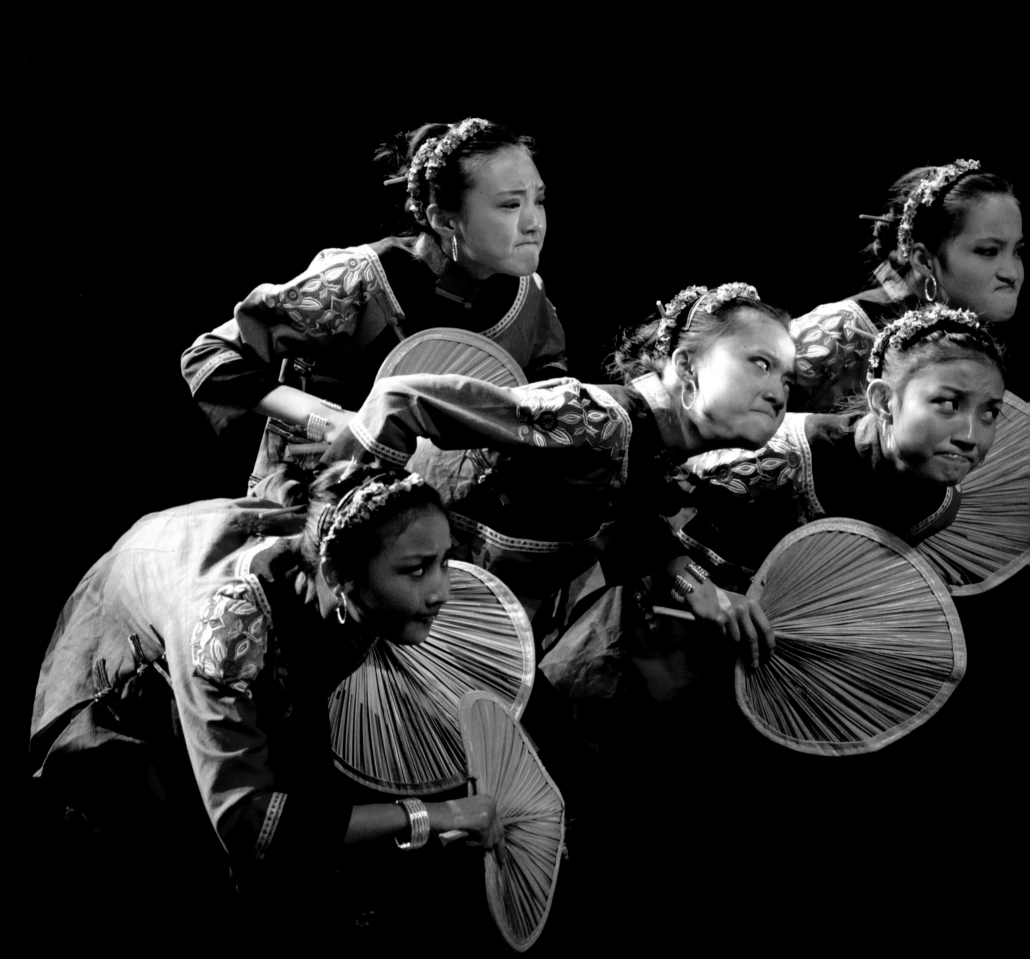

花容失色

Astonishing women

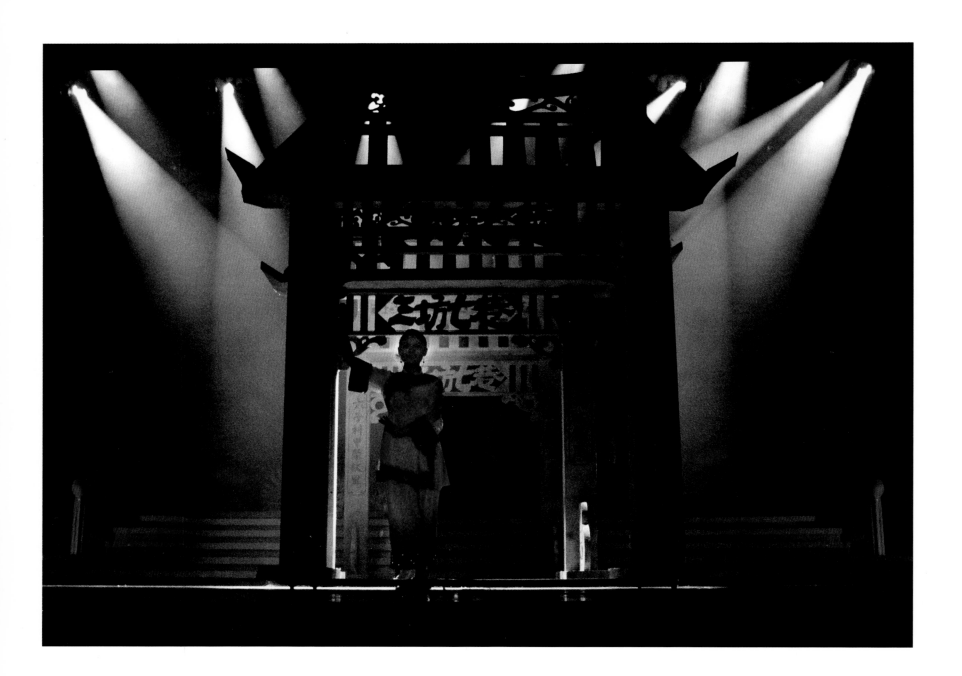

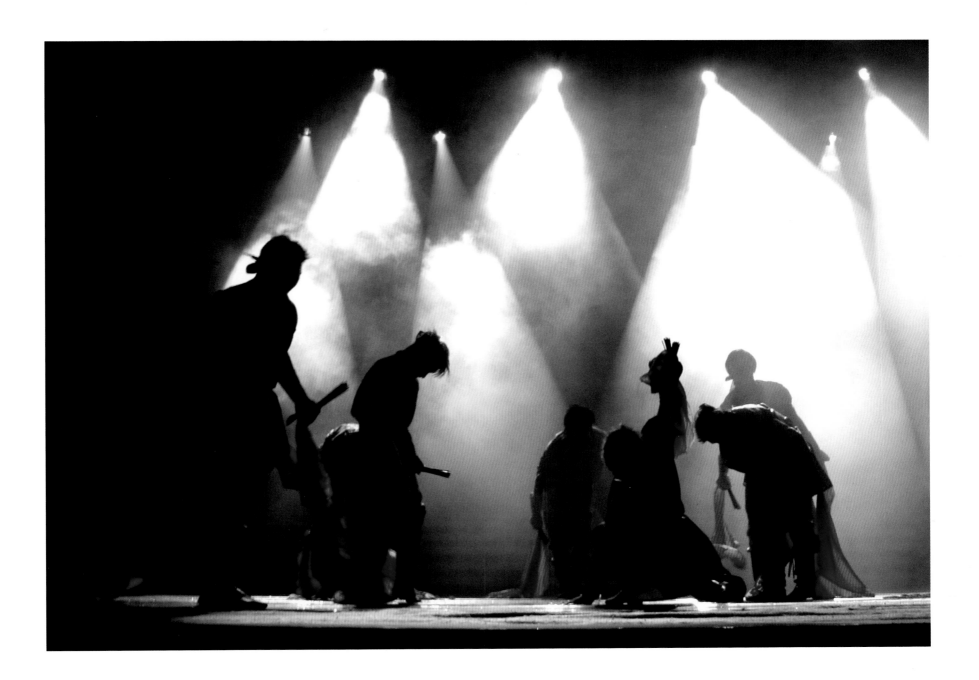

低 调
Lowered heads

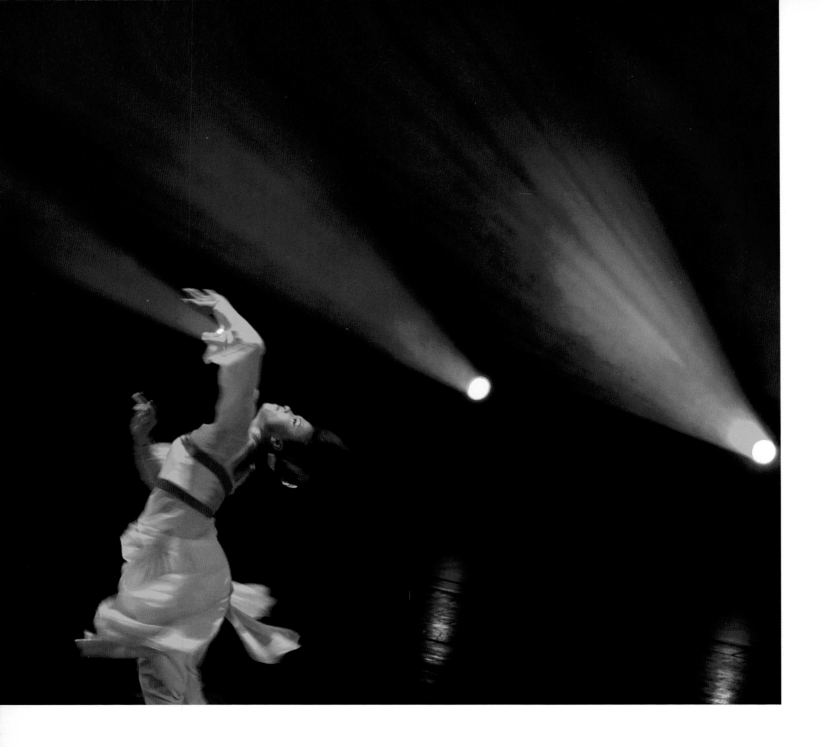

摇首出红尘
Escaping

随 风
Along with the wind

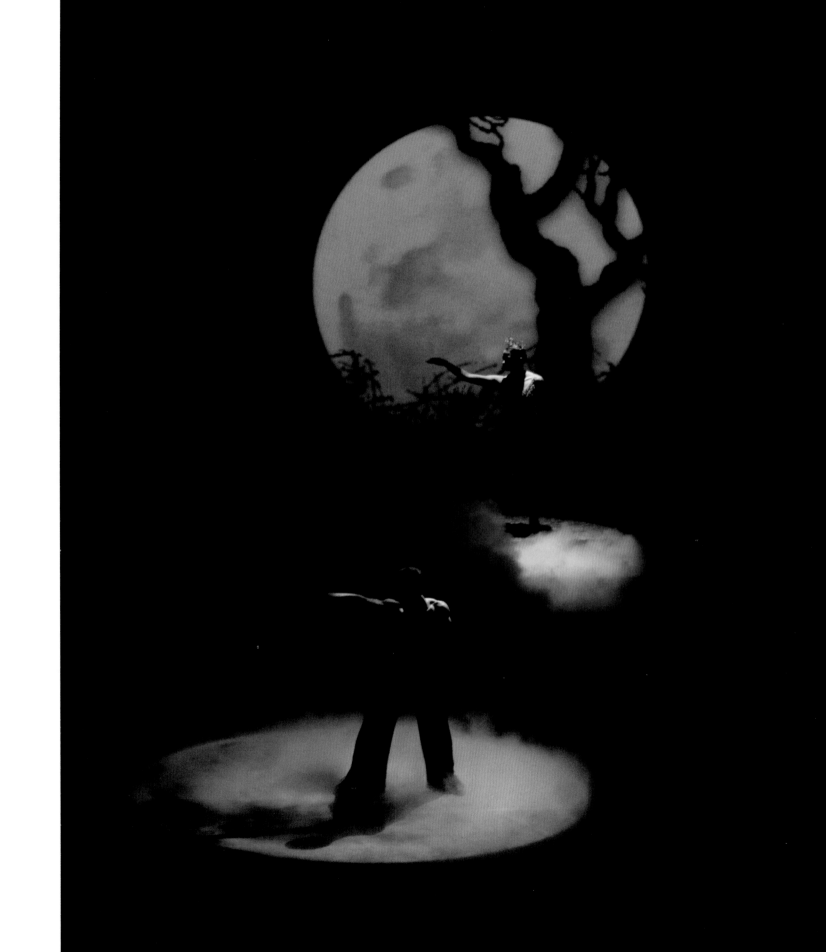

我视世界为无物

Hollow

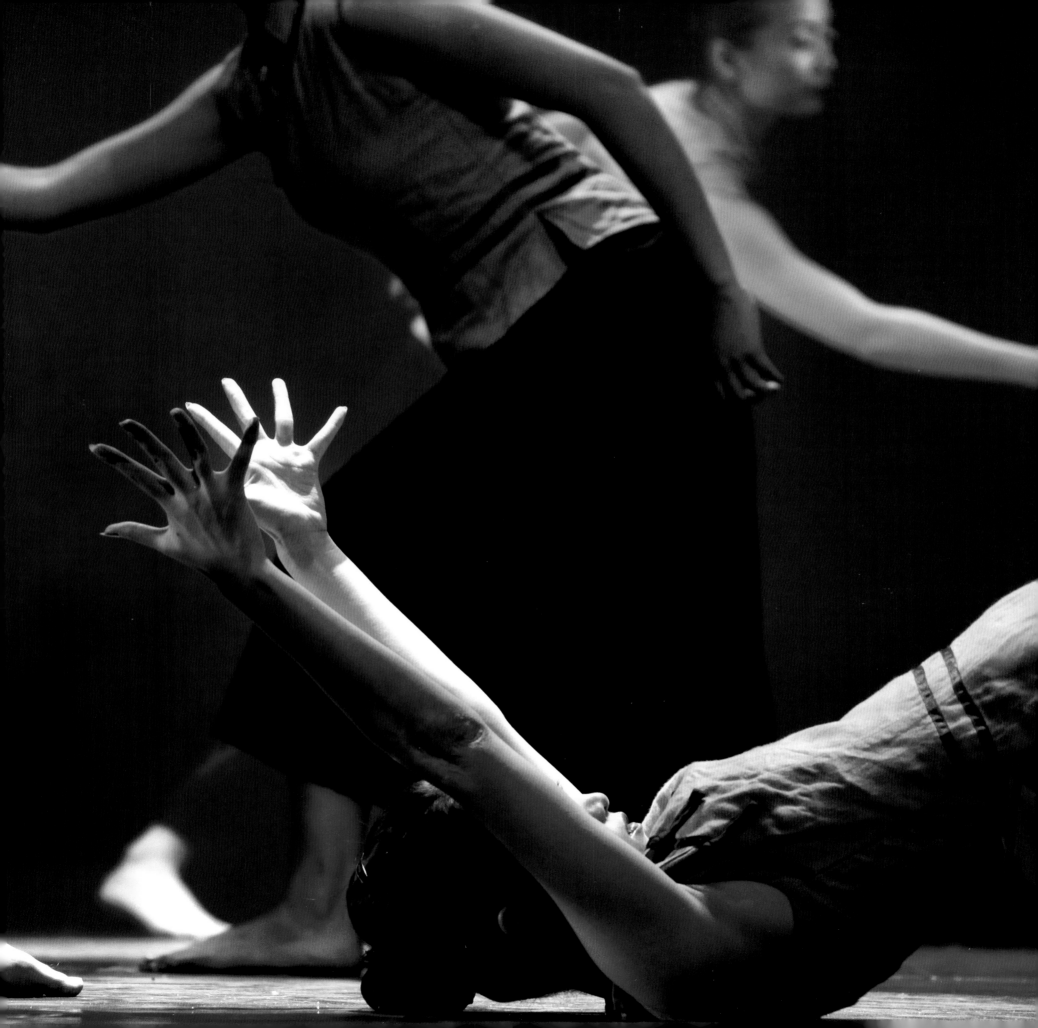

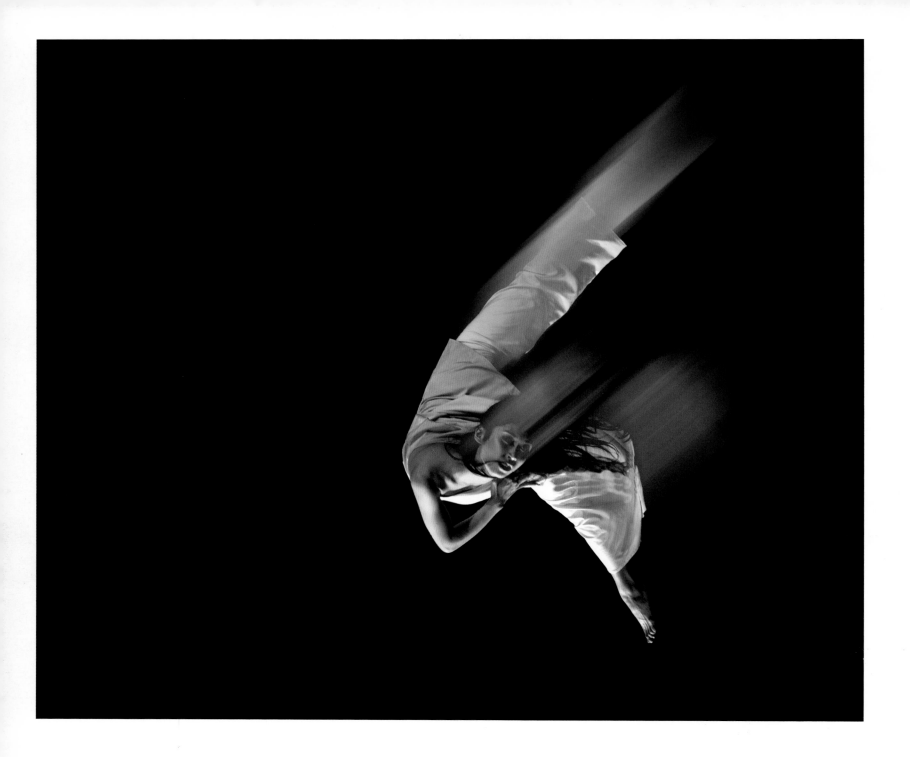

飞来的孤雁

A lonely wild goose

星语心愿

Wishing upon a star

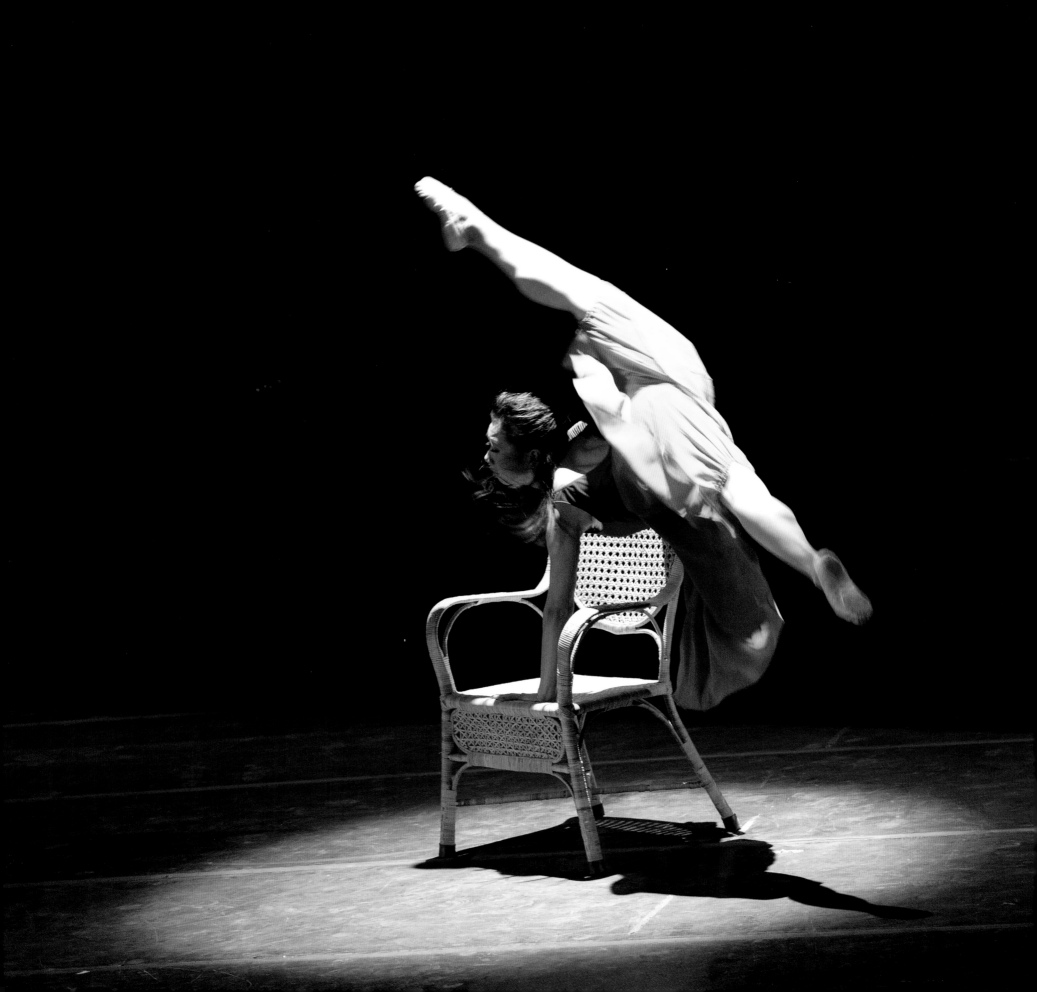

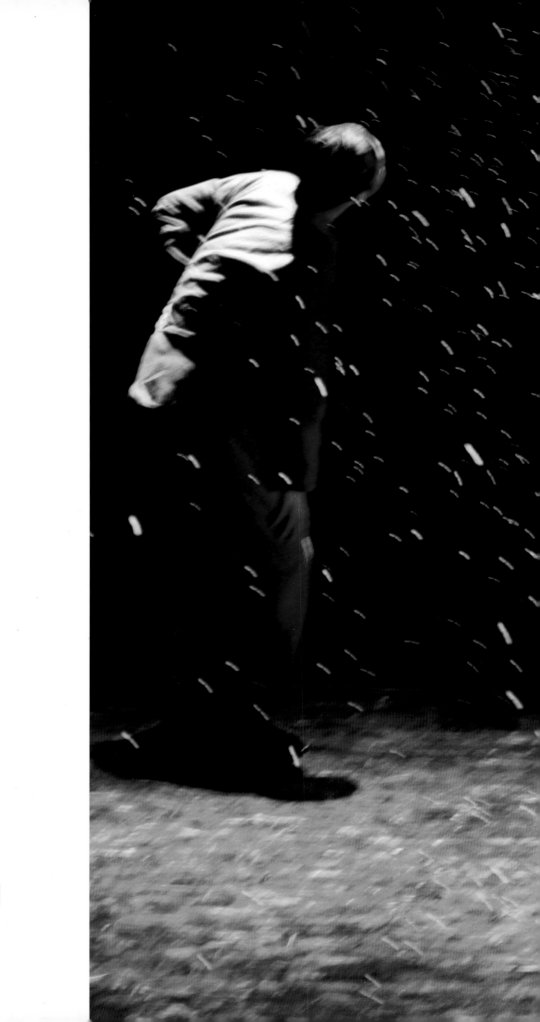

漫天泪水
Falling snow

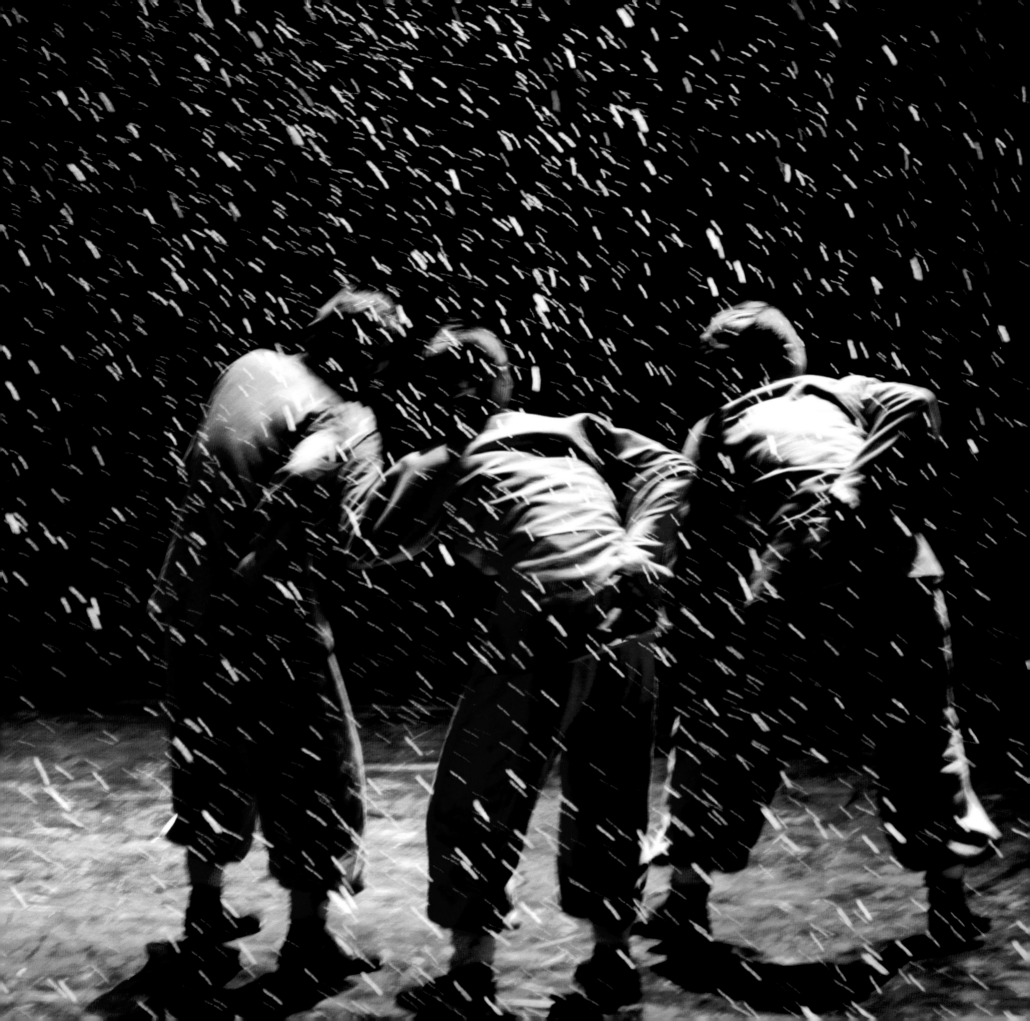

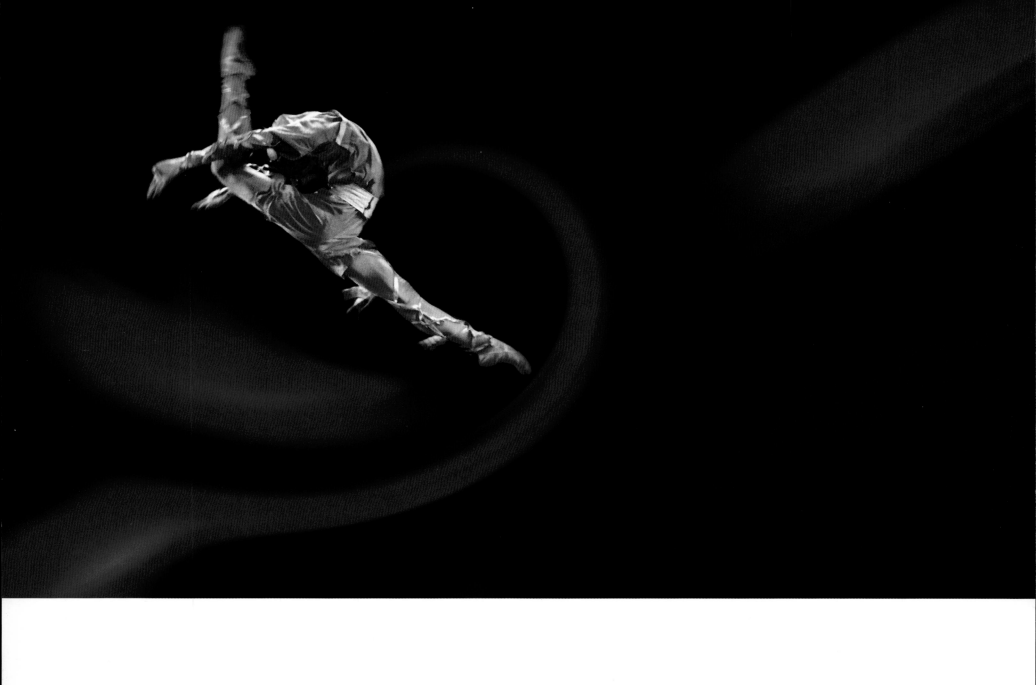

拯 救
Salvation

吟 唱
Intonate

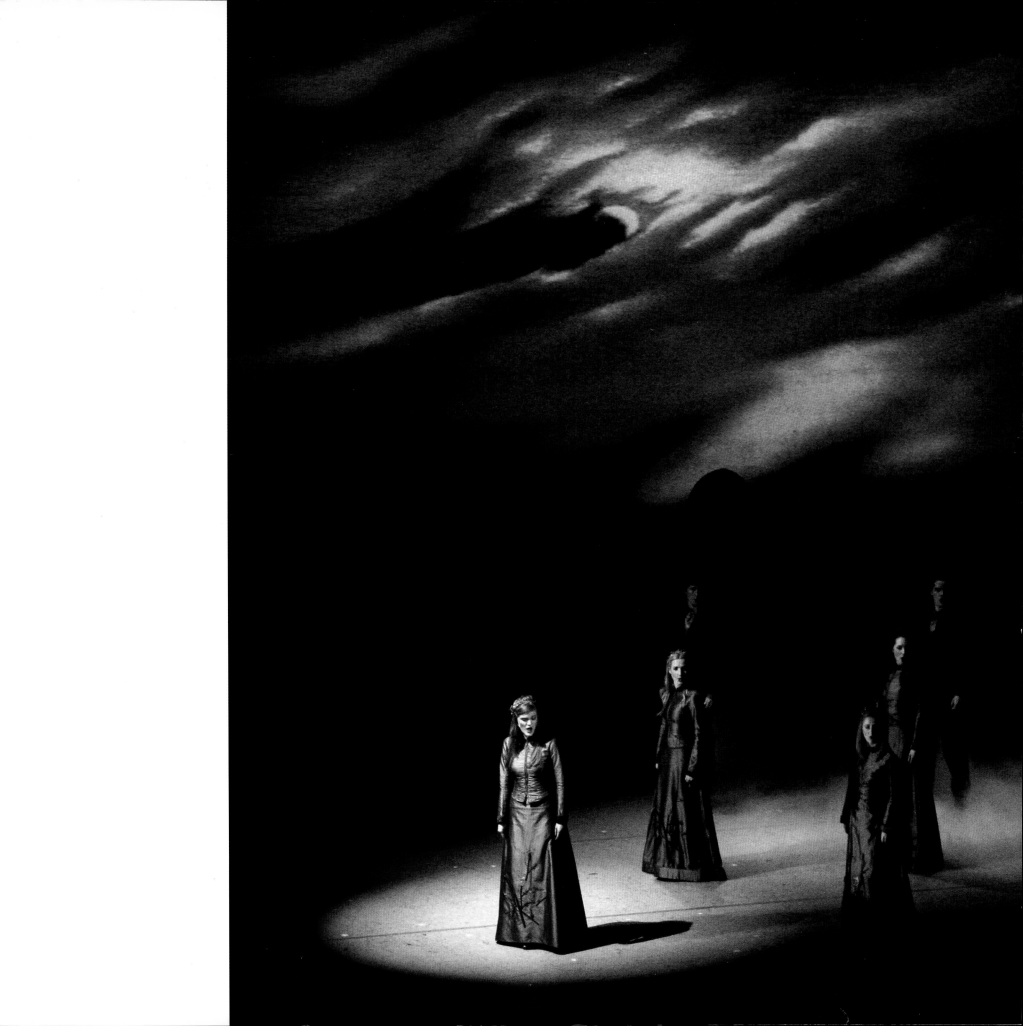

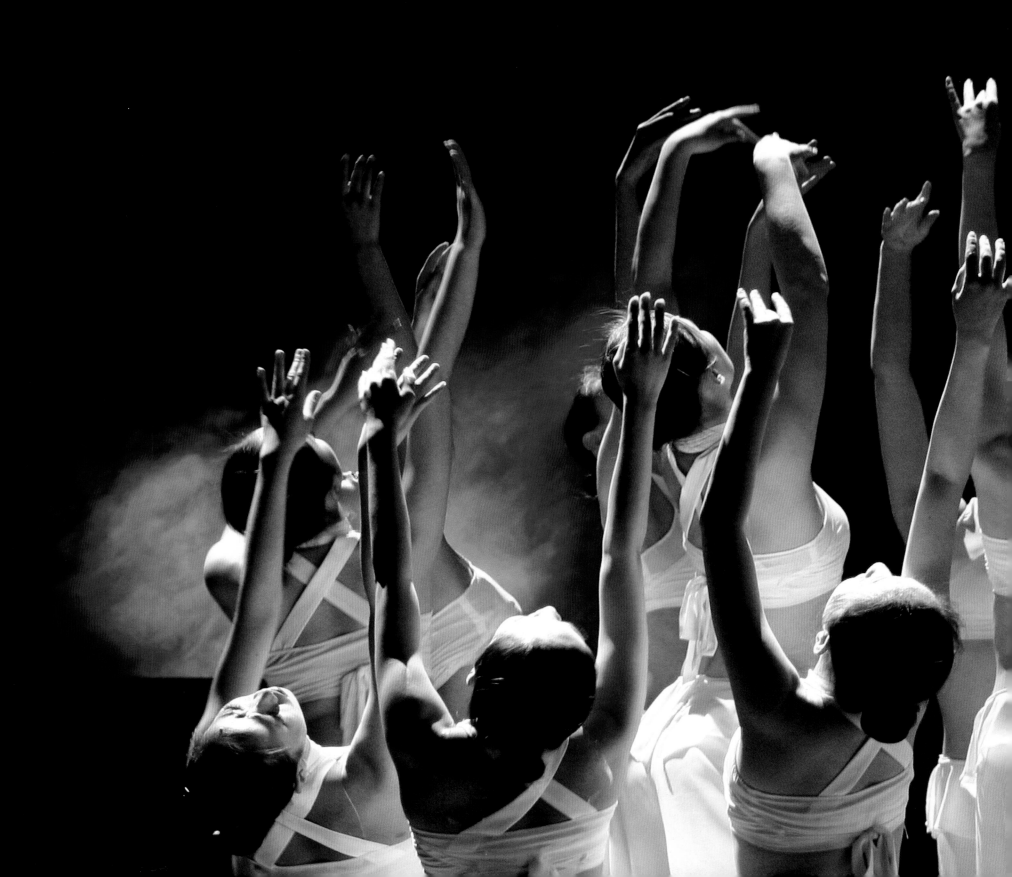

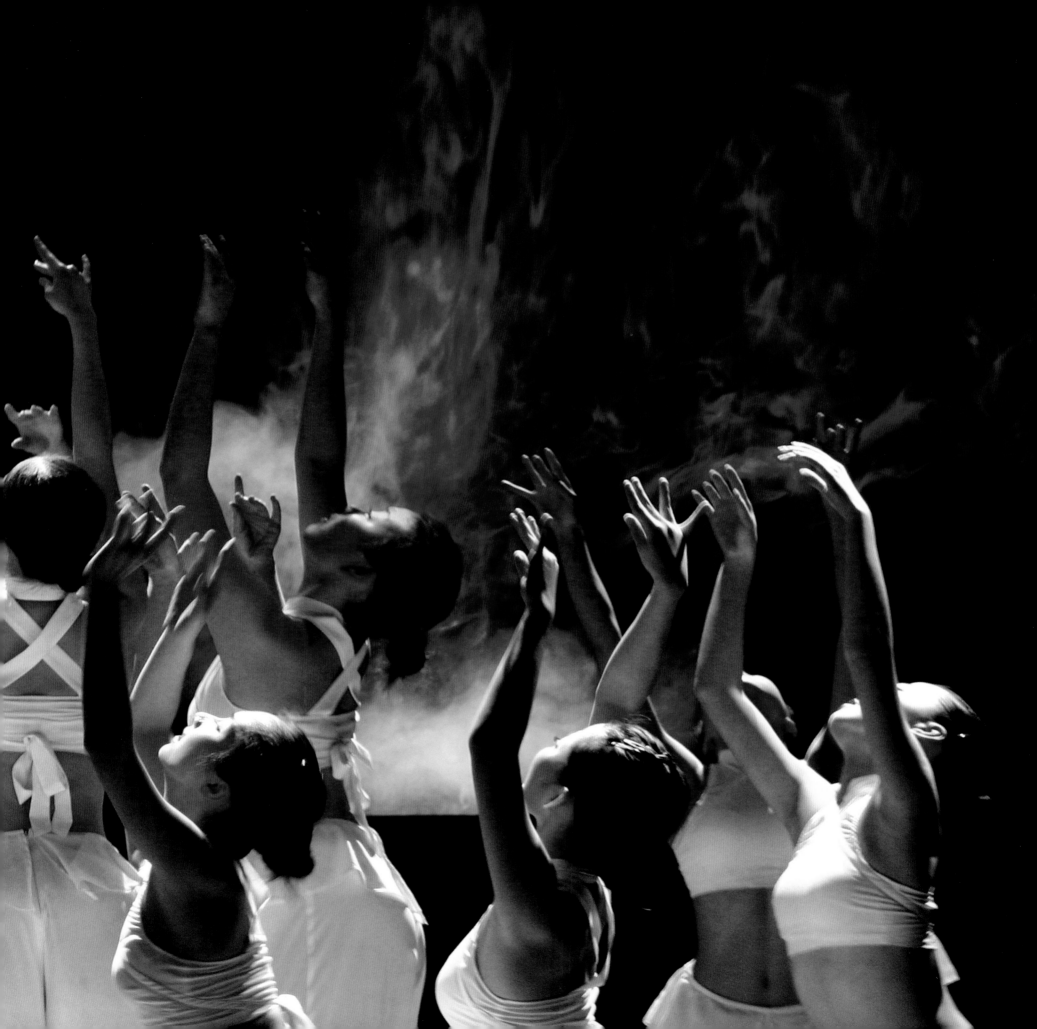

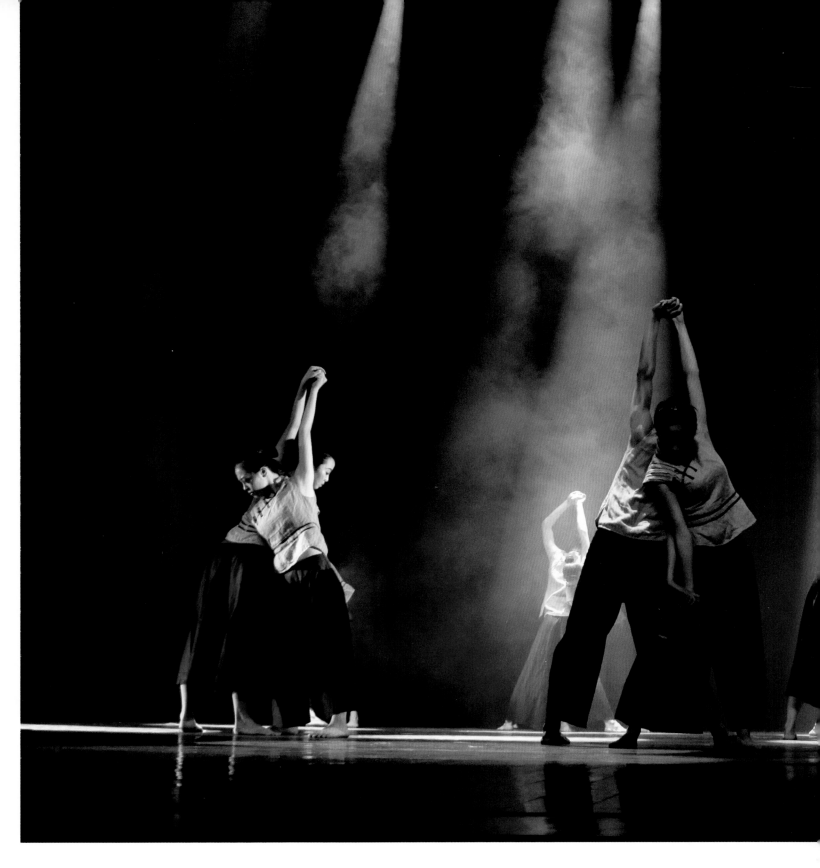

隐 翅
Angels without wings

夜曲声声
Nocturne

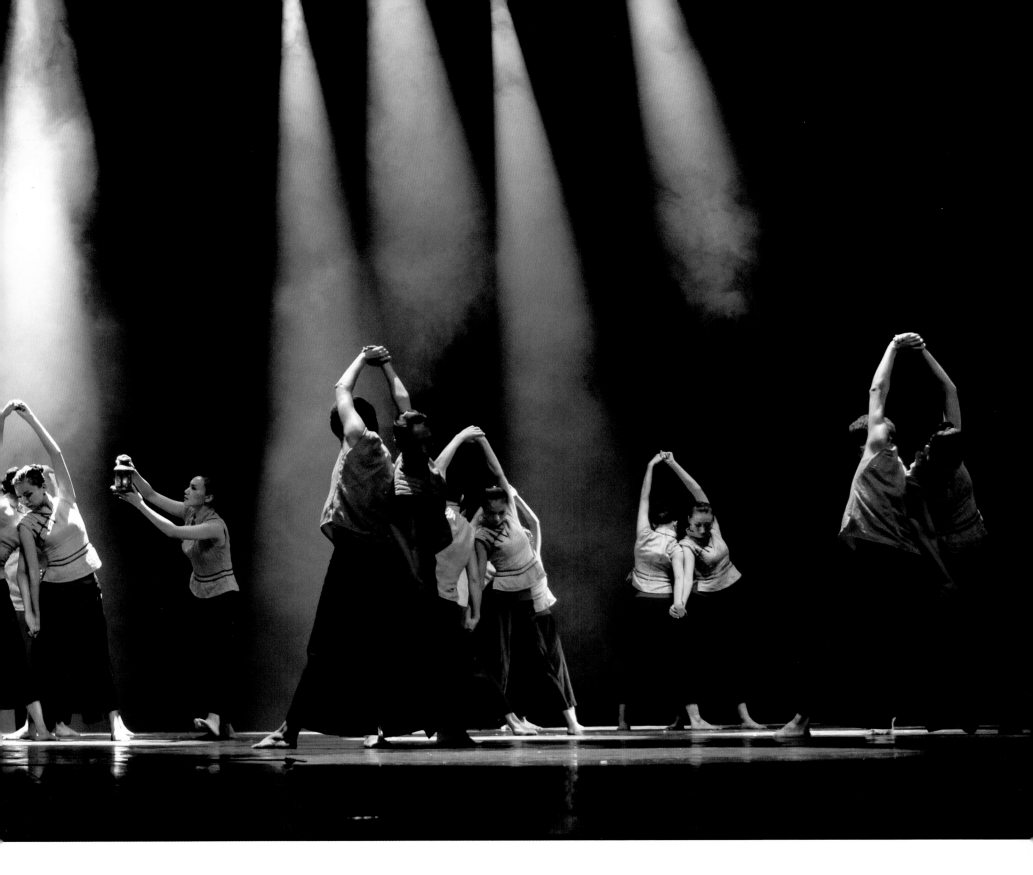

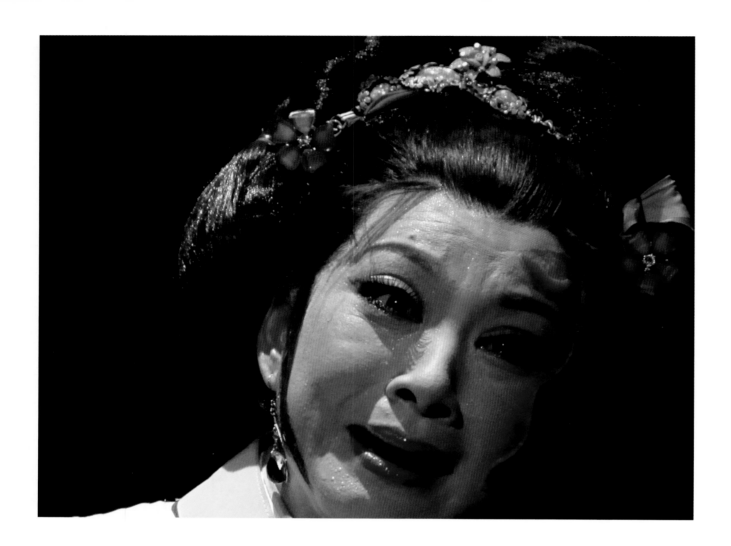

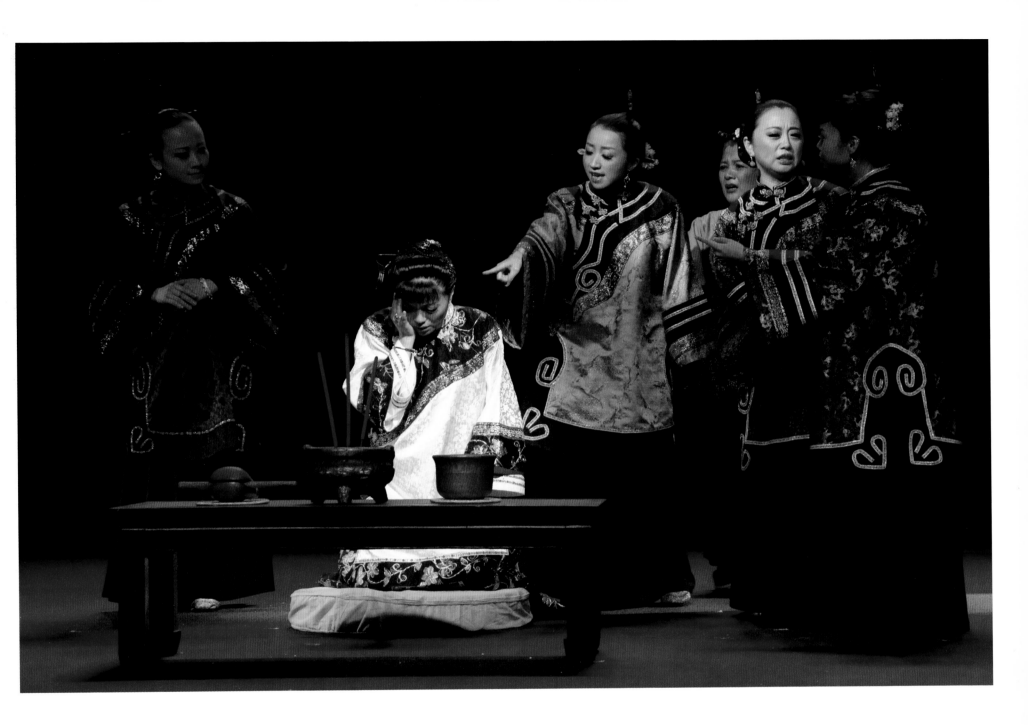

后 院
In the women's quarter

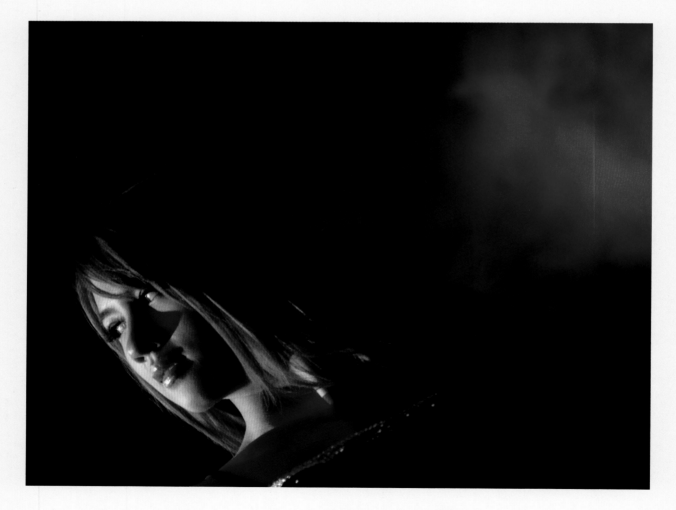

冷 眼

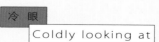

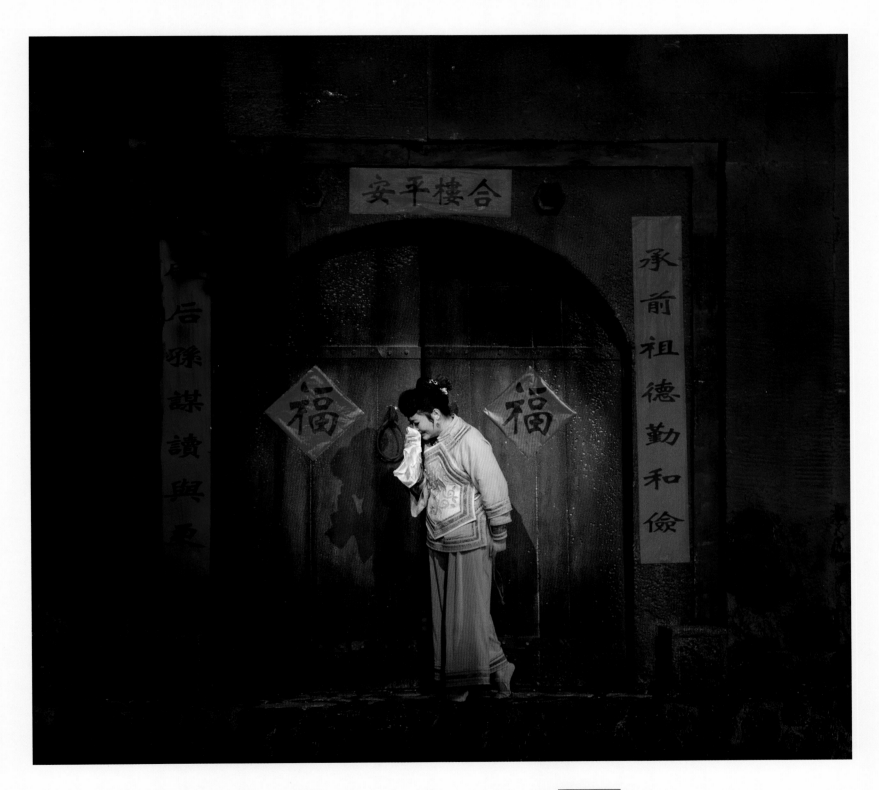

某家门外
Outside the gate

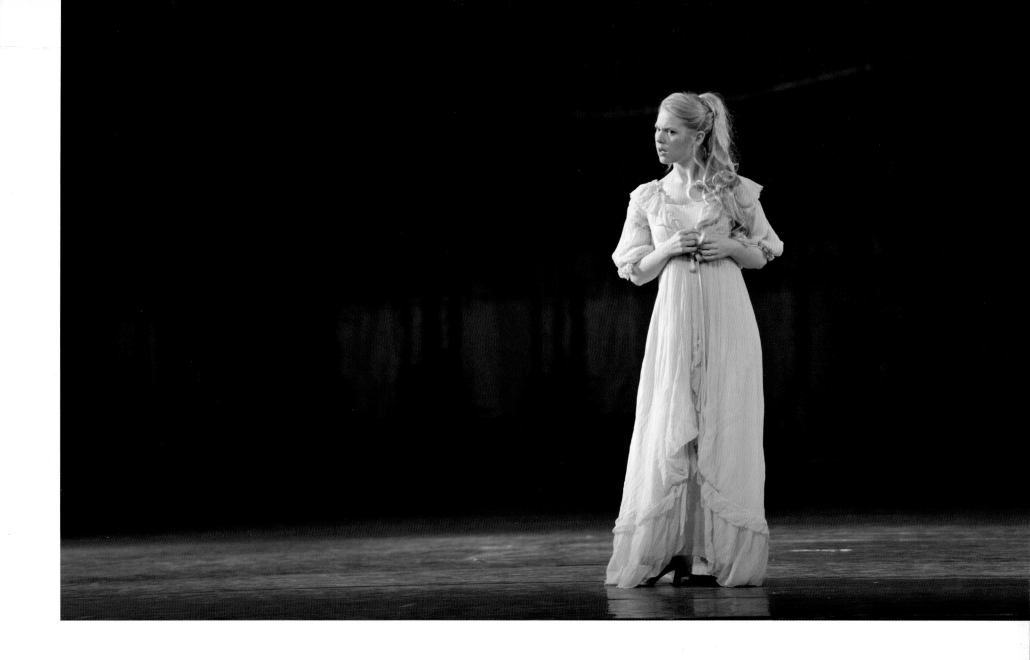

夜飞魂
Soul flying at midnight

我该怎么办
What should I do?

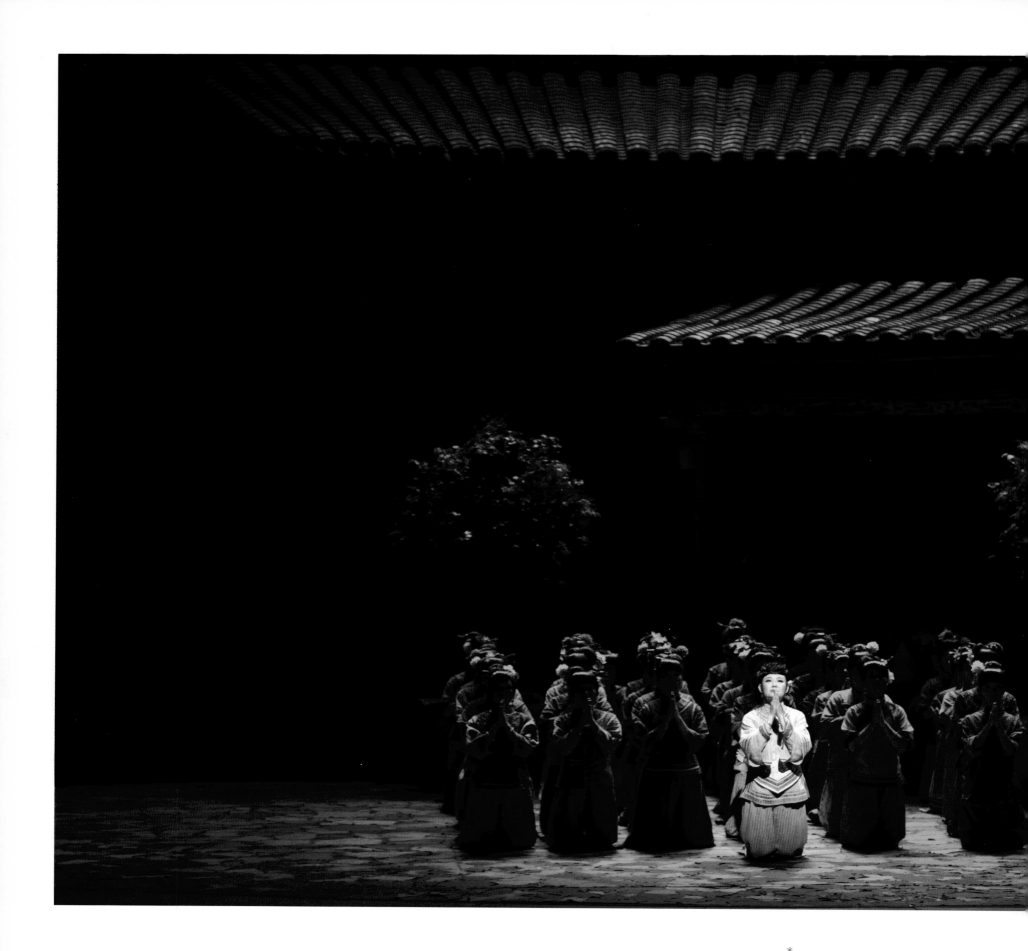

祈盼
Praying

灵动的彩绘
Wei Xinping Stage Photography Art

Optimism

东篱之下，

蓦然回首，

原来天崩地裂，

不过竹间淅沥，

此中有真意，

欲辨已忘言！

When I pick flowers in my
mountain retreat,
I look back in pease.
the yesterday's heartquake of
thunderstorm,
was but a gentle shower
moistening the bushes,
What does this mean,
I'd rather not say.

青鹤凌空笑
High up in the air

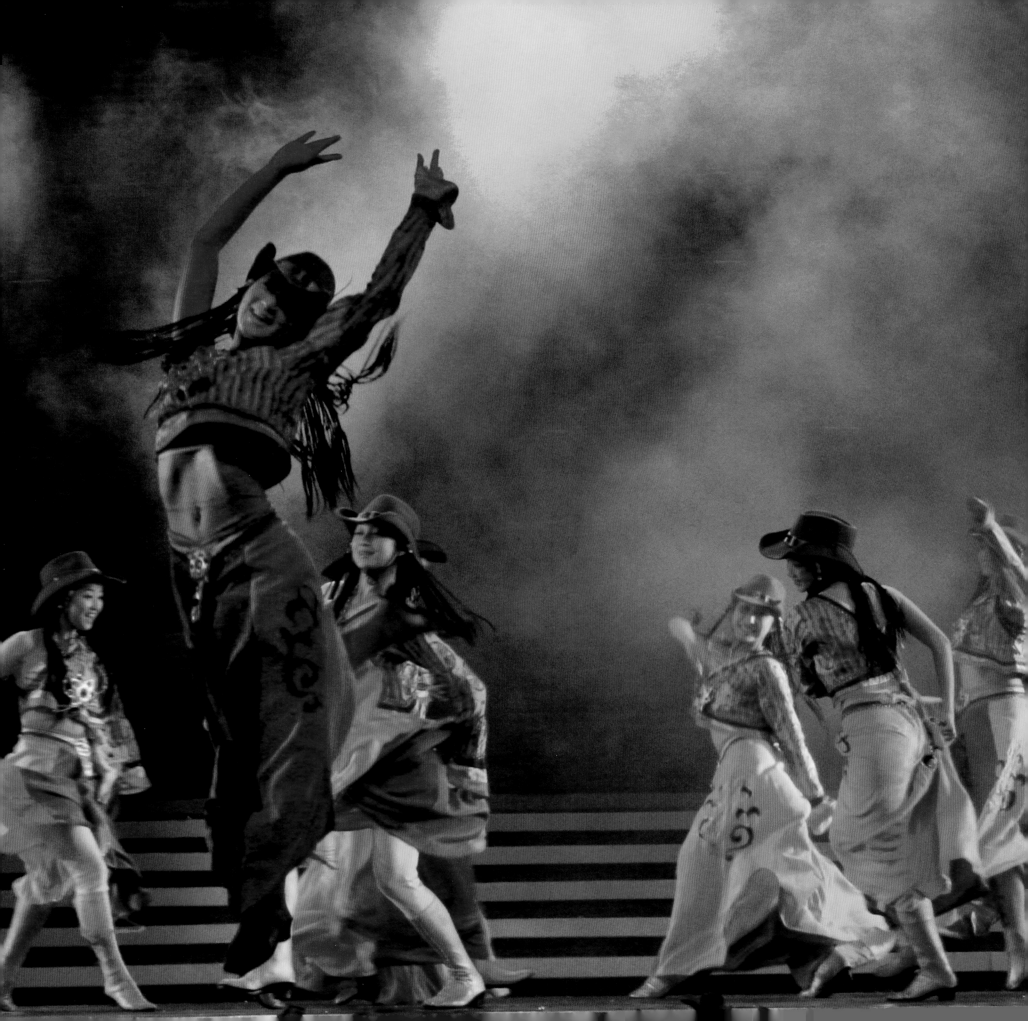

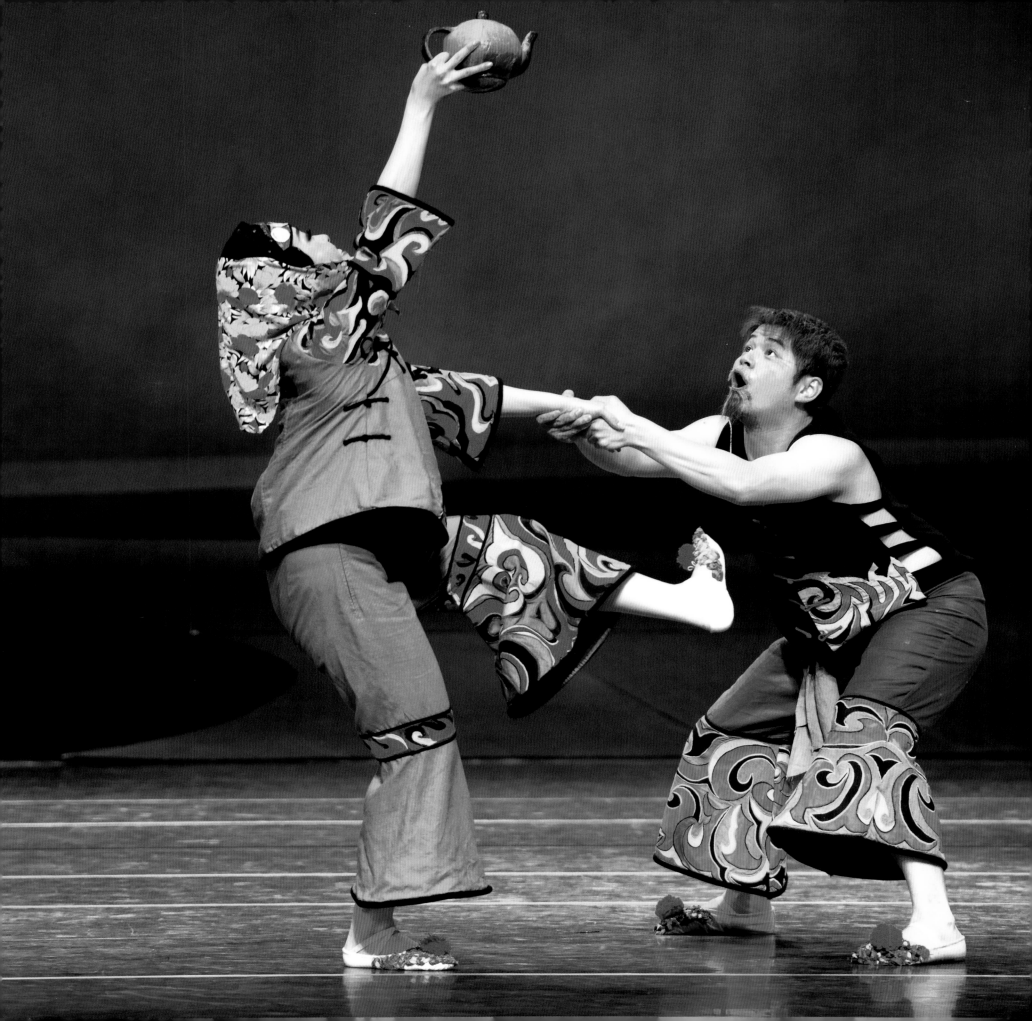

诱 惑
Seduction

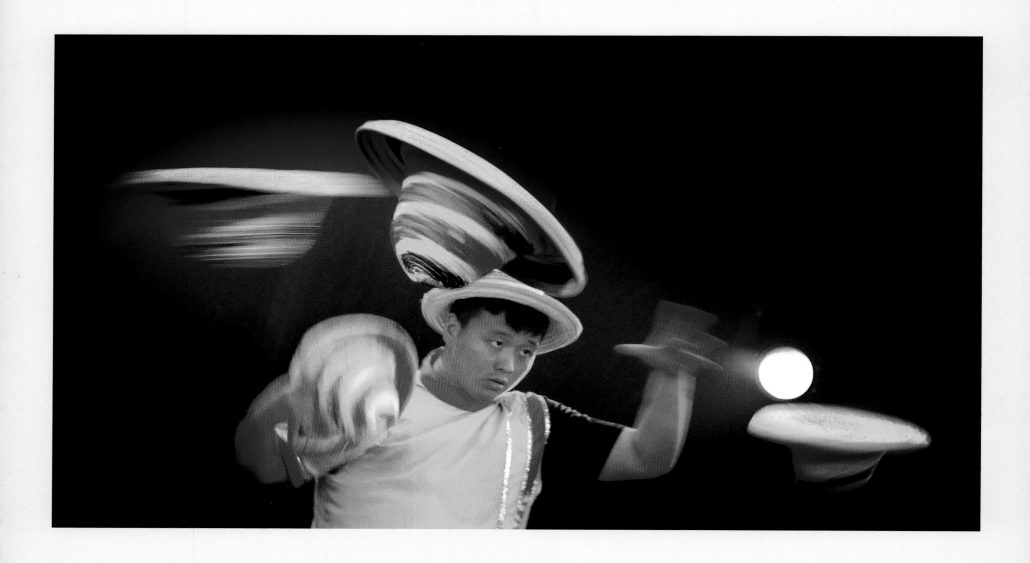

飞帽歌
Flying hats

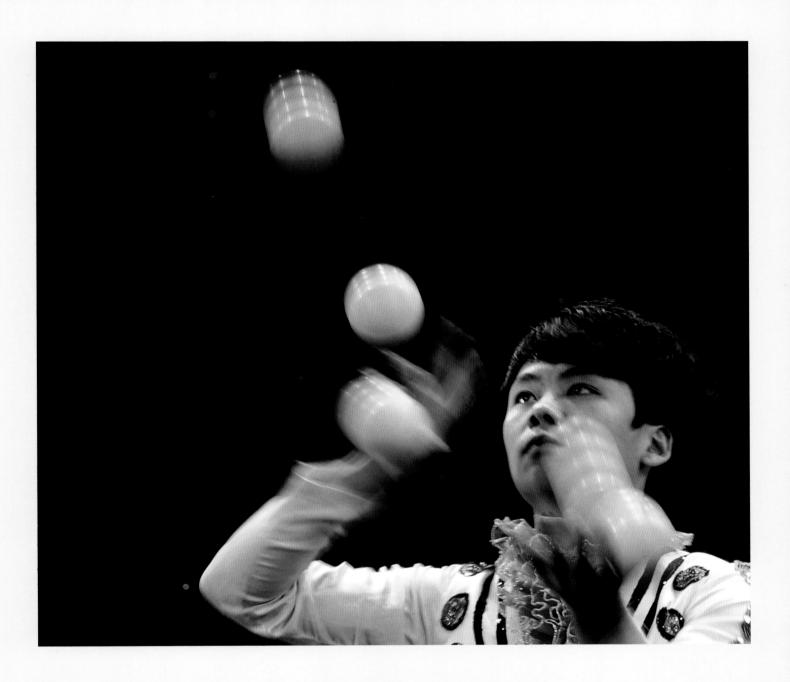

手 技
Deft hands

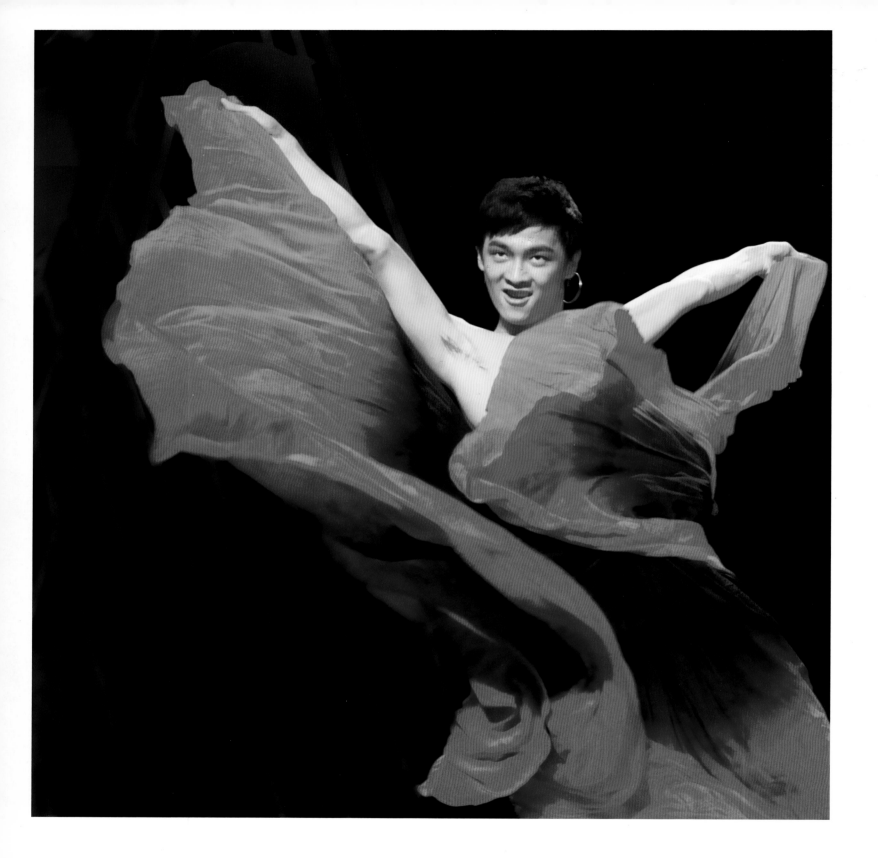

蓦然回首
A sudden turn

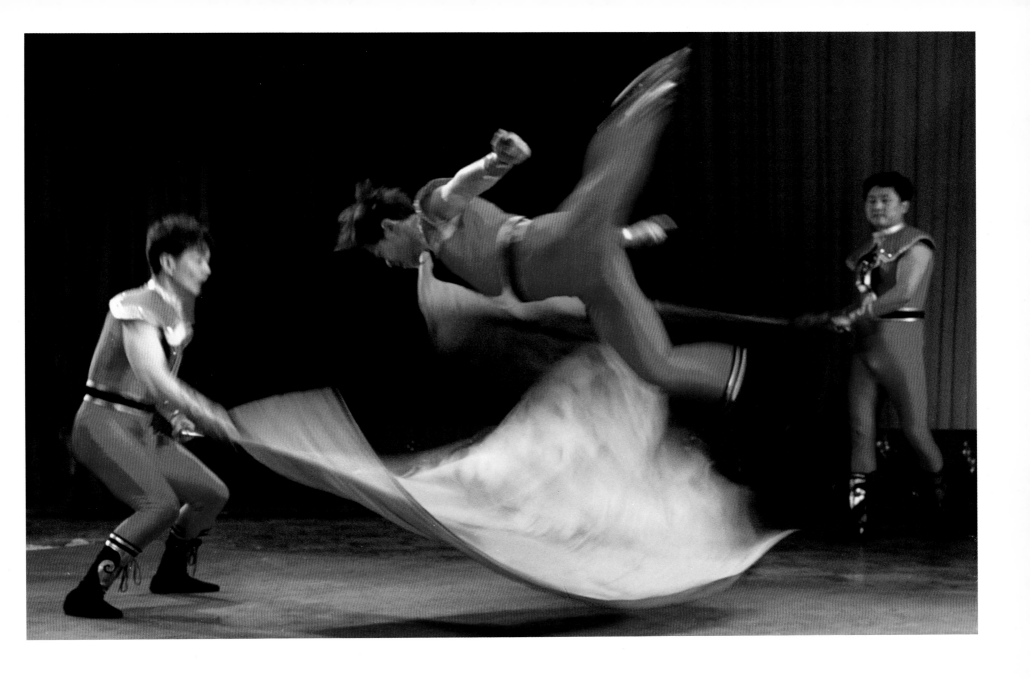

彩旗飞扬
Rising banners

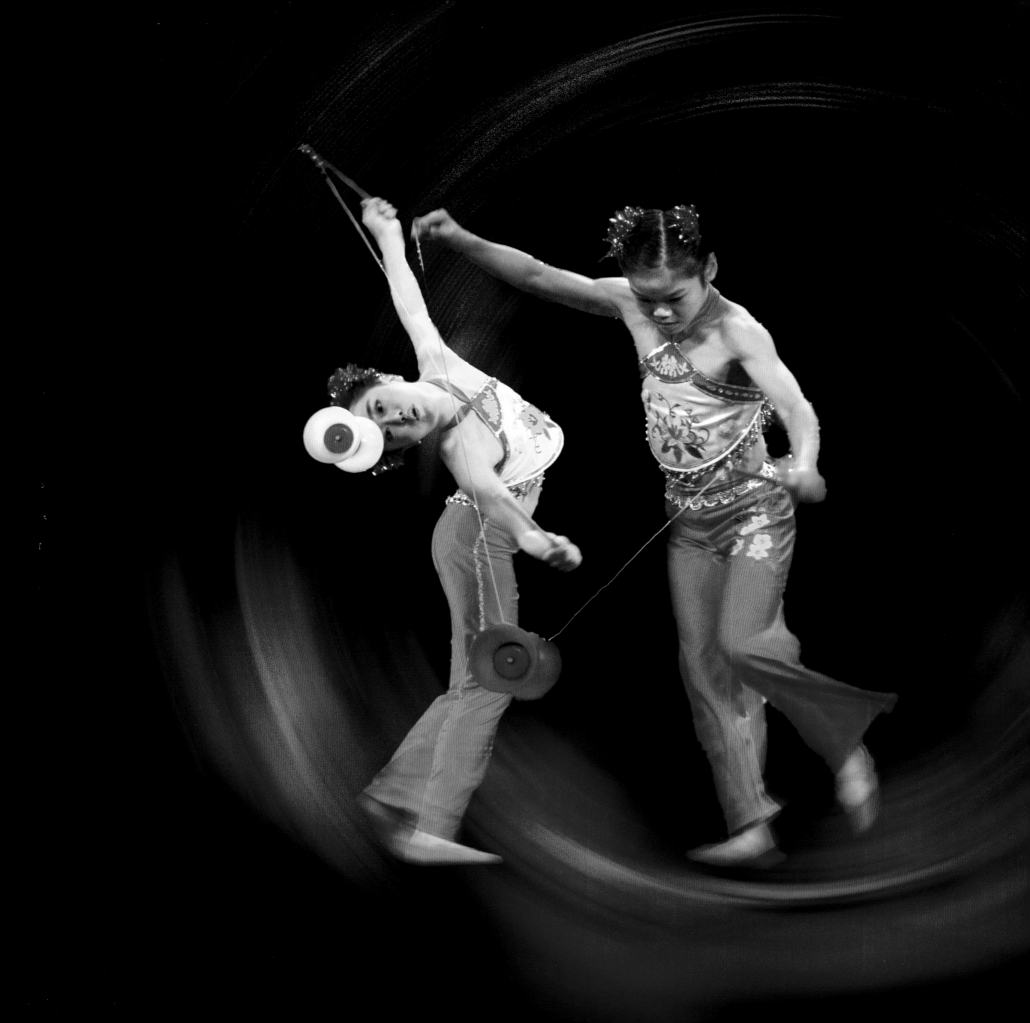

抖空竹的女孩
Girls playing diabolo

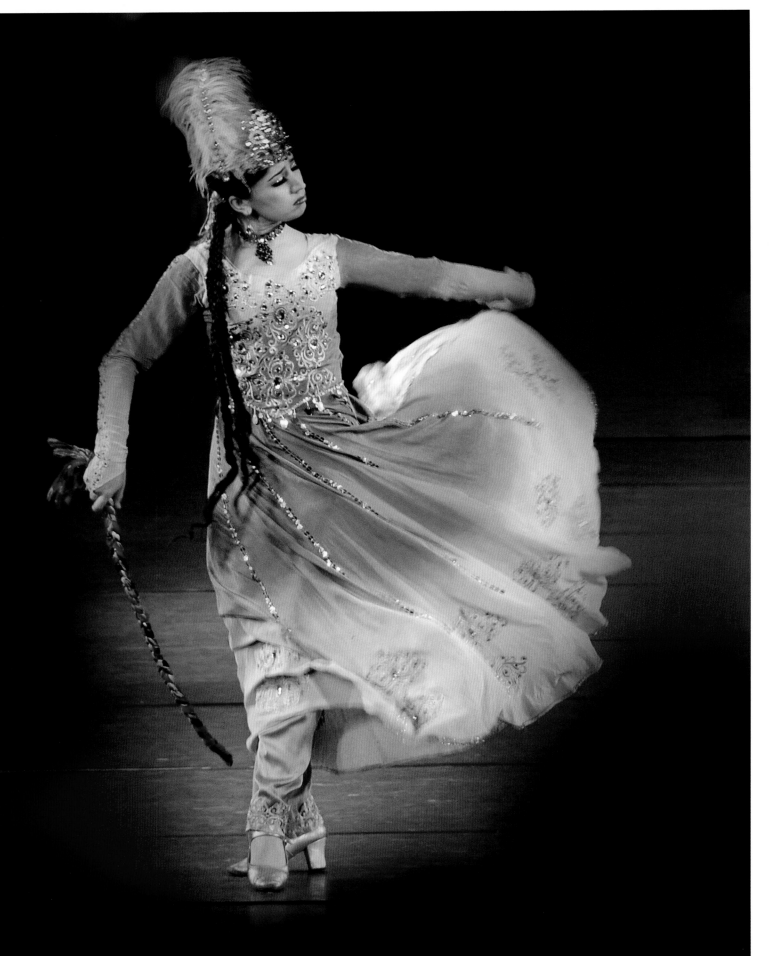

溢娇态
Lovely girl

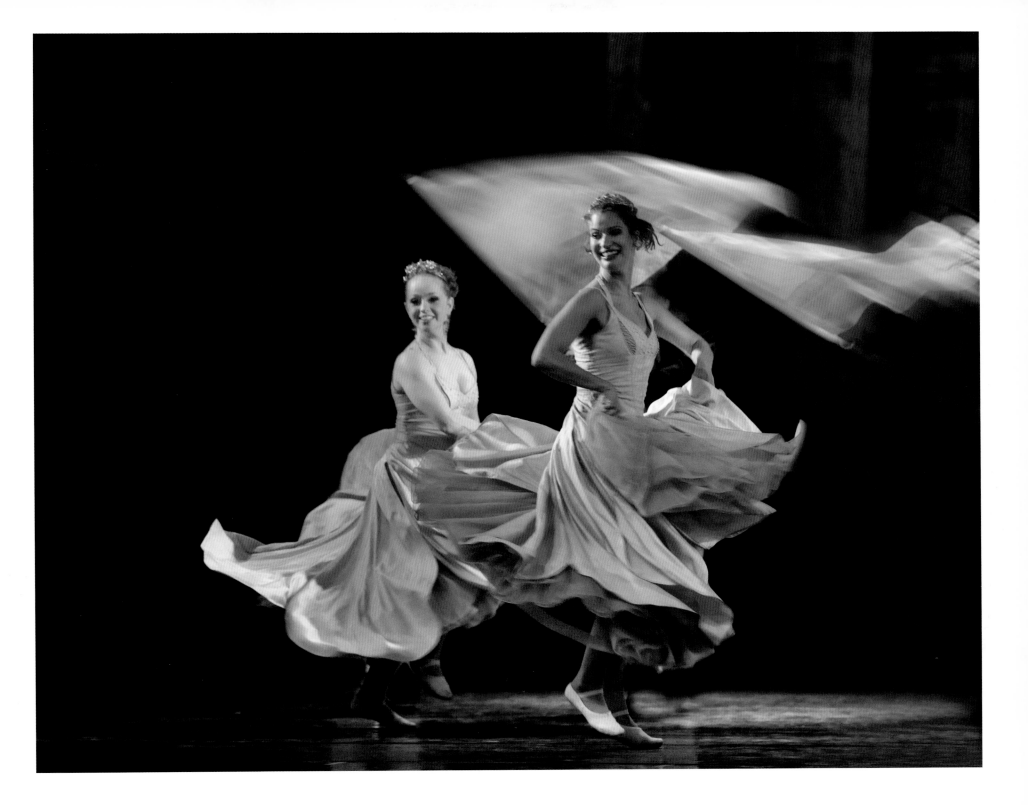

名花倾国两相欢
Pair of beauties

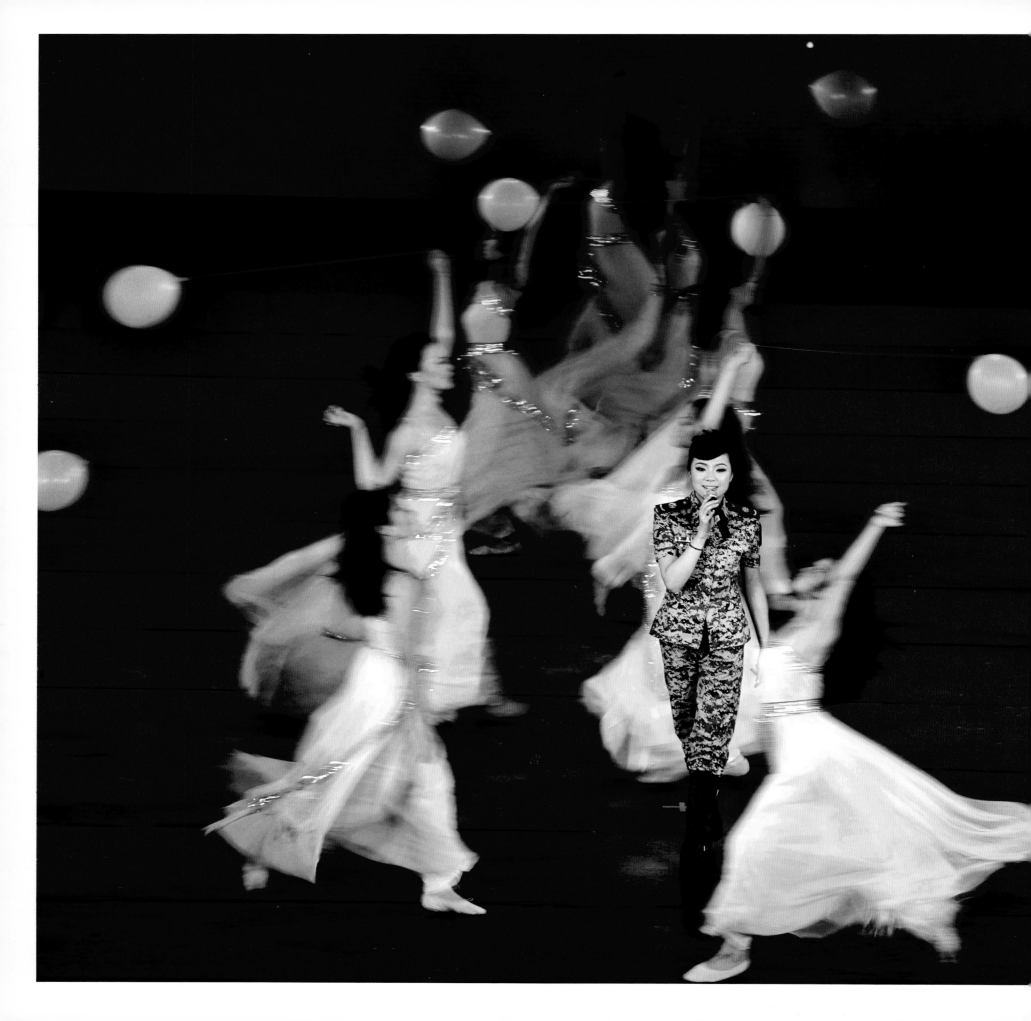

歌舞之间
Singing and dancing

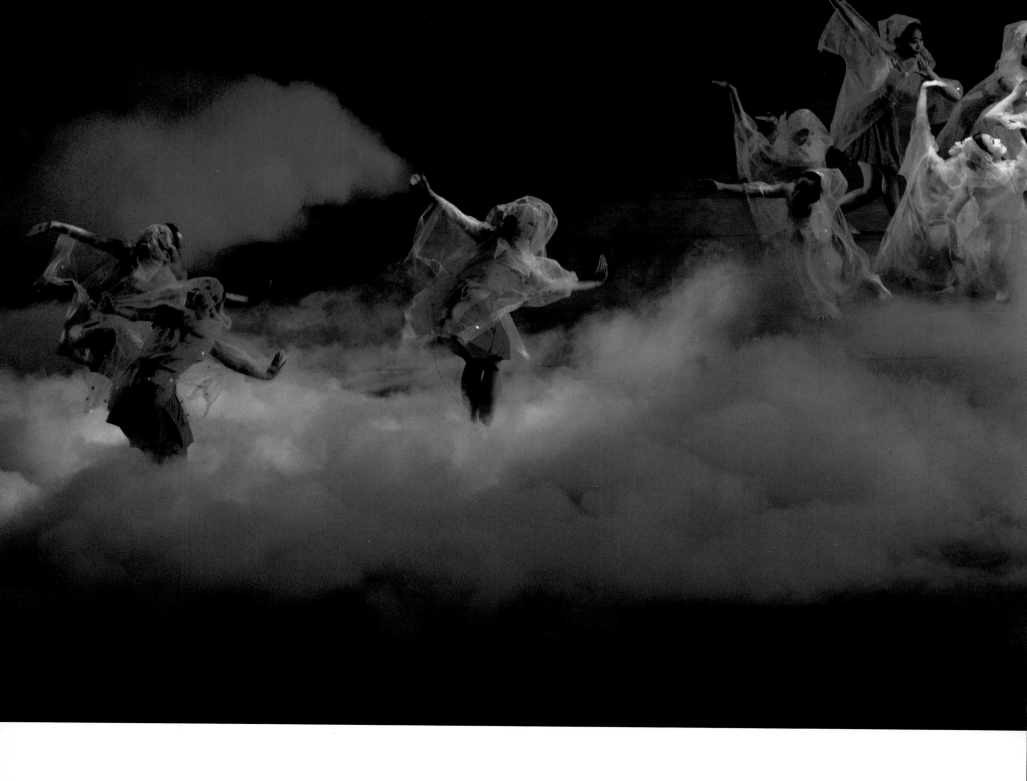

苍茫云海间
Vast clouds

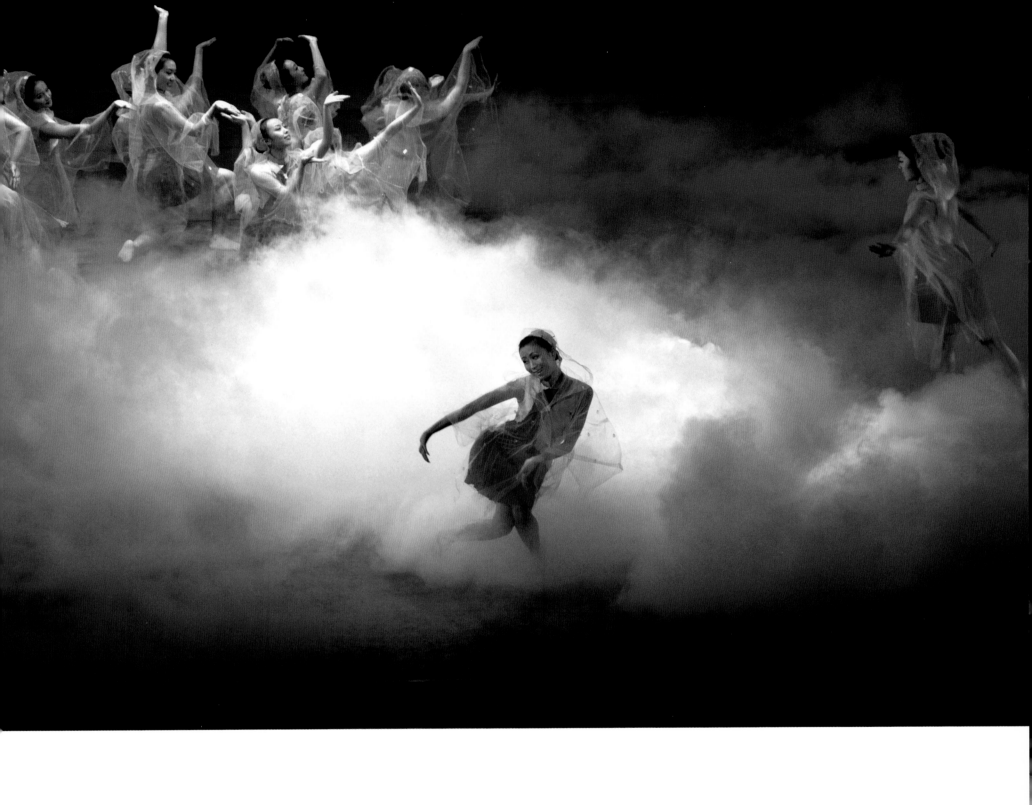

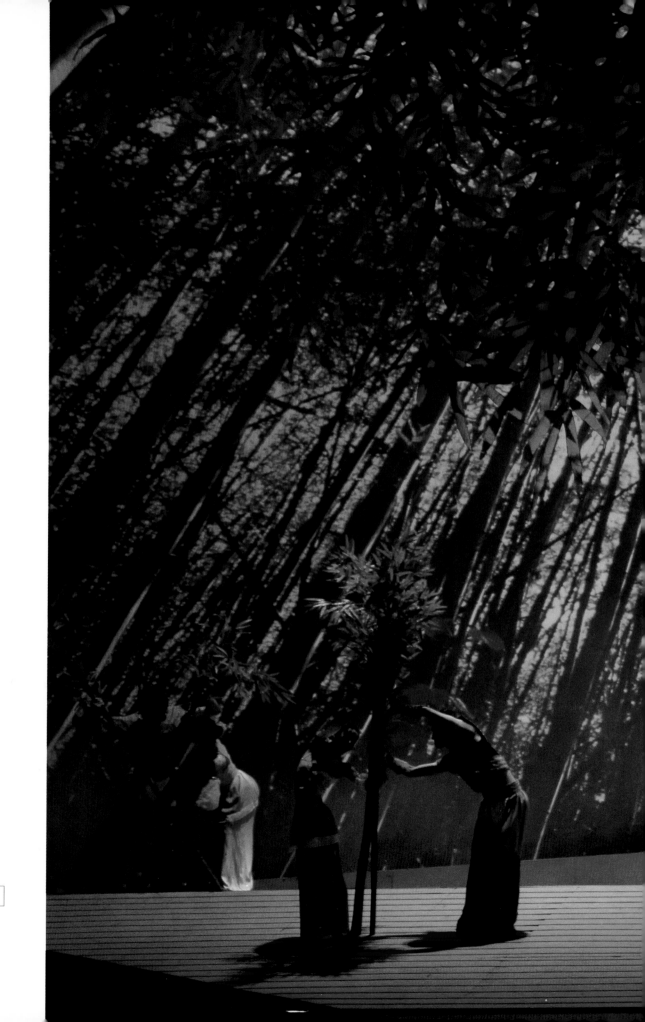

清雅脱俗
Clear and elegant

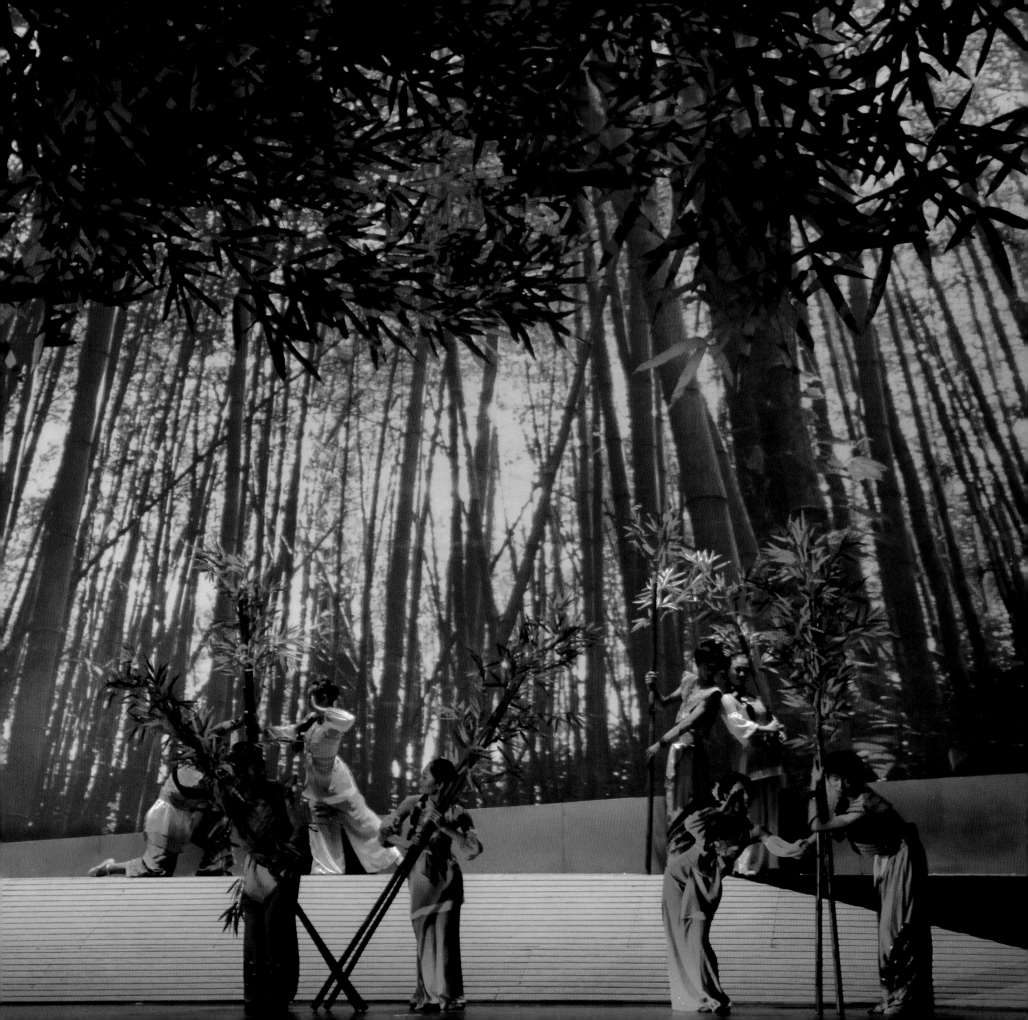

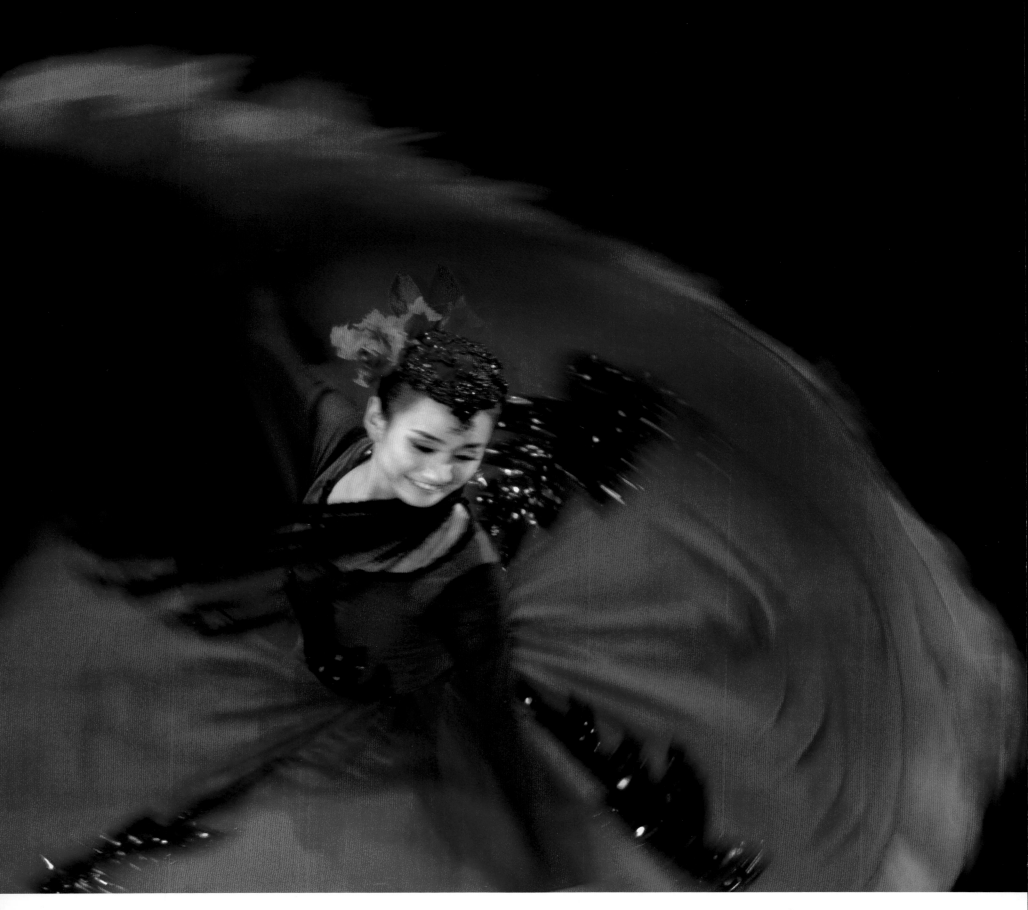

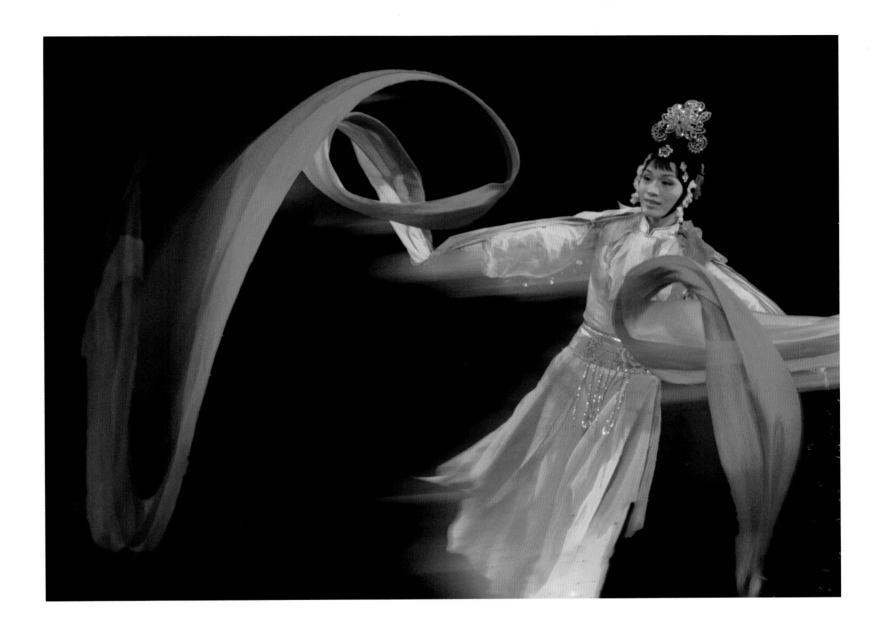

春红始谢又秋红
Mauve flowers

长袖缭绕
Wreaths of long sleeves

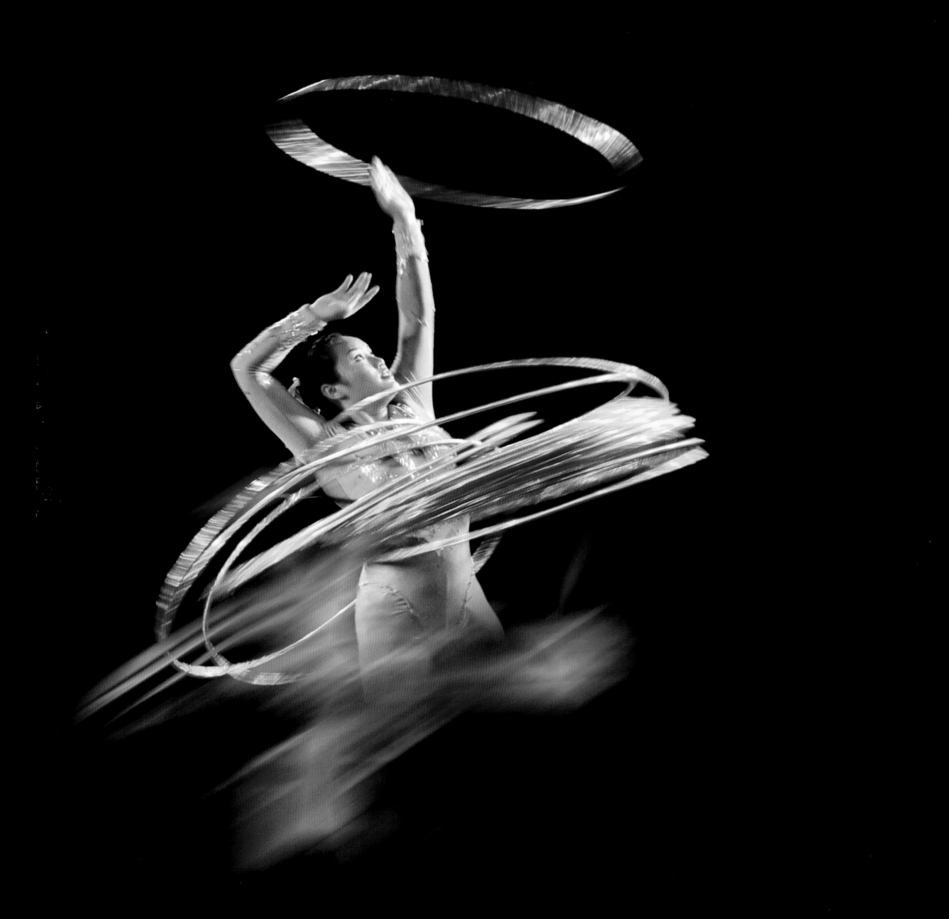

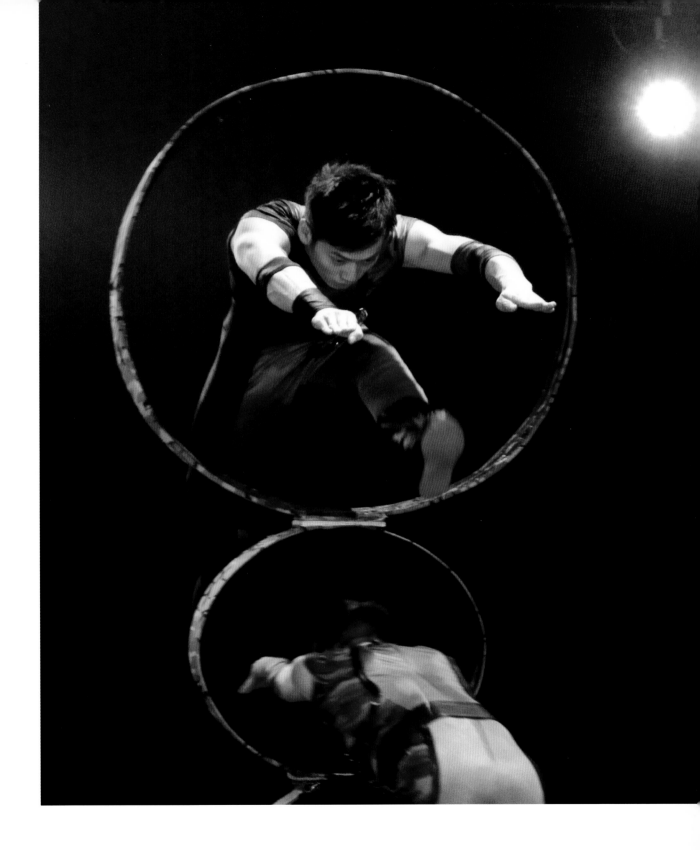

呼啦圈
Hula hoops

穿圈
Jumping through hoops

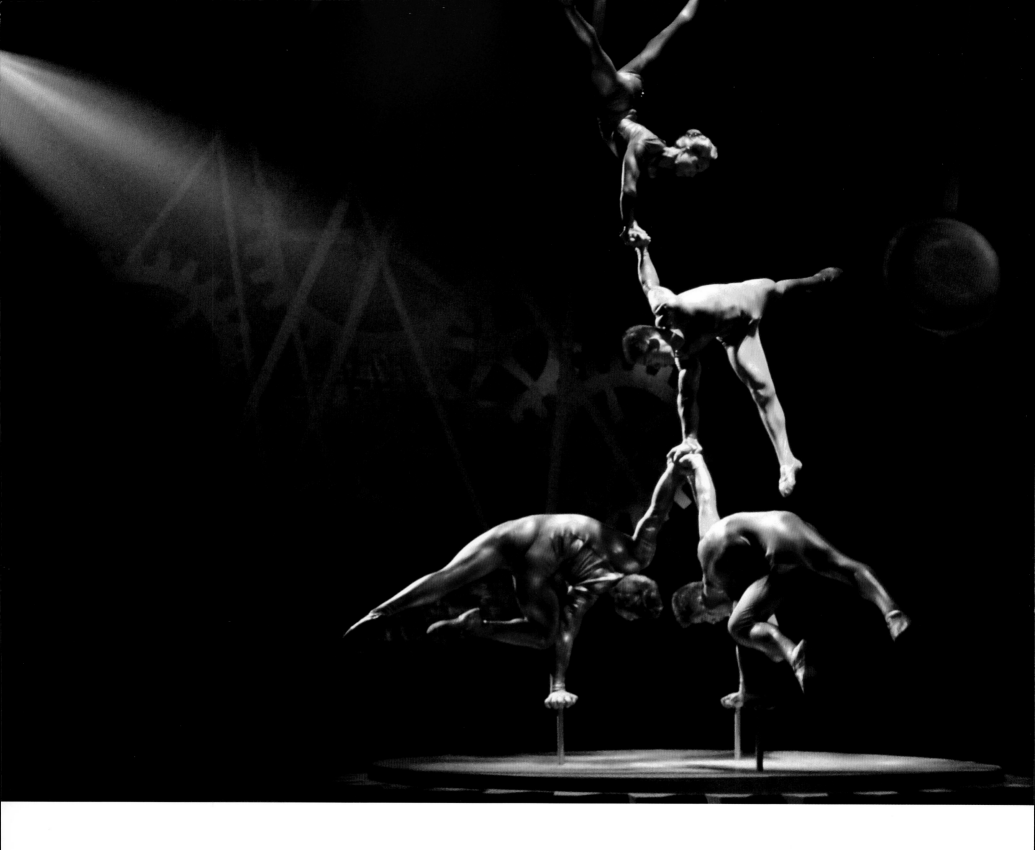

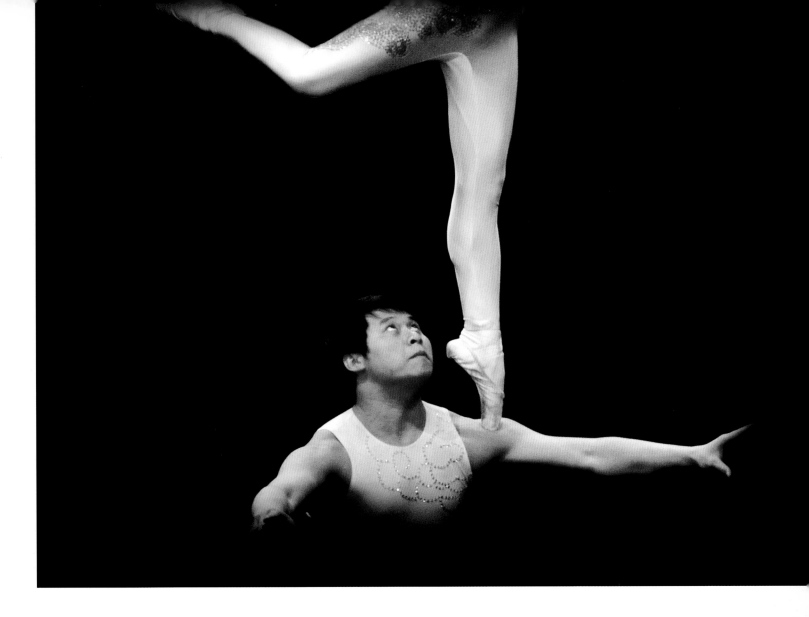

肩上芭蕾
Ballet on shoulders

纤足轻点衣袂飘

Ballet

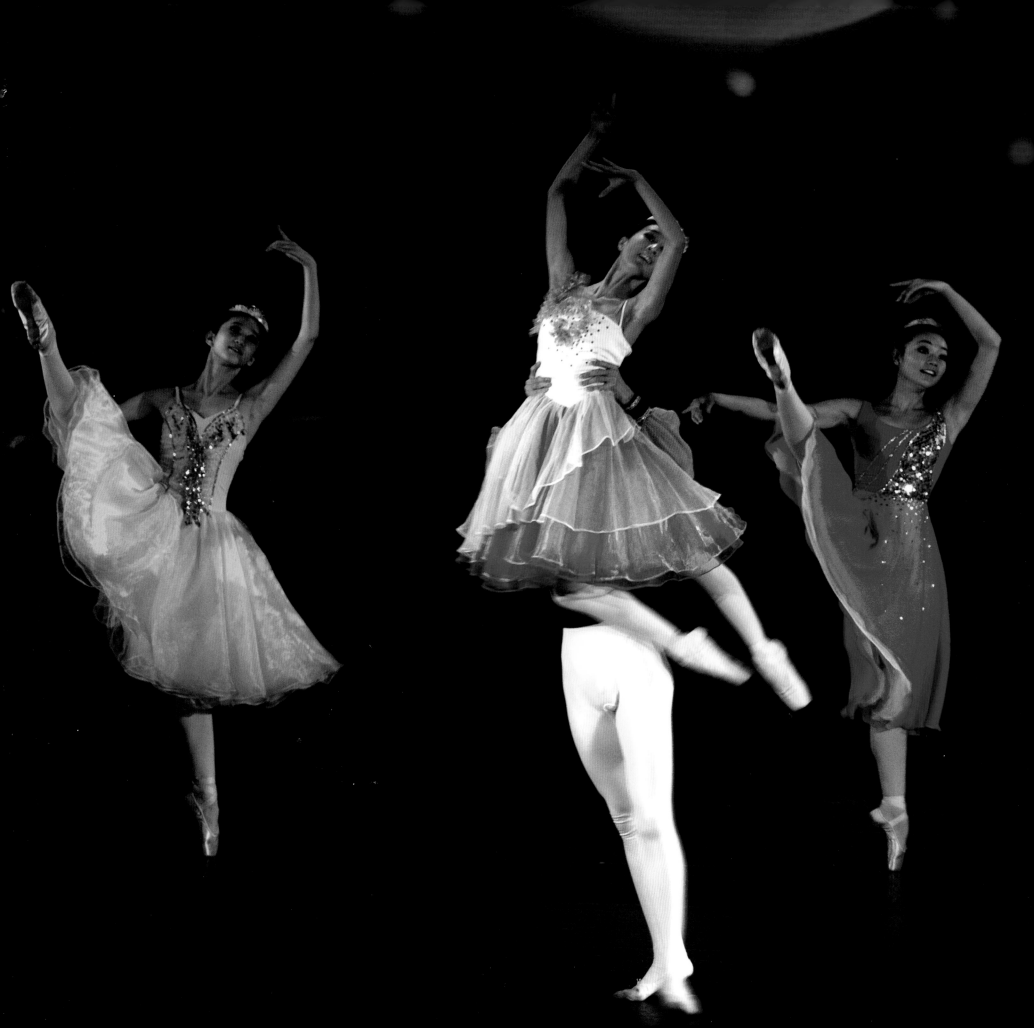

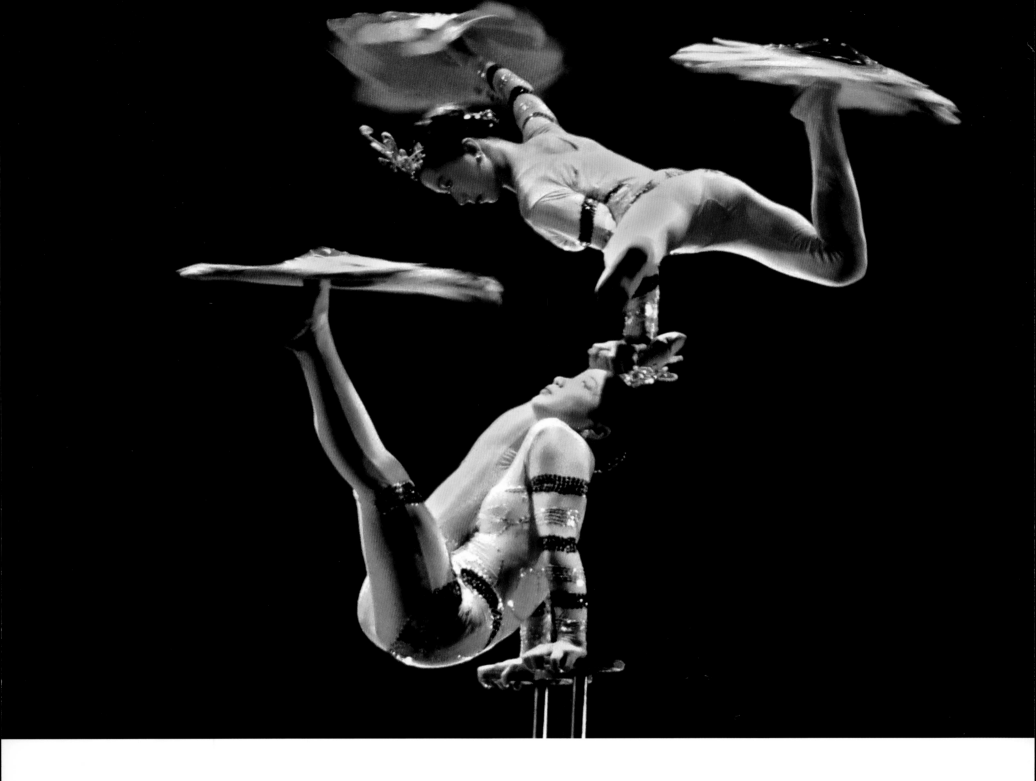

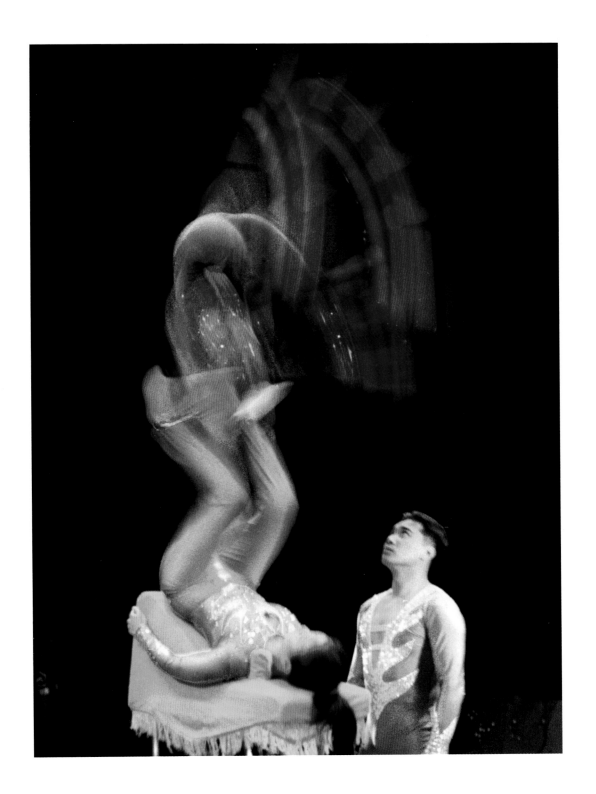

杂技—蹬人
Acrobatics

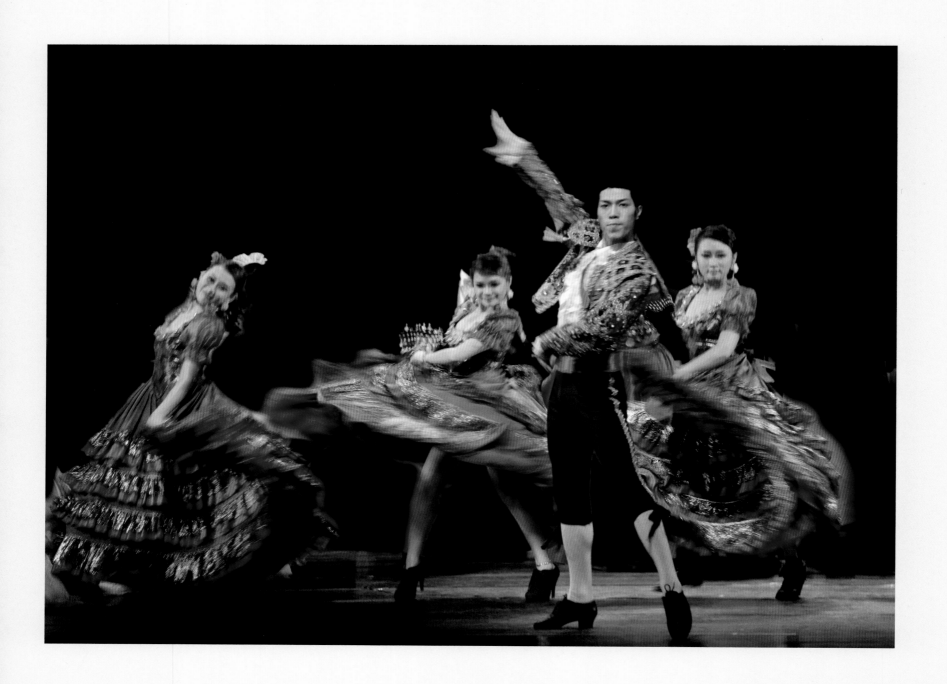

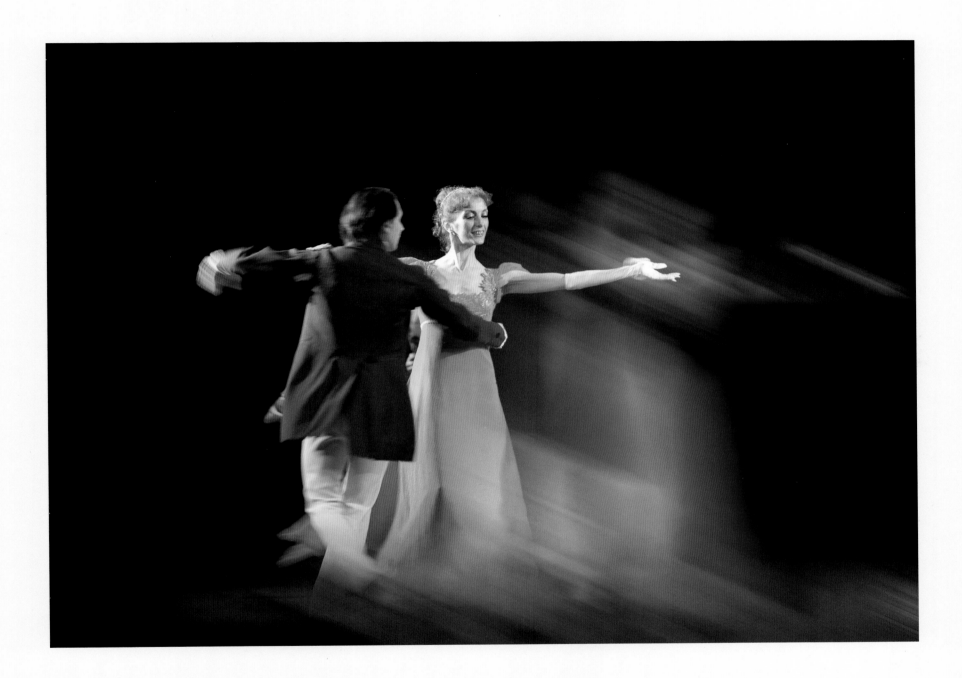

起舞翩翩
Elegant dance

业余生活

After work

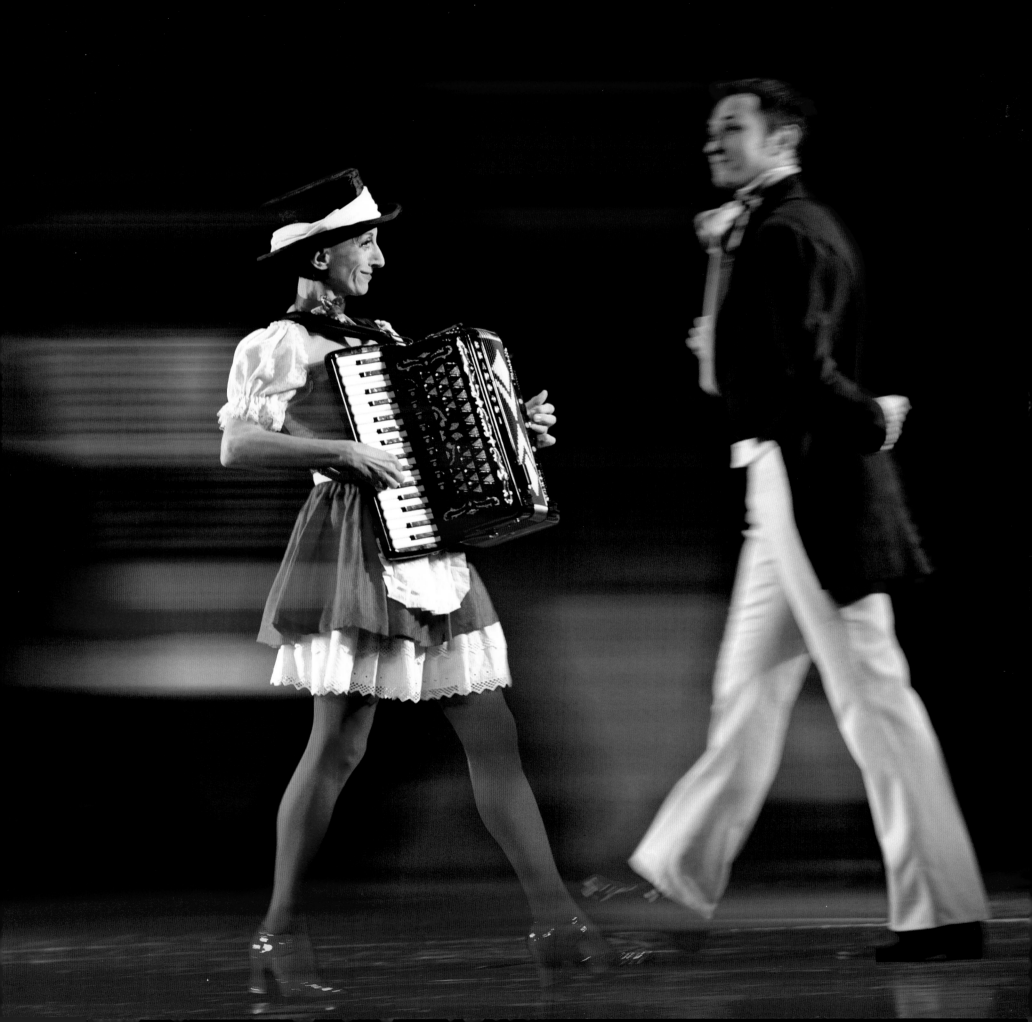

Ethereal
Colors

灵动的彩绘
Wei Xinping Stage Photography Art

Love

一路走来，

变的是镜头前的风景，

不变的是镜头后的那颗心；

那幕幕拼图描绘的全景，

叫"爱"！

In the journey of life,

the scenery keeps changing

yet my heart always remains

the same.

All of the pictures

form a mosaic of love.

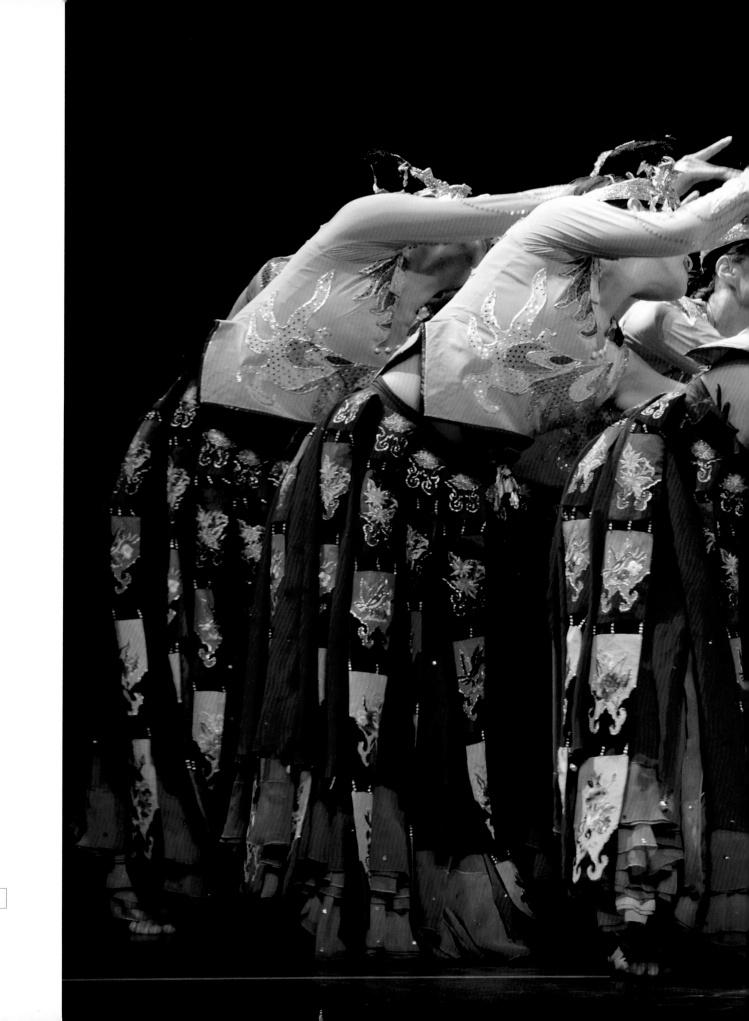

拾娇蕊
Picking flowers

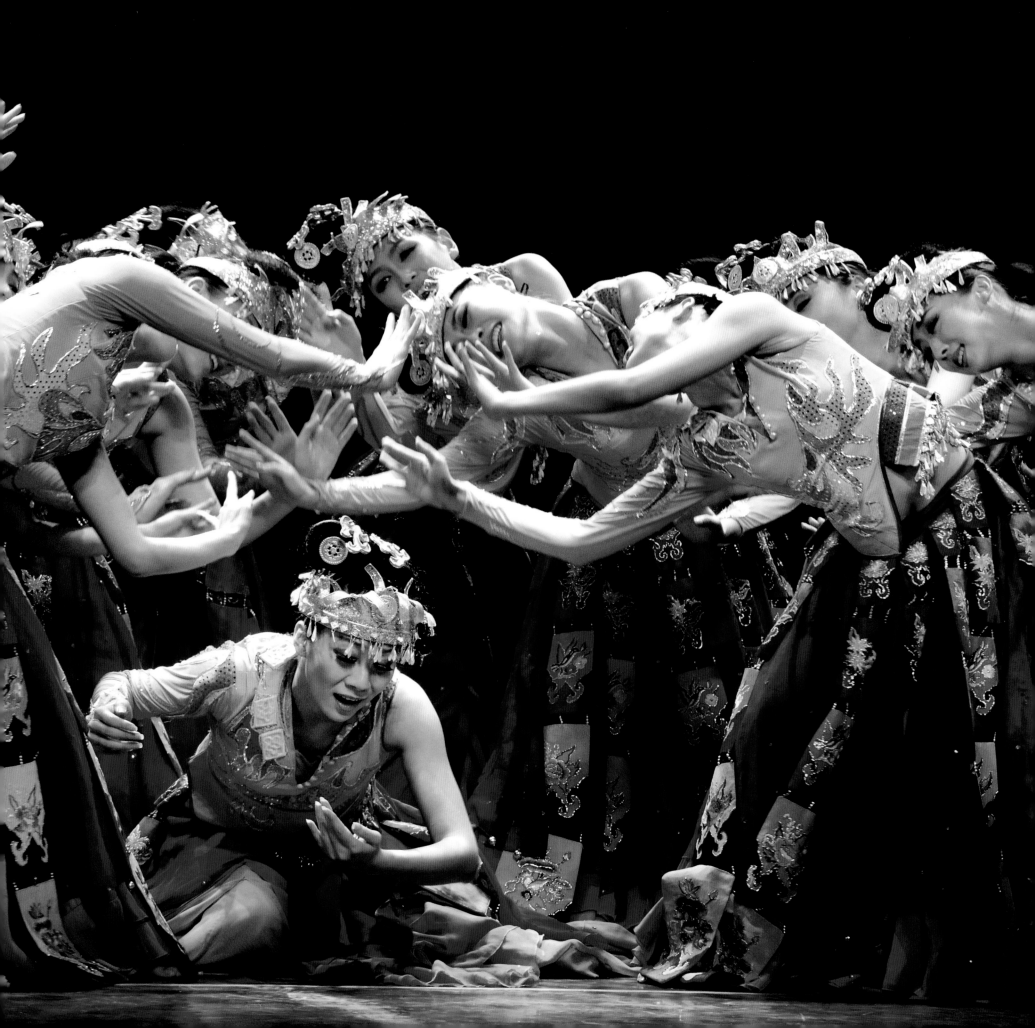

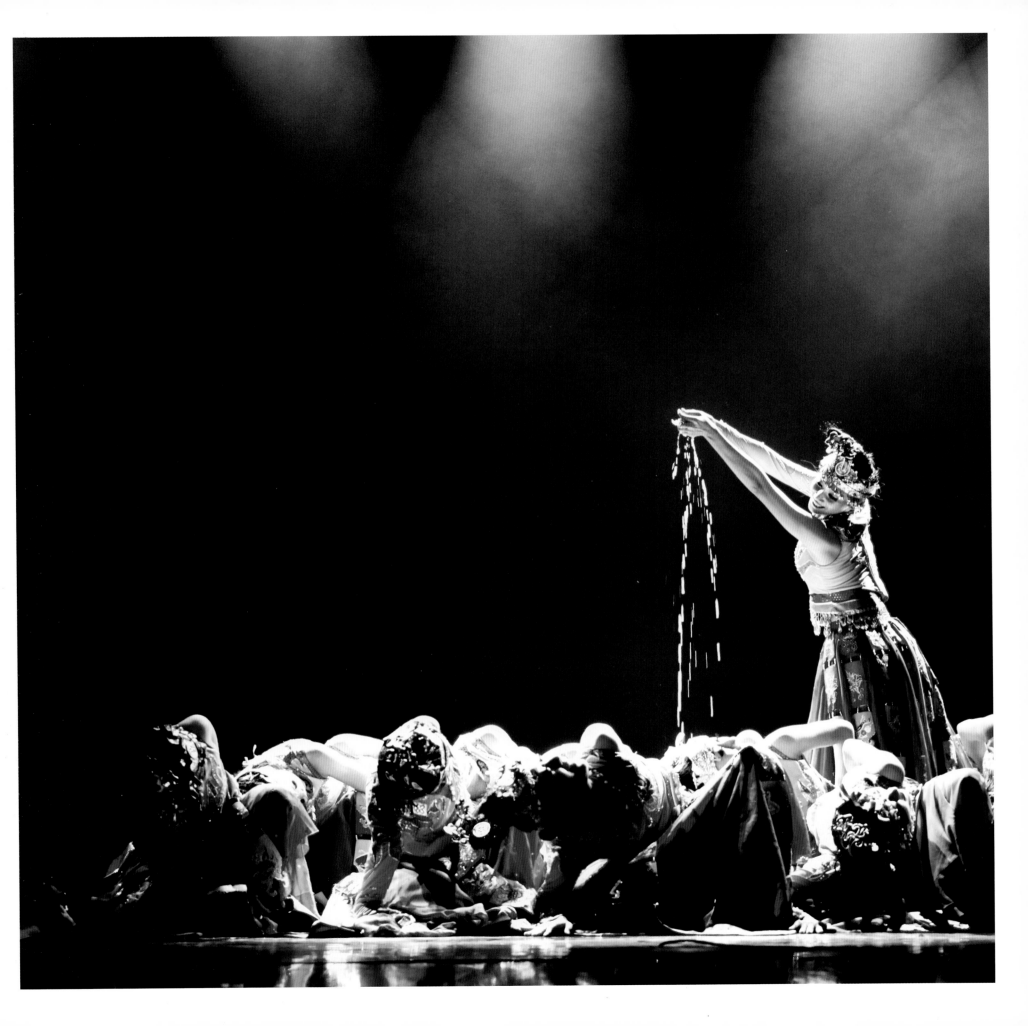

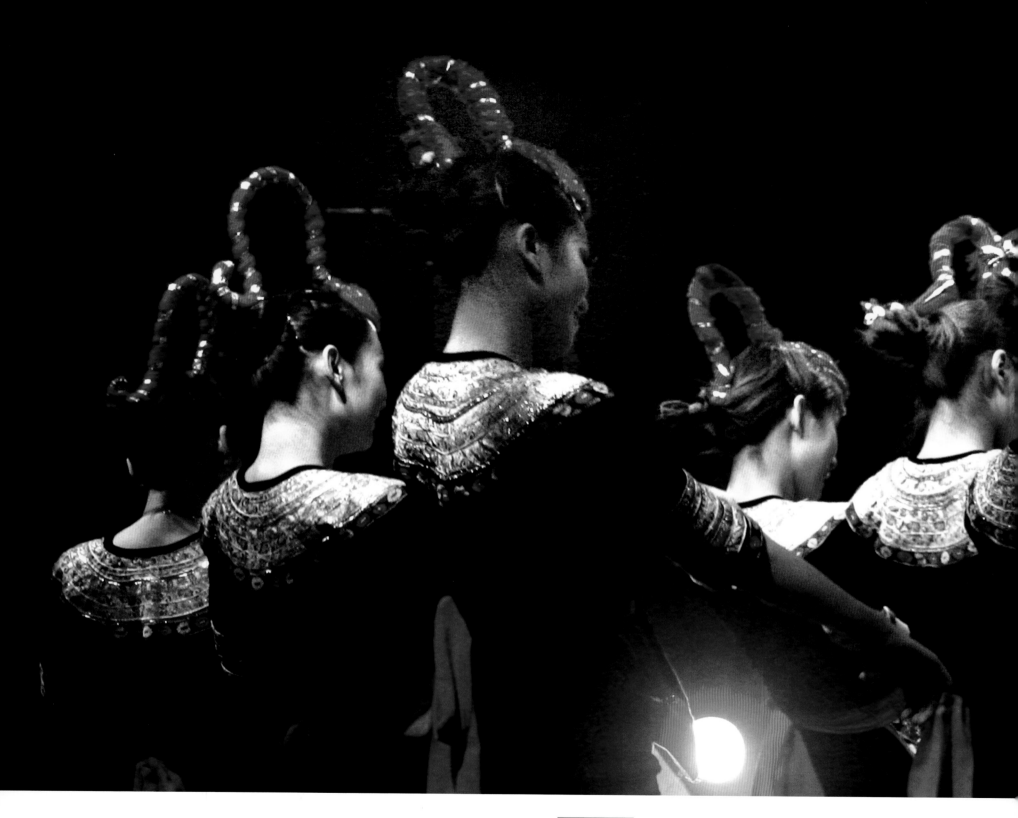

秘态随羞脸
Shy minority girls

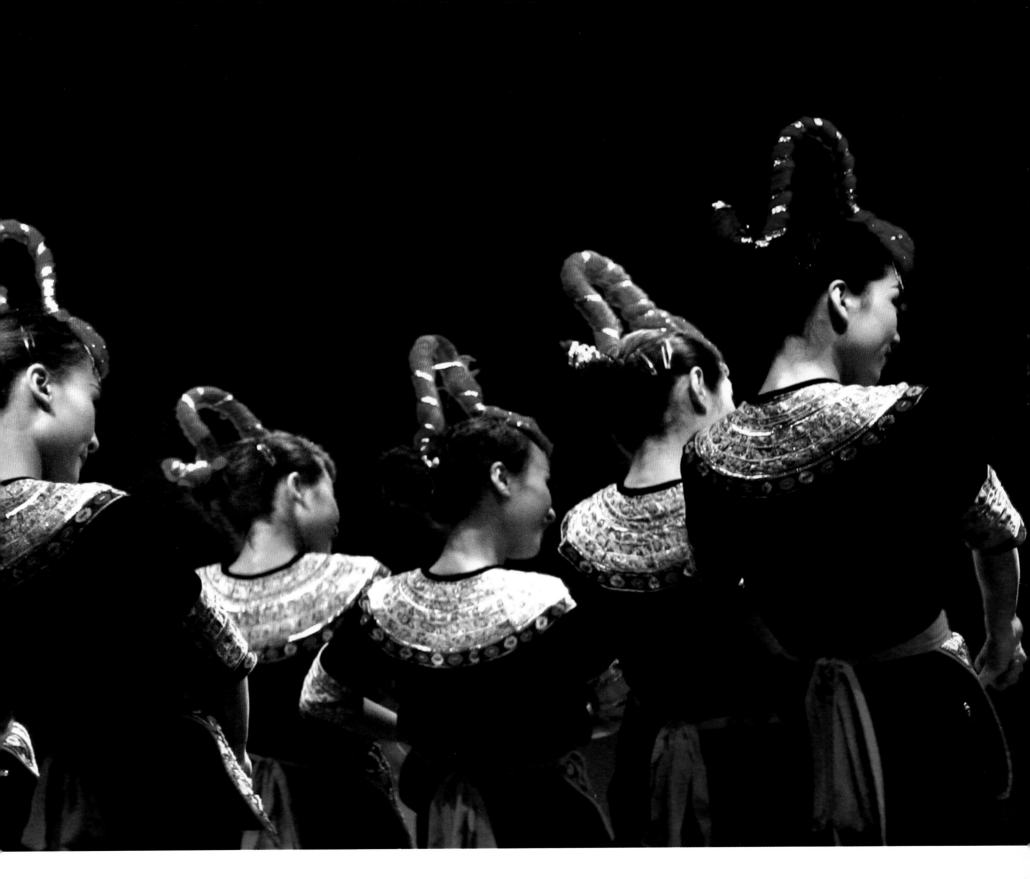

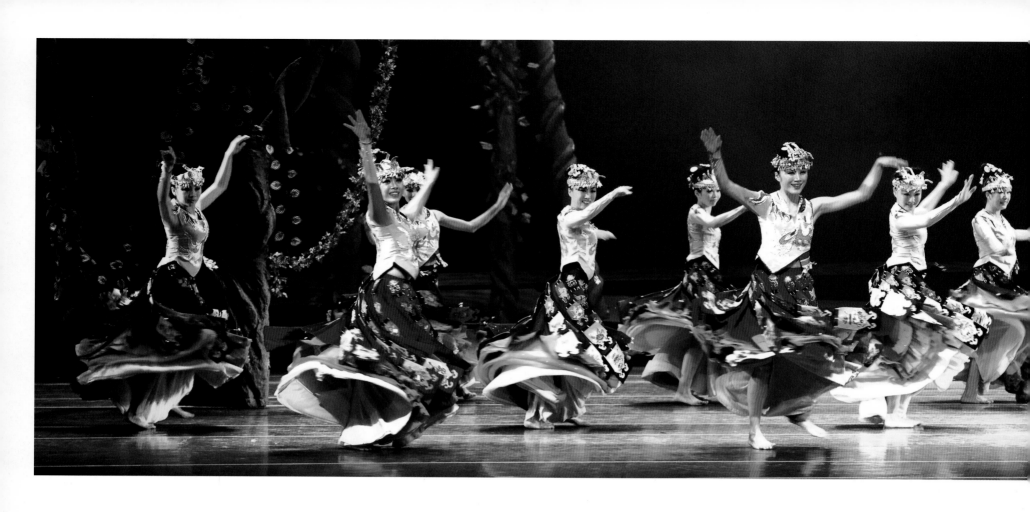

下有渌水之波澜
Green waves

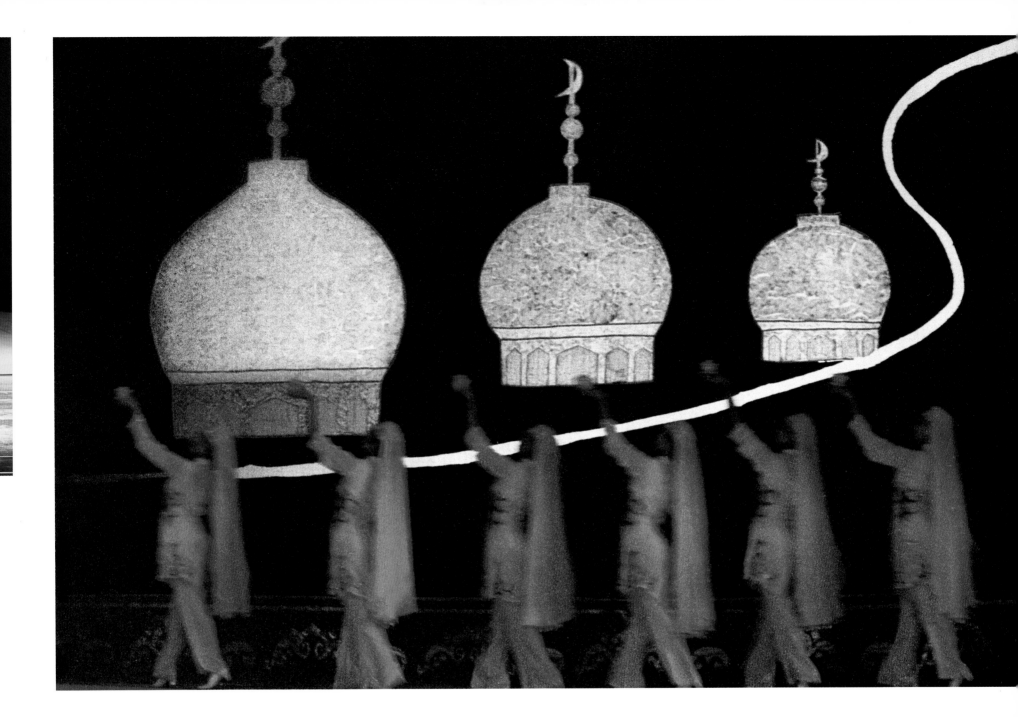

星汉梦归女
Dreaming of going home in starlight

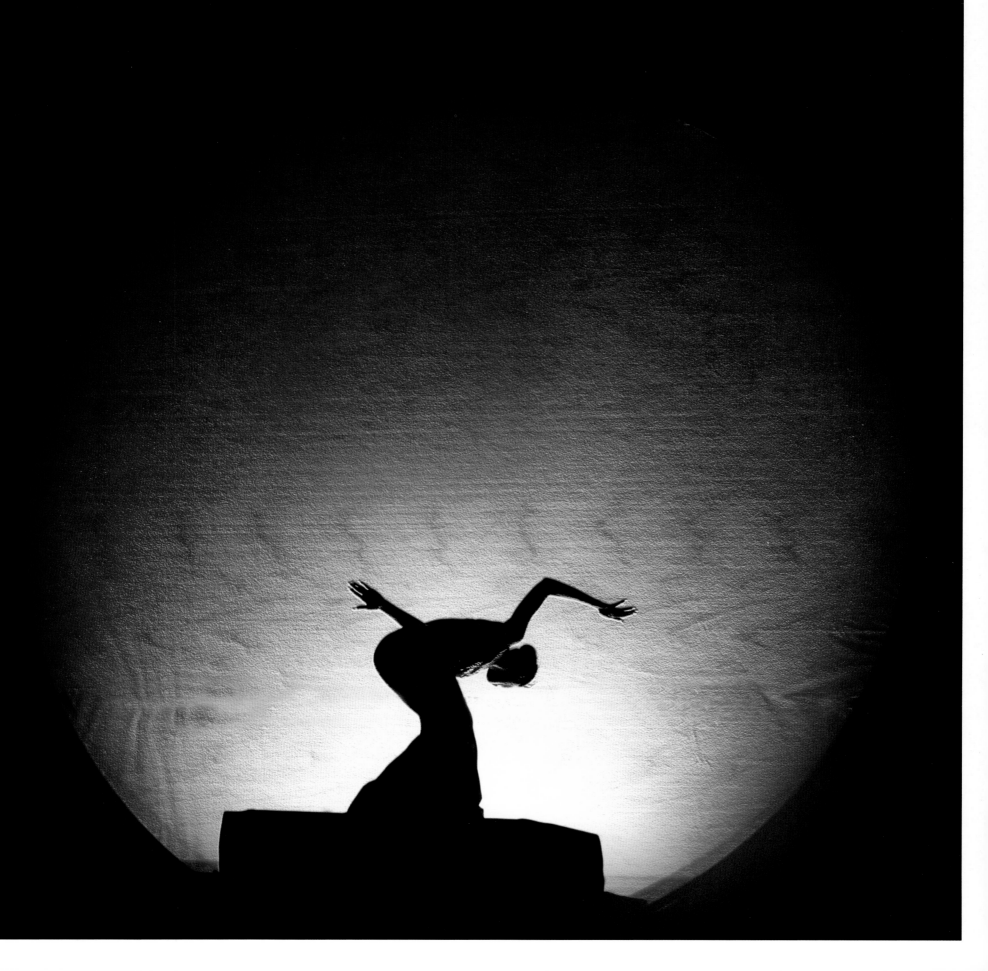

低头思故乡

Homesick in the moonlight

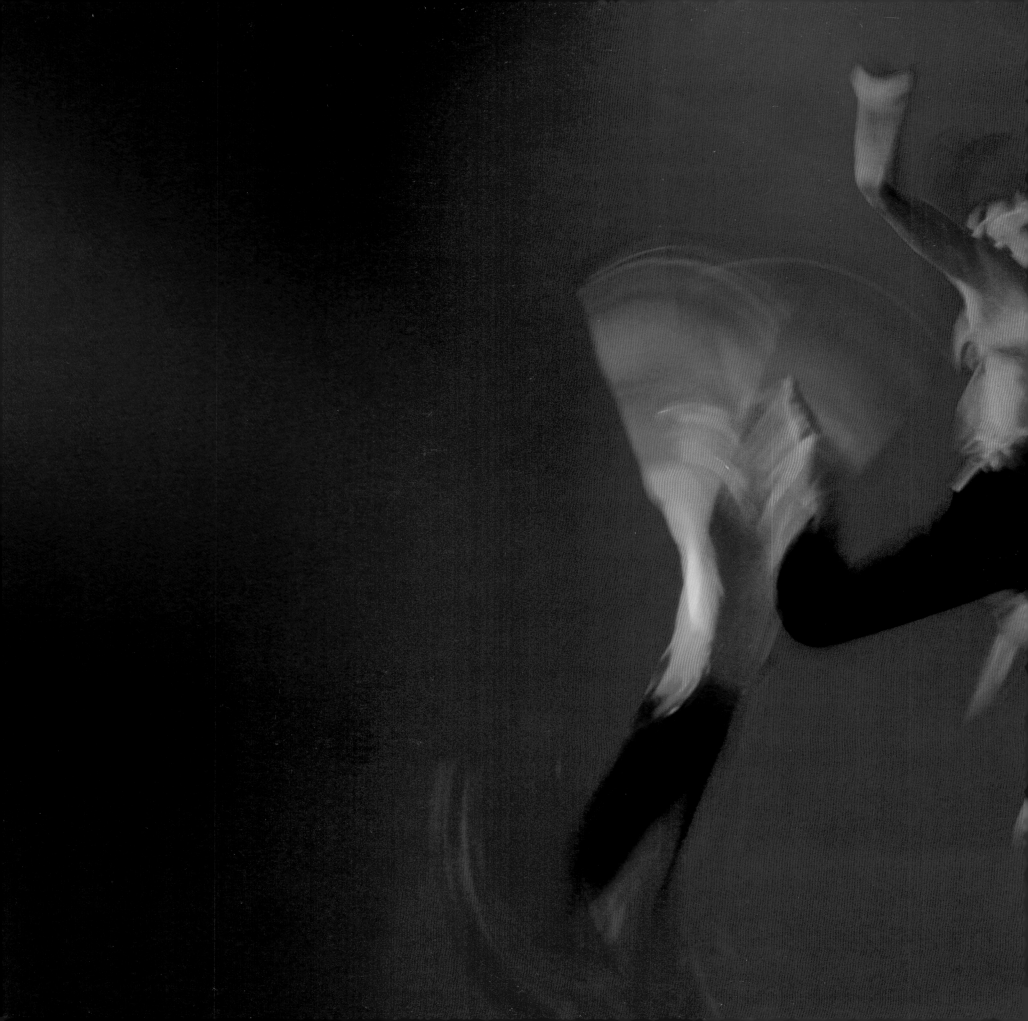

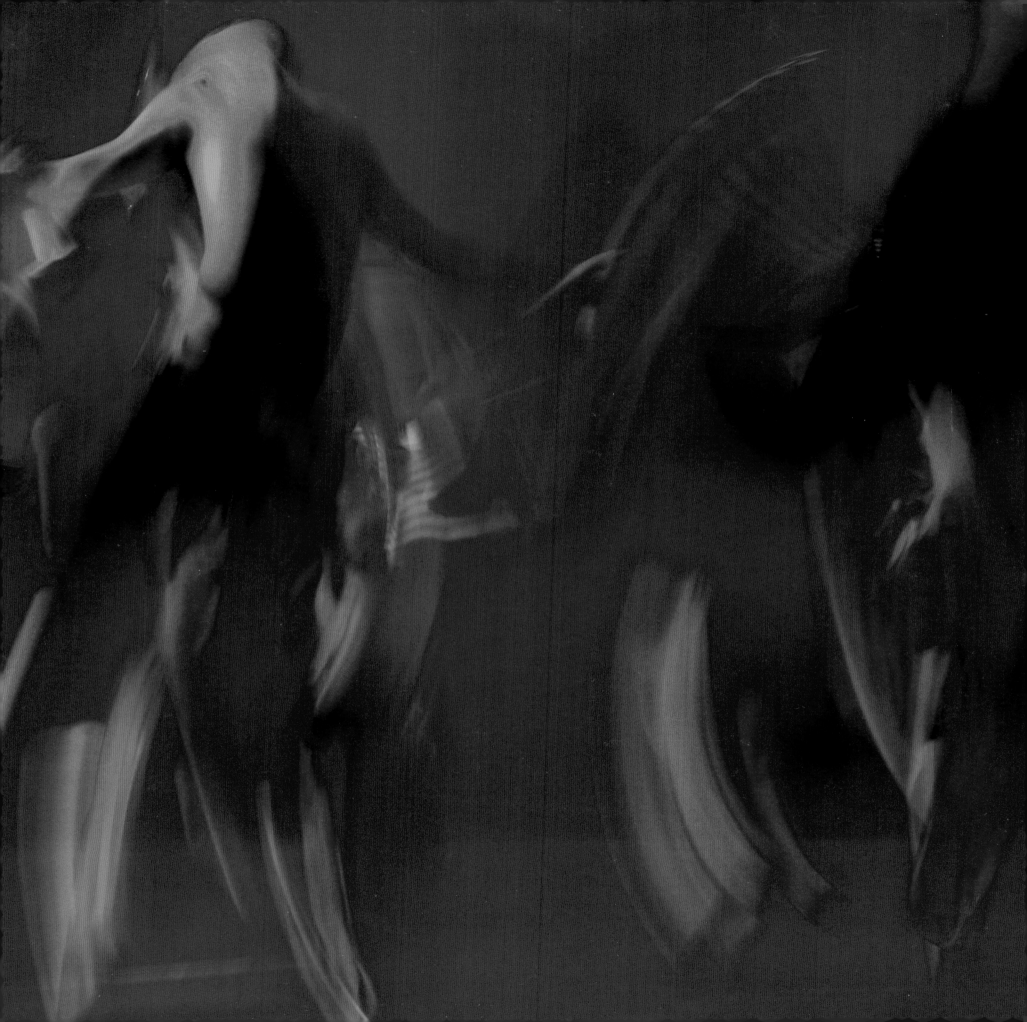

倾城浪花
Spray

凝眸似水心似火
Passion burning up

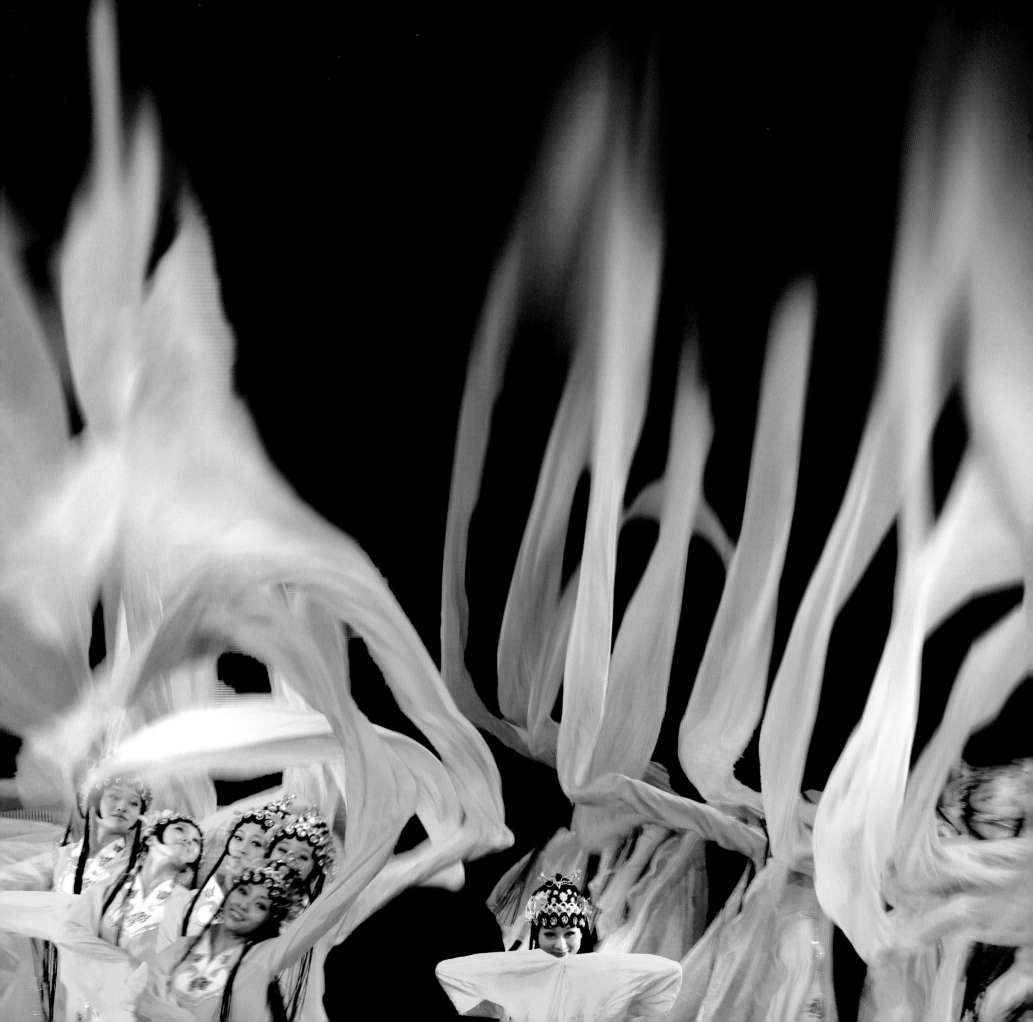

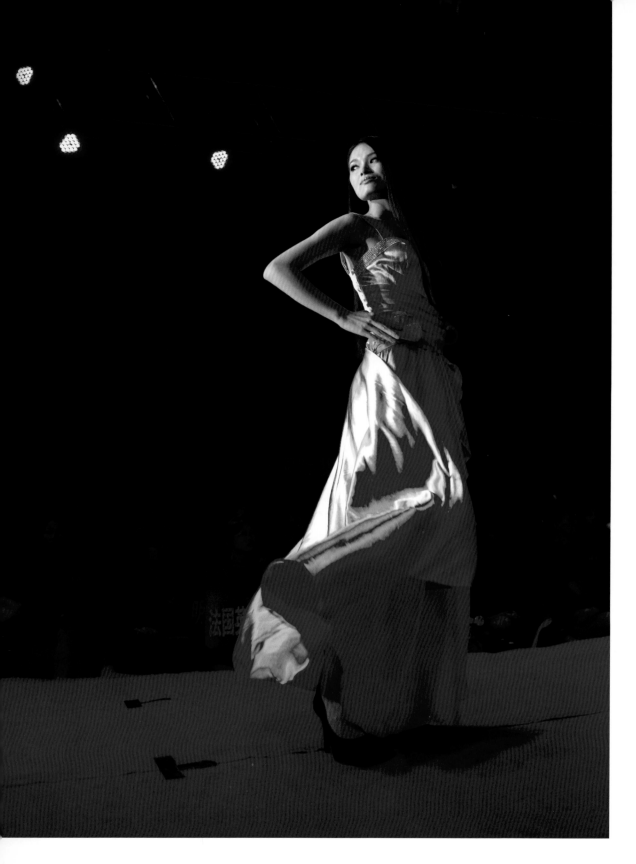

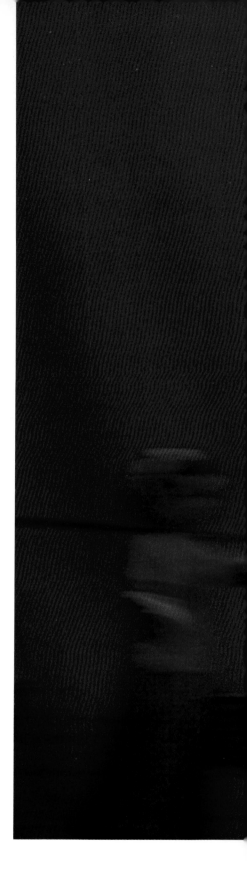

回 眸
Looking back

来去匆匆
Rushing back and forth

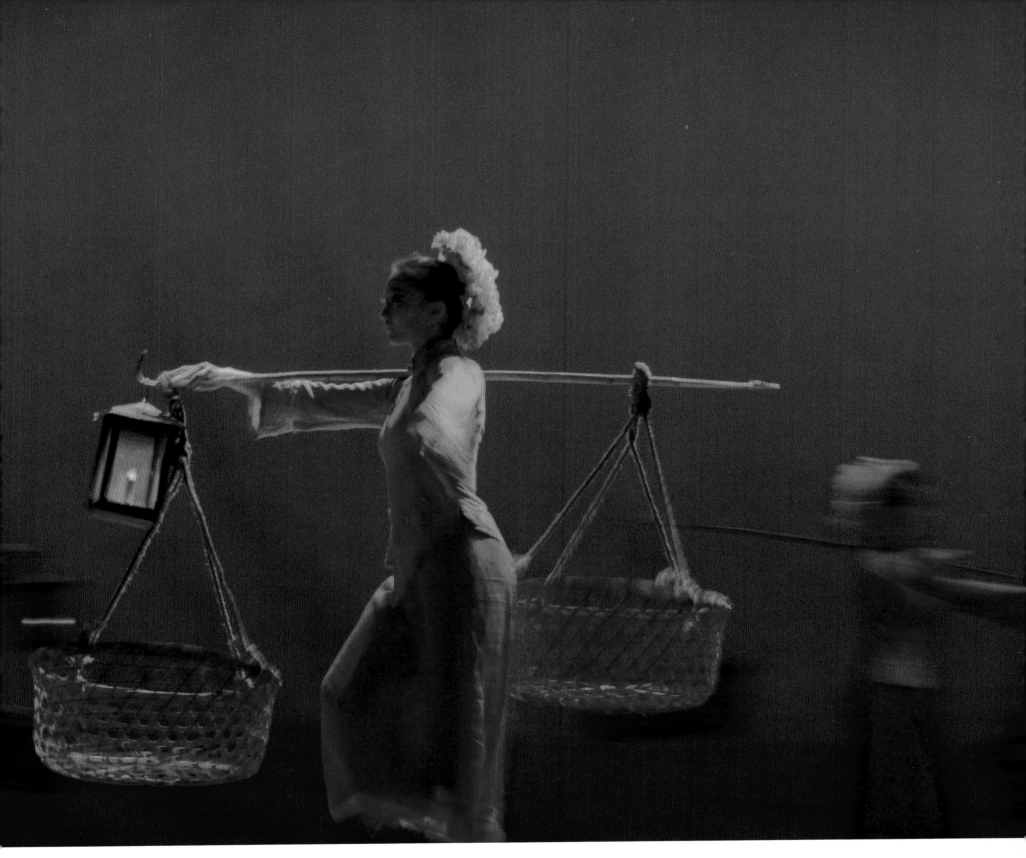

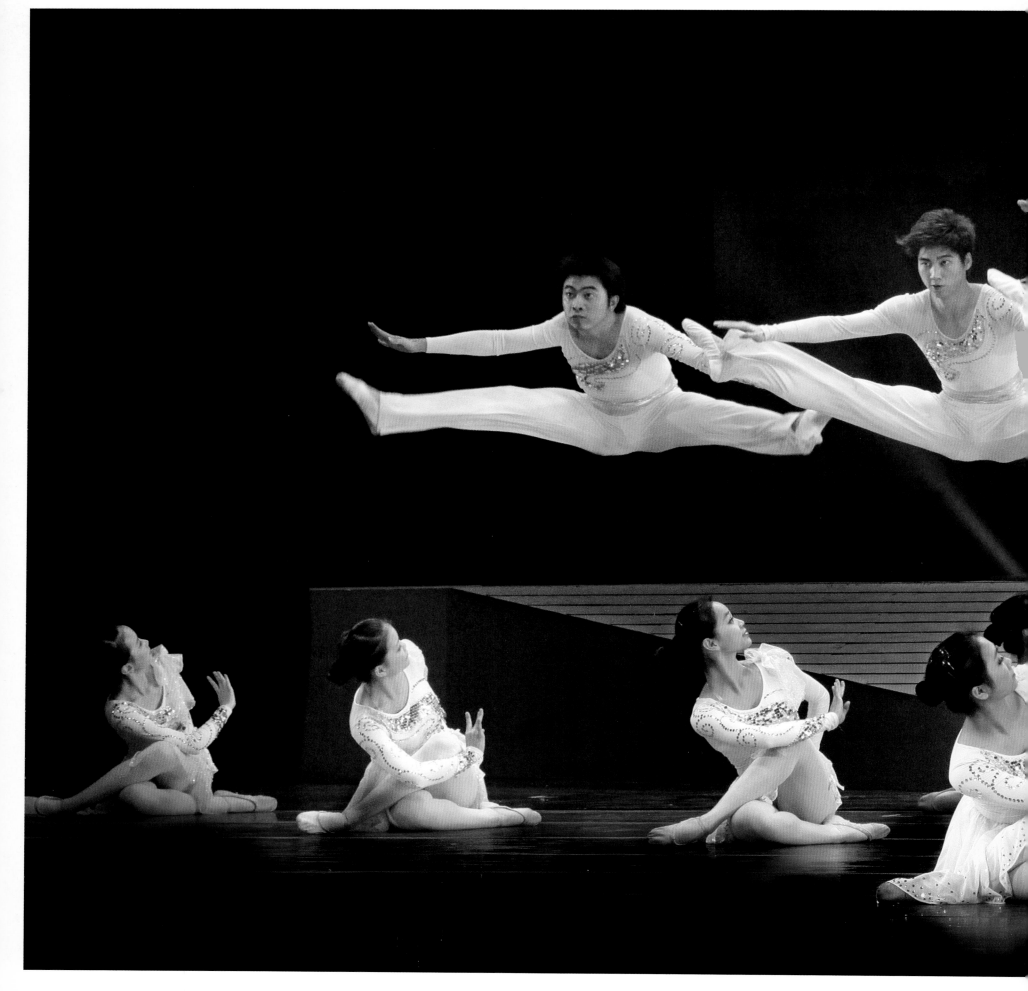

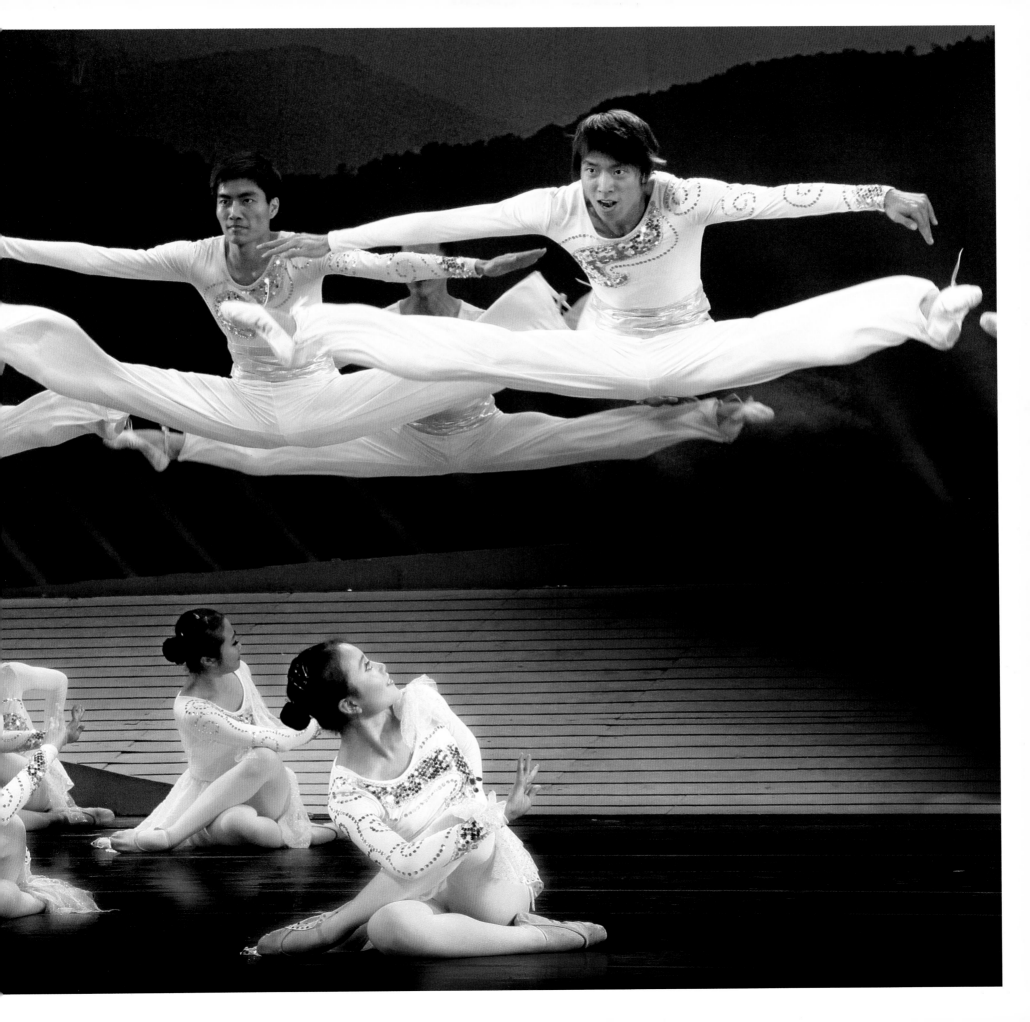

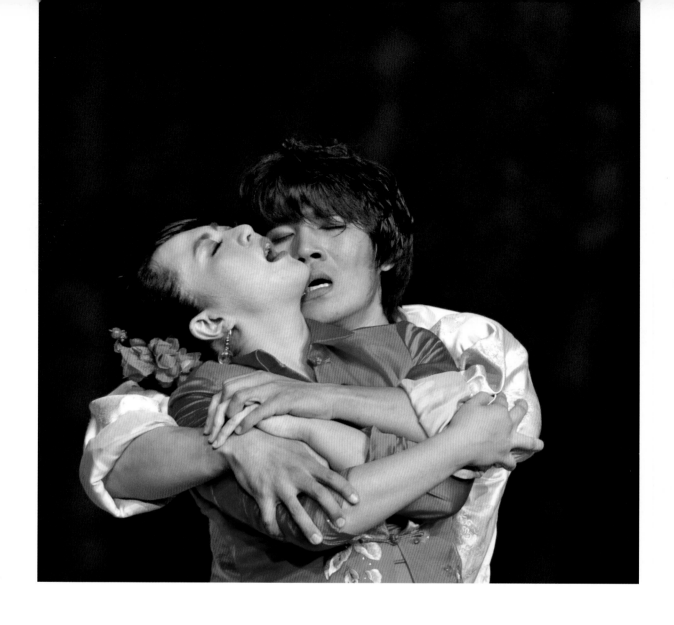

仰 望
Looking up

对 唱
Musical dialogue

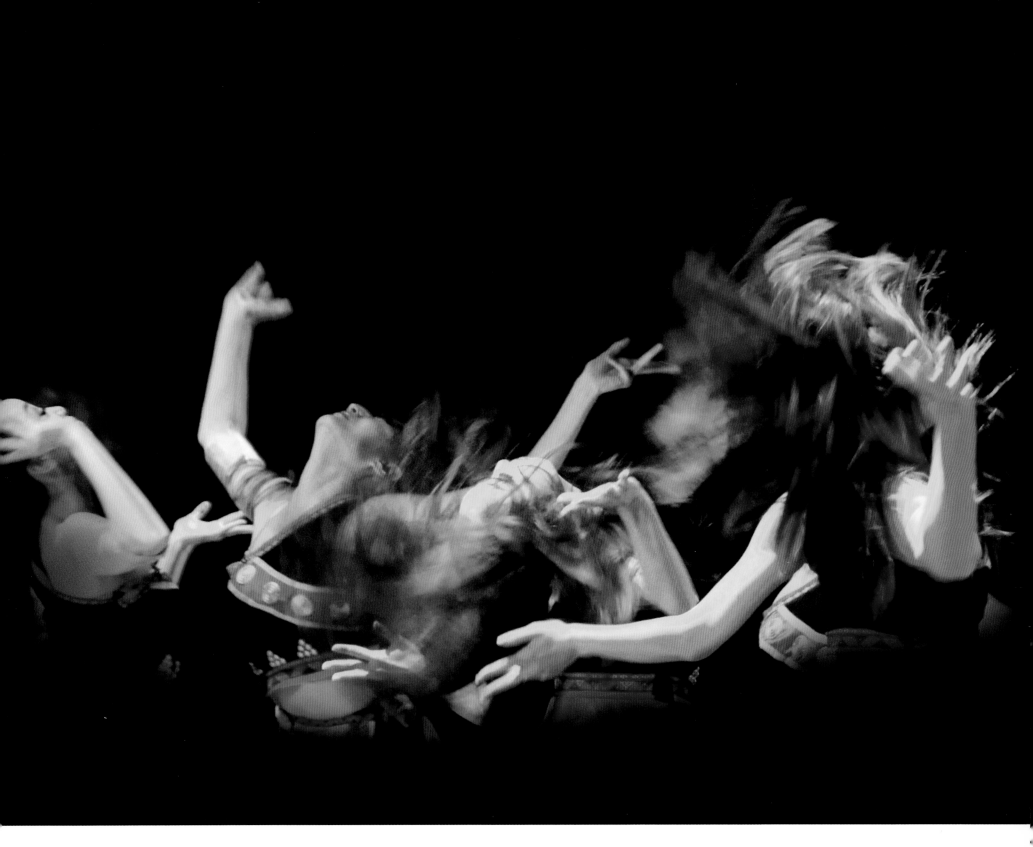

痴 狂
Craziness

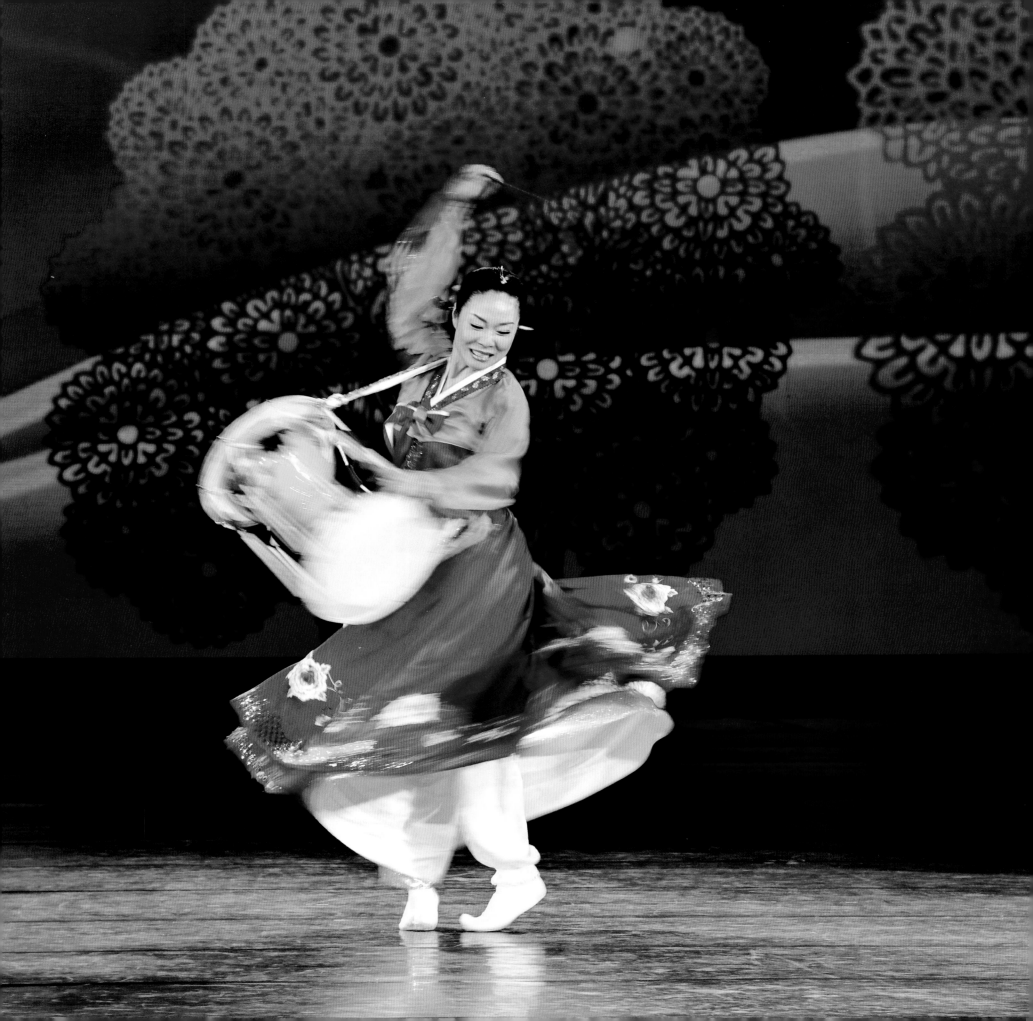

腰鼓旋音

Waving to and fro

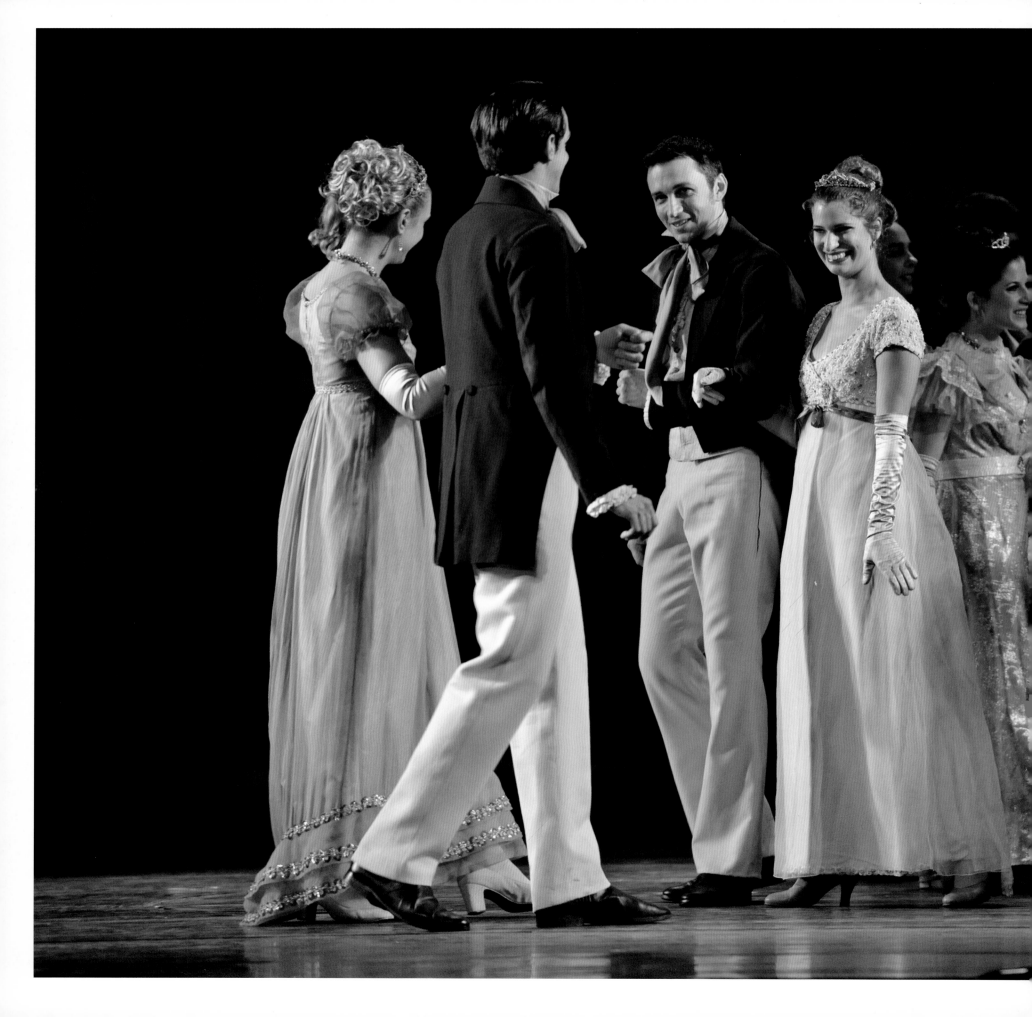

邻里之间
Neighbors

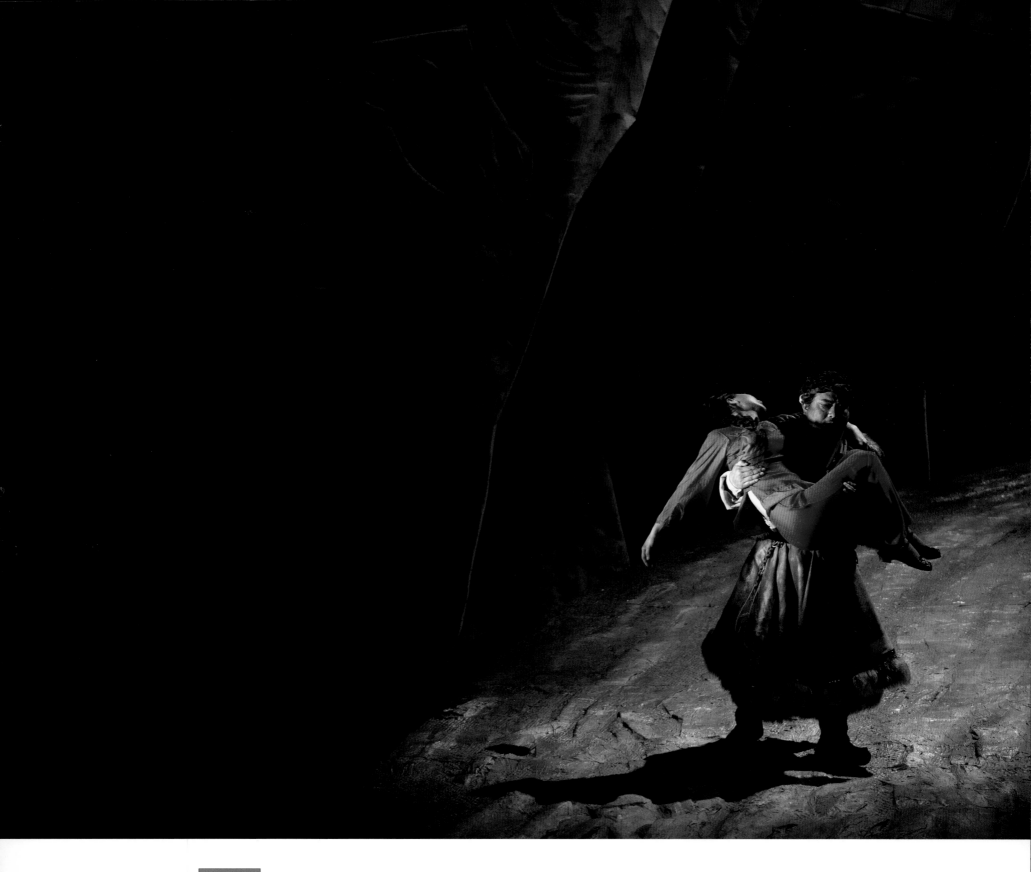

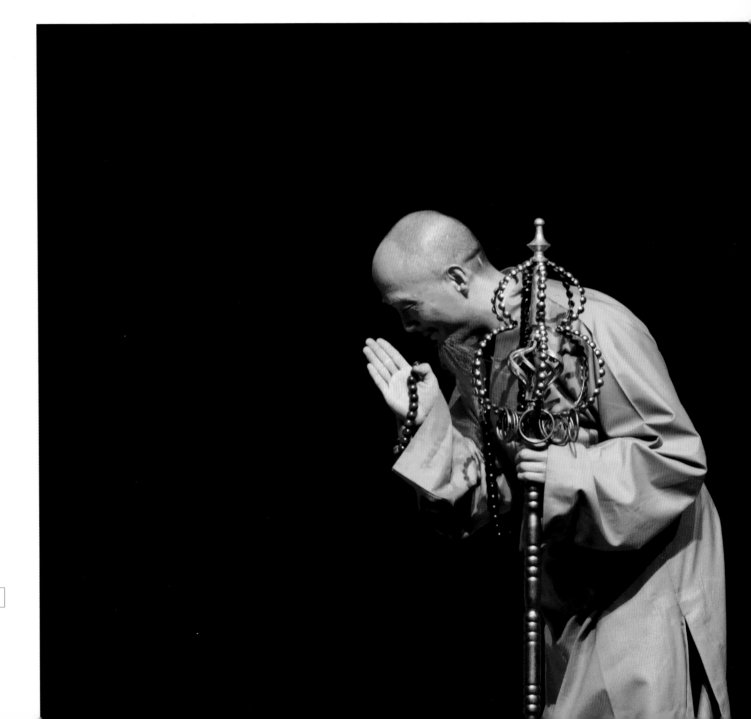

阿弥陀佛
Amitabha

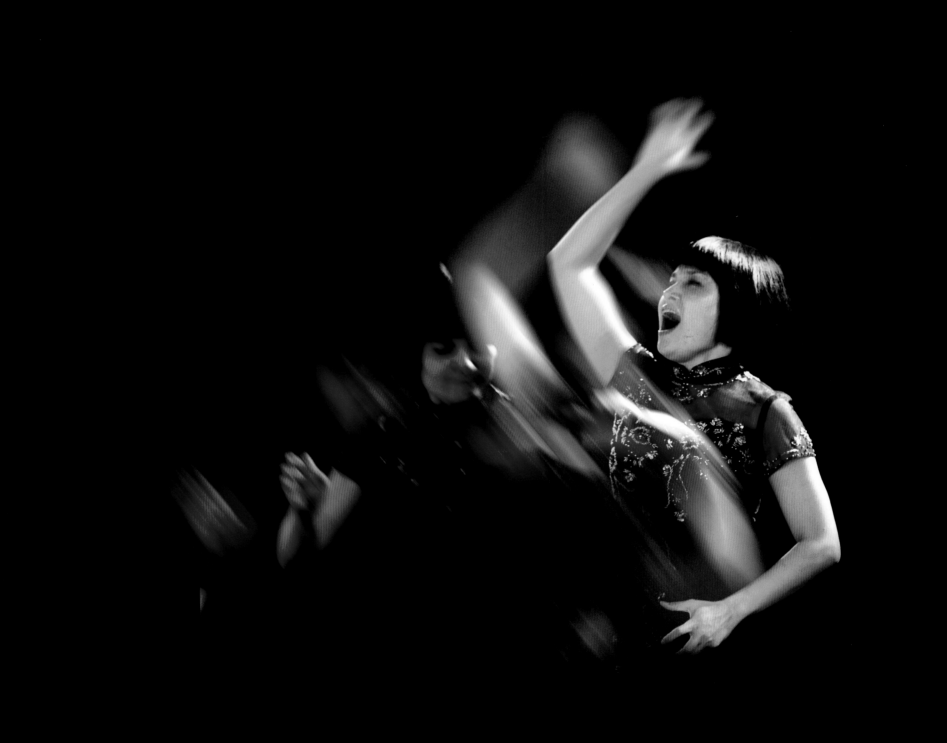

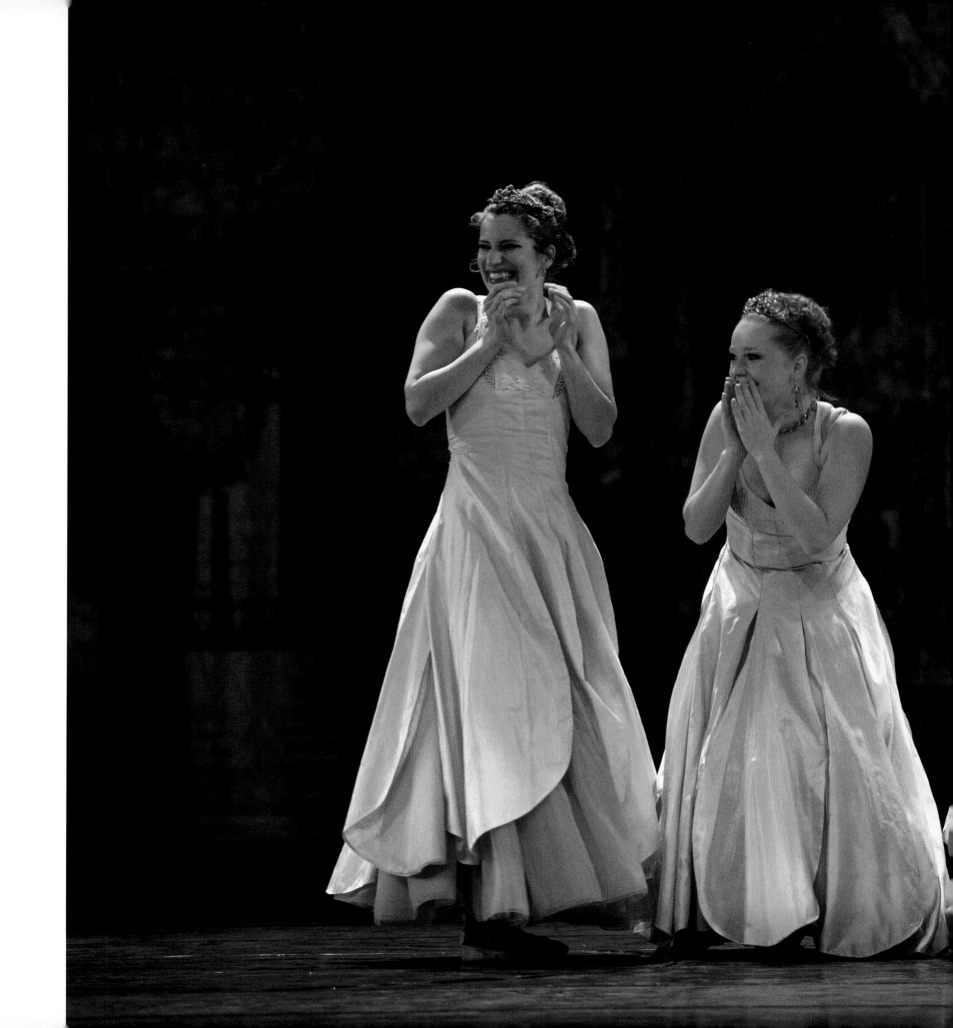

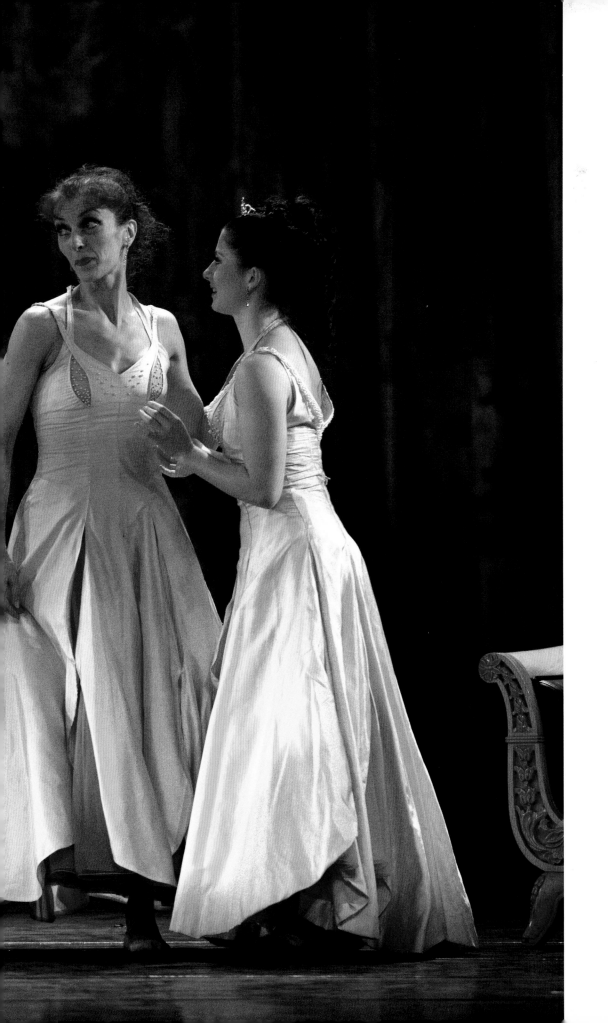

谈笑风生
Talking cheerfully

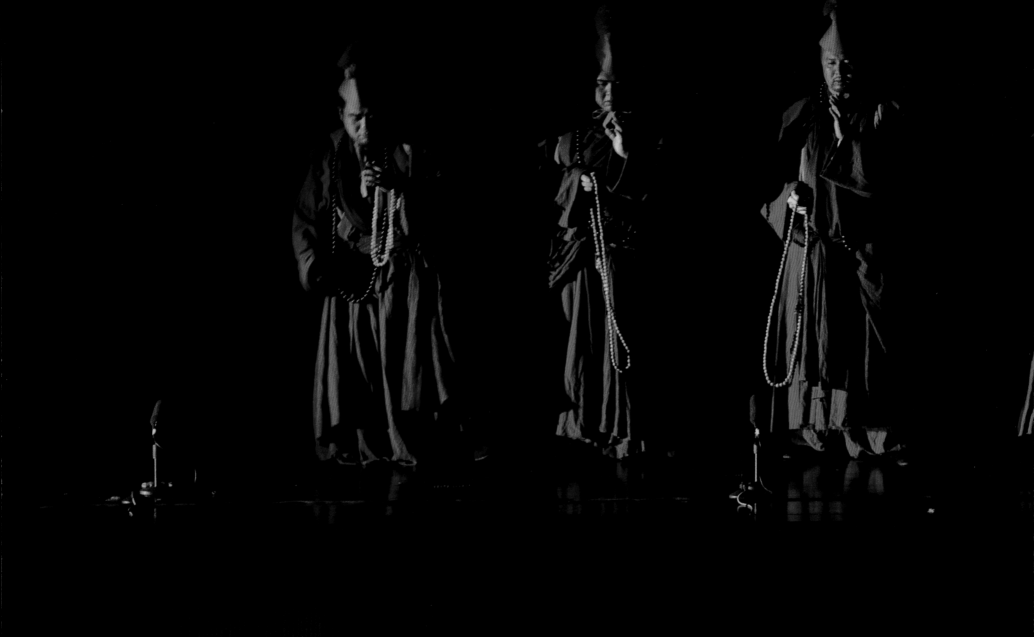

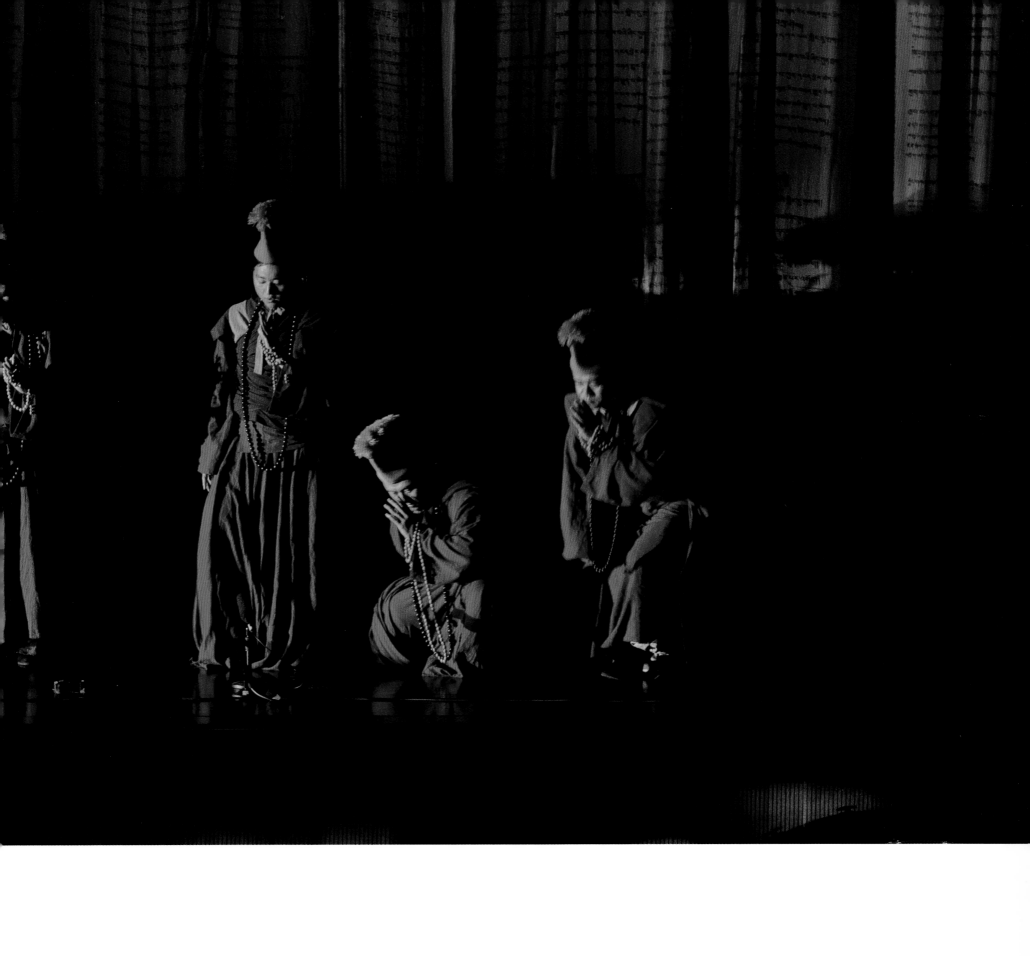

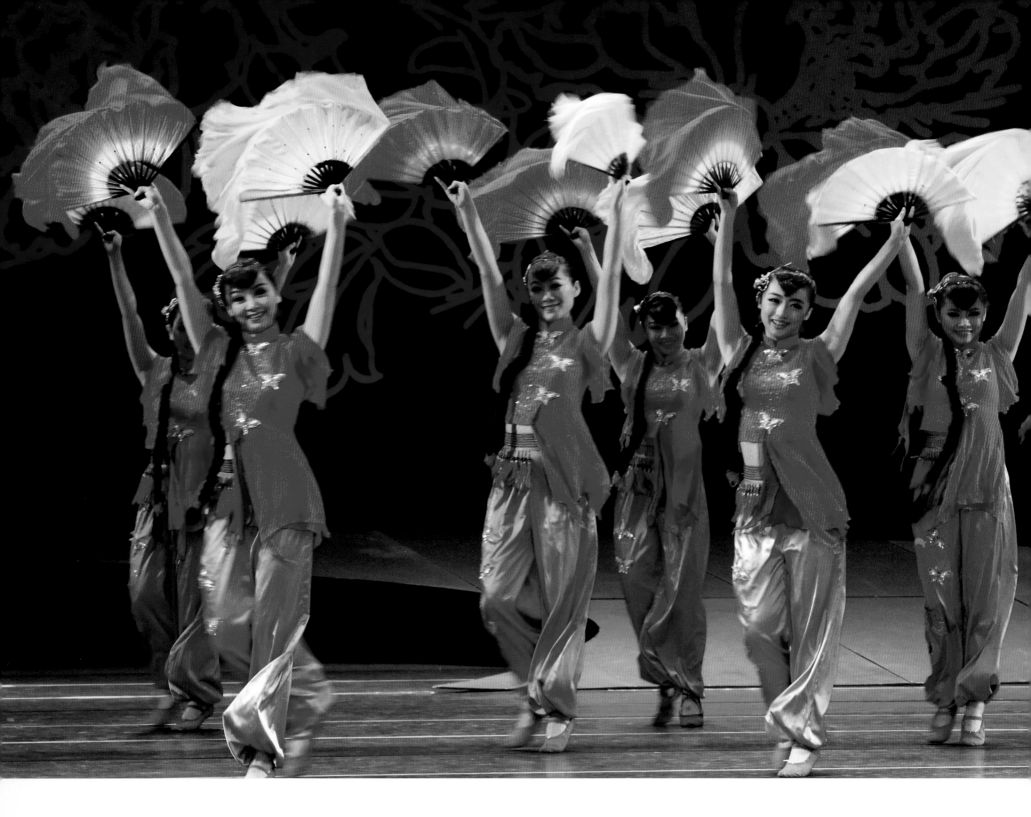

憧憬......

On the way, with love

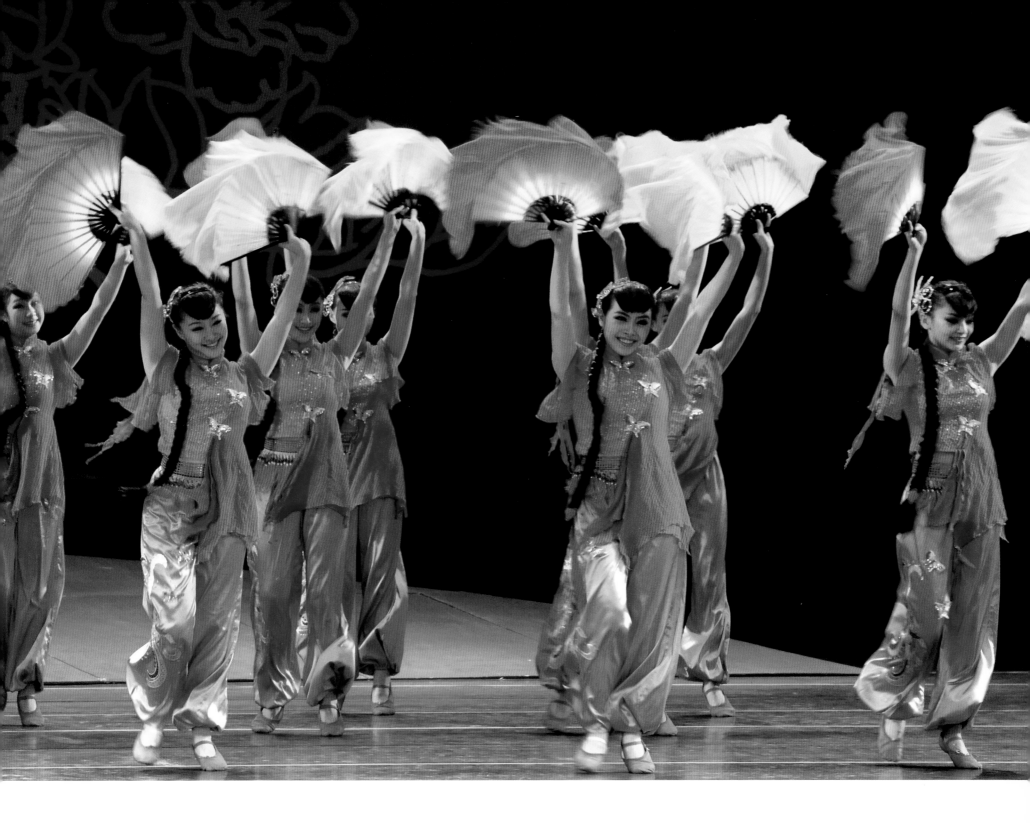

2011年荣获首届"金鹤杯"全国摄影大赛银奖

2000年荣获福建省第十七届摄影艺术作品展金奖，福建省委原副书记何少川为作者颁奖。

东篱之下，蓦然回首，

原来天崩地裂，

不过竹间淅沥，

此中有真意，

欲辨已忘言！

2010年3月8日.策划组织首届海峡两岸女摄影家作品展及摄影采风活动。

When I pick flowers in my

mountain retreat,

I look back in pease.

the yesterday's heartquake of

thunderstorm,

was but a gentle shower

moistening the bushes

What does this mean,

I'd rather not say.

Wei Xinping Stage Photography Art

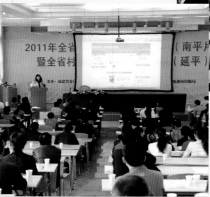

2011年在南平为福建省各地文化馆干部授课

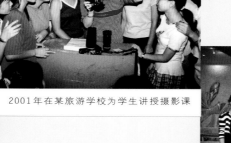

2001年在某旅游学校为学生讲授摄影课

2008年5月随团赴台湾进行文化交流

2008年1月随团出访马来西亚

后记

Afterword

感谢海风出版社为我的作品集《灵动的彩绘》提供出版平台,感谢领导、老师、同行、朋友等的帮助与支持,使画册最终成型。《灵动的彩绘》里的近百幅作品是我个人对舞台人生与人生舞台喜、怒、哀、乐和爱的诠释。

应该说,我是幸运的。因为喜欢舞台艺术又能身处舞台环境,因为热爱摄影艺术并能成为一名职业的摄影干部,而相关的创作、组织、教学、扶贫等工作也都是我的热爱。

然而,从影伊始,我也曾迷茫与困惑过,追求艺术的路上同样伴随着喜怒哀乐。有人曾说:"追求目标不但需要取舍,更需要执着、忍耐、付出和牺牲",拍摄的过程又何尝不是如此?

作为一名文化工作者,我的作品荣获了不同的奖项,曾经有过花季,更懂得树的品格。当我拿起相机记录每一个瞬间时,当我站在讲台上为学员们讲学授课时,当我与海峡对岸的姐妹同行进行交流时,当我被那些天真的农村孩子们围观询问时……我深感肩上的责任,面对荣誉我学会了坦然和镇定。因为,我已经懂得什么是人间最珍贵的情怀,什么才是自然最美的风景……

基于上述原因,在我将作品集《灵动的彩绘》分成喜、怒、哀、乐的同时又添加了爱的篇章……

Many thanks to the Haifeng Publishing House and to many of my colleagues and friends. Without their help and support, there this album wouldn't have been published. *Ethereal Colors* is my personal interpretation of the passions-pleasure, anger, sorrow, joy, and love-on stage, or in real life.

I have to admit that I'm a lucky person, for I love my careers on the stage and with photography. I have enjoyed everything I have been doing-creating, organizing, and teaching as well as my charitable work with the poor.

Yet, I have also experienced loss and bewilderment. I have often met happiness and sorrow, sweetness and bitterness. A wise man said: "In pursuit of success, one must not only choose one's goal wisely, but it is even more necessary to have persistence, patience, and sacrifice." This is also true of photographers.

My works have won many awards. When I went through my blossoming season, I learned the character of the tree. Whenever I snapped a photograph, gave lectures in classrooms, exchanged views with female colleagues from Taiwan, or was surrounded by innocent country children asking questions, I felt the weight of my duty. I learned how to be calm and composed when dealing with honors, because I know the real treasure of the world and the most beautiful scenes in nature.

Because of the reasons mentioned above, I have organized the pictures into five chapters-pleasure, anger, sorrow, joy, and love.

图书在版编目（CIP）数据

灵动的彩绘：魏新萍舞台摄影作品选/魏新萍摄
.—福州：海风出版社，2011.9
ISBN 978-7-5512-0035-6

Ⅰ.①灵… Ⅱ.①魏… Ⅲ.①舞台摄影–中国–现代
–摄影集 Ⅳ.①J425

中国版本图书馆CIP数据核字（2011）第184847号

灵动的彩绘
魏新萍舞台摄影艺术

责任编辑//窦胜龙

书籍设计//窦胜龙

文字编辑//朱　军

英文翻译//[美]Karen Gernant
　　　　　陈泽平

出版发行//海风出版社

（福州市鼓东路187号　邮编：350001）

出 版 人//焦红辉

印　　刷//福建彩色印刷有限公司

开　　本//280×280　　1/12

印　　张//15 印 张

字　　数//2 千 字　　图//120 幅

印　　数//1–1000 册

版　　次//2011年12月第1版

印　　次//2011年12月第1次印刷

书　　号//ISBN 978-7-5512-0035-6/J·210

定　　价// 198.00 元